RE-IMAGINING HERITAGE INTERPRETATION

For my parents

WITHDRAWN

Re-imagining Heritage Interpretation
Enchanting the Past-Future

RUSSELL STAIFF
University of Western Sydney, Australia

ASHGATE

Published by
Ashgate Publishing Limited
Wey Court East
Union Road
Farnham
Surrey, GU9 7PT
England

Ashgate Publishing Company
110 Cherry Street
Suite 3-1
Burlington, VT 05401-3818
USA

www.ashgate.com

British Library Cataloguing in Publication Data
A catalogue record for this book is available from the British Library

The Library of Congress has cataloged the printed edition as follows:
Staiff, Russell.
 Re-imagining heritage interpretation : enchanting the past-future / by Russell Staiff.
 pages cm.
 Includes bibliographical references and index.
 ISBN 978-1-4094-5550-9 (hardback)—ISBN 978-1-4094-5551-6 (ebook)—ISBN 978-1-4724-0735-1 (epub) 1. Interpretation of cultural and natural resources. 2. Cultural property—Philosophy. 3. Heritage tourism. I. Title.
 GV181.18.S83 2013
 363.6'9—dc23

 2013020847

ISBN 9781409455509 (hbk)
ISBN 9781409455516 (ebk – PDF)
ISBN 9781472407351 (ebk – ePUB)

Printed in the United Kingdom by Henry Ling Limited,
at the Dorset Press, Dorchester, DT1 1HD

Contents

Acknowledgements

This book had its origins a long time ago. I was with a group of students in Budaroo National Park, south of Sydney, and for the first time I heard the word 'interpretation' in a way that struck me as distinctly odd. 'The interpretation is getting tired' we were told by the park manager. As an art historian who had very recently moved sideways into heritage and tourism studies, the use of the term 'interpretation' in such a precise context and with such a particular meaning was strange to me. 'Isn't everything about interpretation? What else is there?' I asked myself.

Fifteen years later this book is an attempt to answer these questions. First and foremost, I want to thank a number of people and institutions that have been crucial to the project. I owe a considerable debt to the University of Western Sydney for granting me sabbatical leave in 2009-2010. The Faculty of Architecture at Silpakorn University in Bangkok (within their Architectural Heritage Management and Tourism international programme) hosted me during this period and both institutions have my sincere gratitude for providing such stimulating environments. The first four chapters of the book were drafted during this sabbatical.

I want to sincerely thank my heritage colleagues in the School of Social Science and Psychology and in the Institute of Culture and Society within the University of Western Sydney, particularly Robyn Bushell, Tim Winter, Emma Waterton, John Giblin and Fiona Cameron. They have, in various ways, provided the critical fire within which the book was forged. I'd also like to thank my colleagues (past and present) in the heritage and tourism studies unit who have been lively companions along the trek: Corazon Sinha, John Streckfuss, Ian Knowd, Julie Wen, Poll Theerapappisit, Wendy Holland and Amie Matthews.

A special acknowledgement goes to the many PhD students I have had the pleasure to mentor at the University of Western Sydney and Silpakorn University. It has been a rich engagement with a number of the themes in the book over many years. To my parents who, for varying short periods of time, provided me with a place of tranquility well away from the hustle and bustle of Sydney, I offer heart-felt thanks. To Kym and Nikki I give thanks for memorable travel, conversations and accommodation in a most beautiful and exhilarating heritage setting. I offer particular thanks to the folk at Ashgate who have been nothing less than supportive and encouraging.

And, finally, I owe a great debt to the legion of undergraduate students whom I've had the privilege to teach over many years. They were the inspiration for and the *raison d'être* of the book.

Prologue: the known, the unknown and other ruminations

Those who do not expect the unexpected will not find it, for it is trackless and unexplored.

These words appear in a surviving fragment of the writings of the philosopher Heraclitus who lived in the ancient Greek city of Ephesus between c.535 and 475 BCE (Kahn 1979: 105). If any aphorism were to somehow capture my expectations of visiting a heritage site, it would perhaps be this one: to expect the unexpected. But Heraclitus suggests something more than this: that the unexpected is not a mapped entity; it is not found along a pre-determined path; it resides in that which has yet to be known.

Of course, heritage sites are, almost by definition, anything but unexplored places having been subjected to critical surveillance in minute detail. They have been measured against all sorts of criteria. They have endured countless physical interventions in the attempts, often heroic, to preserve, restore and conserve them for the present/future. They have become the subject of a multitude of representations – maps, guidebooks, management documents, conservation plans, drawings, photographs, videos, films, scholarly treatises, in art works, tourism promotional material and interpretation in all its forms (see Waterton and Watson 2010).

This dualism between what I expect (a place of discovery, of imaginative engagement, of speculation, of confrontation, of being confounded, of exploring the unknown, of emotional entanglement, of a place where I may tussle with the self, where I might dare to court with danger or bliss or controversy or sensuality, of *being there* – with all its embodied implications) and the often much more prosaic encounter with something that feels as though it has preceded me, something that is already over-determined by the discourses that circulate through a heritage site (and beyond) is, admittedly, a personal conundrum. However, I have never been able to fully ignore this intensity, as I wildly oscillate between entering a heritage place that is already in some way known to me (for whatever reason) and the *desire* to explore afresh (even when I'm aware of how this desire has been constructed and/or manipulated).

This enduring tension, to a degree, animates the journey of this book. I love to visit a place I know almost intimately because of the deep knowledge, memories, feelings and associations that I carry around with me. But, equally, I love to visit those places that are unknown, where the elements of excitement and surprise are still possible. However, the more rational part of me knows that these two things are hinged. I can find wonder, awe, surprise, loss, joy, foreboding, imagining, anger

and frustration even in the most visited and known of heritage places. Florence, with all its crowds and the way visitors, these days, are highly managed in places like the Franciscan church of Santa Croce, still inspires. So does Uluṟu-Kata Tjuṯa in Central Australia. As for unknown heritage places, to what degree are they ever completely unknown? To see a sign pointing to a place denoted as 'heritage', but a place completely unknown to me personally, already carries certain expectations and ideas about what it is I may find at the end of the road.

So is this tension I write about a phantom, an invention of my own? Not entirely. I think that within heritage discourse and practice there is a paradox: to manage change, the enduring constant in the physical world, we have to record, label, classify, quantify, fix places in maps, photographs and diagrams, plans, discourses and so forth. Conservation would be impossible without these tools of the trade (cf. Munos Vinas 2005; Stubbs 2009). But 'heritage' is also about all the reasons people feel attached to places, sites and objects and the heritage literature is now abundant and rich in descriptions of the many ways heritage places become important for people and communities (for example, Smith 2006; Byrne 2007; Winter 2007; Ashworth 2008; Byrne 2008; Hancock 2008; Langfield, Logan and Craith 2009; Smith and Akagawa 2009; Labadi and Long 2010; Waterton and Watson 2010; Anheier and Isar 2011; Daly and Winter 2012; Staiff, Bushell and Watson 2013; Harrison 2013). The collapse between the natural and cultural distinctions in heritage thinking and practice, the assertion of the concept of intangible heritage (Smith and Akagawa 2009) and the recent debates about whether there are 'Western' and 'Asian' ways of conserving heritage (Daly and Winter 2012) bear witness to an ongoing evolution of that we name 'heritage'. It is a dynamic entity, not a stable category. As many of my colleagues increasingly suggest, 'heritage' should be regarded more as a verb rather than a noun; 'heritage' is something we do, rather than something that is (Smith 2006; Byrne 2007, 2008; Harrison 2013).

And what do visitors do in heritage places? The list is long and cannot easily be exhausted: we look, we hear, we smell, we touch (if we are allowed), we walk, we ramble, we climb, we rest, we interact with our companions, we imagine, we feel, we recall memories, we may laugh, we may cry, we may feel anger, anxiety, maybe disorientation, we may feel loss, we may feel pain, we may feel numb. We photograph (a lot), we read signs, we listen to audio-tours, we trail after a guide, we consult guidebooks, we may attend a lecture or multi-media presentation, we pore over maps, we closely observe models and diagrams, we watch a performance, we refer to Google on our iPhones, we download an e-tour, we chat with our companions or on our phones, we think about something quite removed from where we are, we reflect, we may argue, we may feel confronted, we may feel small, we may feel proud, we may feel like a cosmopolitan or we may feel patriotic. We may feel nothing. We may feel overwhelmed. Whatever we do, it is a keen mixture: actions often mediated by representations plus somatic and cognitive participation. And what is the common denominator in this less than complete list? All of these interactions focus on the visitor, and all of them,

therefore, are infused with social and cultural characteristics. In its broadest sense, visitors at heritage places can be regarded as being in dialogue with places, objects and landscapes; as having a dialogic relationship with parts of our planet marked out as being special (for whatever reason) and with something from the past/ present that needs to be kept (for whatever reason, official or unofficial) for the future (Staiff, Bushell and Watson 2013).

There is nothing new in the claim that attachment to heritage places is a social and cultural phenomenon. The making of meaning can never escape its own distinct social and cultural dimensions. Visiting heritage sites is a social and cultural immersive practice. Aesthetic appreciation of heritage places is a culturally inscribed response. Conservation might appear to be scientific and technocratic, but it is riddled with social and cultural ideas and values that nourish, on so many levels, the physical process of conserving biodiversity and restoring an ancient, or not so ancient, structure or object (see Eggert 2009). And so it is with heritage interpretation. My constant vacillation between, on the one hand, heritage as the unexpected, a source of inspiration, imagination and even consternation and, on the other hand, heritage as strongly framed by many knowledge practices, has lead me to think anew about the interaction between people and heritage places.

Heritage interpretation is a social and cultural process because, like all forms of interpretation, it cannot be limited to functional definitions, practical manuals, communication techniques, informal learning, planning approaches, multi-media performances and so on. Across the many disciplines, interpretation has a variety of meanings and applications: explication and elucidation is but one. Exegesis involves the study of different meanings of sacred texts or juridical texts and the proposition of new meanings, new understandings. In art theory it refers to the way different representations negotiate subject matter or the different understandings viewers perceive in a work of art, and in musical performance it is about the various ways a musical composition may be performed. The same goes for any dramatic performance where different stage or film interpretations are compared with each other and with what is written in the playwright's script or screenplay's script. In language studies, interpretation is closely allied to translation from one language to another. In science, interpretation relates to possible hypotheses and explanations related to a particular data set. It is similar in medicine with diagnostic testing.

Consequently, this book is not a heritage interpretation manual, it is not a set of principles and guidelines, it is not an approach to planning or to guiding or to designing an iPhone app, it is not about effective communication techniques or how tourists and visitors learn things at heritage places. There are plenty of very good studies, publications and websites devoted to the practice of heritage interpretation (for example, the websites of the national interpretation associations: guidelines like Carter 2001; UNWTO 2011). This book is a series of personal meditations about the relationships between heritage places and visitors; it is a *cultural study* of the phenomenon now known globally as *heritage interpretation*. And it is an intensely individualistic account.

The word 'meditation' is a quite conscious choice. Any thesaurus will offer a clutch of similes for 'meditation': musing, pondering, reflection, rumination, brooding, contemplation and cogitation. The list evokes both the tone and the approach of the book. After many years of thinking and teaching about heritage interpretation in Australia and Thailand, and of witnessing a number of important changes in the field (that is, within heritage studies, tourism studies and museum studies) and the advent of challenging practices to do with Web 2.0 and the evolution of social media, I wanted a space where I could 'muse', 'ponder' and 'ruminate'. Therefore, the book is thematic in structure (as I explain in Chapter 1) and not entirely consistent. My arguments often shift ground depending on what I'm discussing. Partly, this is because of the diverse nature of each theme (and when considered together they throw up a degree of complexity that is often not very neat) and partly, this is the nature of 'musing'.

But why write personal meditations and not an academic analysis as traditionally conceived? The answer is simple. This book is the result of countless conversations I have had about heritage interpretation over a fifteen-year period, conversations with university colleagues and co-researchers, with my undergraduate and doctoral students in Europe, Australia and Thailand, with people who work in museums and national parks, with those who work for heritage and conservation agencies, with people who work in the tourism industry. I wanted to preserve the conversational tone of these many encounters and to insist that this is *a reflection about heritage interpretation* after thinking, teaching and writing about it for a decade and a half.

The emphasis on the personal is, also, for other reasons. The book is not the result of empirical studies or even the result of having read everything that has been researched, written and said about heritage interpretation in recent times. Rather, it is a conversation I want to have with students, with practitioners and with colleagues. Not any old conversation, of course. It is a conversation that reflects my own view of the world of heritage and travel, is one that tries to write about the complex ways people grapple with and connect with what they deem as 'their heritage places', that explores 'heritage dimensions' not easily represented (emotions, feelings, somatic responses) and which preserves something of the way I teach, through narrative and personal observations that are, hopefully, nourished by cultural theory in a way that is accessible and understandable. To this degree the book is unavoidably biased because my major aim is to inject a different, maybe richer, perspective, or, as the title dares, a re-imagining, into the conversations about heritage interpretation. If I achieve nothing else, I will feel I have succeeded.

There is one very important caveat. I originally trained as an art historian and my early academic career after my doctoral studies was in art theory and history. It is therefore inevitable that most of my engagement with heritage places is through built or made heritage rather than natural heritage and the conservation of biodiversity. I make no apology about this because material culture is knitted into the way I think about heritage in all its various dimensions. This will be obvious in the pages to come. Nevertheless, I have not been hermetically sealed from natural heritage and my conversations over the years have been with people intimately

connected to biodiversity conservation. I also emphatically note that 'nature' itself is a cultural inscription and conservation as much a social and political process as an ecological intervention (Staiff 2008). But I don't *think* heritage interpretation from the perspective of 'natural' heritage. Despite drawing on examples that are mainly to do with cultural heritage, this is not the same thing as saying the book has nothing to offer those who are involved with natural heritage. I would suggest the opposite. The meditations in this book apply to all types of heritage, however defined, but the prism of analysis is cultural heritage.

A note about examples and case studies

The text of this book is laden with examples of objects, places, buildings, archaeological sites and natural heritage sites, cities, towns, landscapes, museums and so forth.

A worthwhile way of reading the text is to have a vivid visual impression of the examples cited and the case studies examined. I therefore strongly urge the reader to have an image search engine open and near at hand so that each example can be experienced visually during the reading.

Chapter 1
Anecdotes and observations

Past/Present

For some time I have been wrestling with the question of whether or not the advent of digital media and the rapid and continual developments in digital technologies was fundamentally changing not only how heritage interpretation was being created and delivered, but also whether or not digital media was changing heritage interpretation itself (Kalay, Kvan and Affleck 2008). This was one of the more pressing starting points for the book.

It soon became apparent, however, that any question about digital media quickly opened out to include a number of other issues that were also pertinent to the way heritage sites presented and communicated themselves to their publics and the way these publics engaged and interacted with 'heritage'. Consequently, a key question about digital media and heritage interpretation encompasses a series of related issues: the heritage experience itself and its relationship to the tourism experience; the history of heritage interpretation; the role of representation in interpretation; the role of fiction in all its guises; the way heritage interpretation is knitted into visual cultures; the predominance and power of narrative; the problems associated with cross-cultural translation; and finally the social and cultural practices associated with digital media. The more I researched the original question, the more complexity was made manifest.

One of the problems I encountered, very early in these investigations, was the increasingly standardized definition of heritage interpretation operating in the Anglophonic world and now, with the 2008 ICOMOS *Charter for the Interpretation and Presentation of Cultural Heritage Sites*, penetrating the non-English speaking world. It is fair to say that before the 1980s there were a variety of understandings about the interaction between visitors and heritage sites, places, landscapes, museums and objects all shaped by a number of disciplines. In art museums stylistic analysis (loosely the composition, colour, texture, materials and techniques of art) and iconography (loosely the study of the subject matter and the meaning of art works) dominated how paintings, sculptures, prints and drawings, mosaics and so on were interpreted to the public. My own disciplinary background resides in the world of the visual arts and any gallery guiding I did never strayed too far from the discipline of art history even as it was undergoing changes wrought by the debates now clustered under the term 'postmodernism'. A colleague in classical studies and archaeology and another in history regarded the material culture of the past as more a stage for historical narratives. House museums and history museums did much the same thing. Historical method, a

clumsy term for a great variety of approaches for researching and (re)presenting the past, was inevitably the frame within which objects, places and landscapes were described by historians (see, for example, the way material places are integrated into three recent, but very different histories, by Clendinnen's 2003 story of the encounters between the English and the Eora people in Sydney Cove in the late eighteenth century CE; Gere's 2006 study of Agamemenon's tomb and Starkey's 2010 history of the English monarchy). The Palazzo Medici in Florence was used by my colleague to tell the story of the Medici clan, its economic and political power, its patronage, the neighbourhood networks within which it operated and individual biographies of family members. In the sphere of natural heritage, ecology was the frame and as ecotourism began to make its mark into the late 1980s, messages about environmental futures were the hallmark of the interpretation. In other words, there was a huge variety of approaches and understandings of interpretation operating across a vast and diverse field of objects, places, landscapes and museums.

Increasingly, during the 1980s, disciplinary approaches to interpreting tangible heritage couched in disciplinary traditions, thinking and methodology (art history, history, architecture, ecology and environmental science, science and technology, ethnography, geography, musicology and so on) began to give way to similarities rather than differences. International conferences addressing heritage interpretation appeared and in the Anglophonic cultural sphere the Second International Conference on Heritage Interpretation held in the UK in September 1988 stands out because of the two volumes of papers, edited by David Uzzell, that appeared soon after (Uzzell 1989). National interpretation associations were founded – for example, the UK Association for Heritage Interpretation, the US National Association of Interpretation and the Interpretation Association of Australia – and, via the conference circuit and the important work of these associations, heritage interpreters began conversing across disciplines and across heritage fields so that museum curators and educators were talking with ecotourism interpreters and guides and national park staff and so forth. While this is a shorthand description of what was actually happening in those years, it serves to indicate the move towards a shared terrain. What could be common to a visit and the interpretation offered to a tourist visiting the Great Barrier Reef off the eastern coast of Australia or a visit to Pompeii in Italy or a visit to the Metropolitan Art Museum in New York or a visit to Warwick Castle in the UK or the British Museum in London or the Forbidden Palace in Beijing or the rock art sites of the Ukhahlamba-Drakensberg Mountains in South Africa or the National Air and Space Museum of the Smithsonian Institute in Washington DC or historical cities like Siena in Italy or the Taj Mahal in India or the Tuoi Sleng Genocide Museum in Phnom Penh? To speak across disciplines – and across cultural contexts – the common denominator at heritage interpretation conferences and within national interpretation associations was communication and education.

While Freeman Tilden's 1957 book *Interpreting Our Heritage* was well known within natural heritage circles in North America and increasingly in other national

parks' services, the book became a pivotal influence when it was used to define interpretation across disciplines and across hugely different cultural and natural heritage sites. Because education was a key characteristic of Tilden's description of heritage interpretation, education was reinforced as the central characteristic of the interaction between visitors and heritage sites/places where interpretation activities were offered. And education was underscored by urgency: the perceived environmental crisis enveloping the developed world. Thus, through the 1980s and 1990s, the definitions of heritage interpretation became increasingly systematized. Many of these definitions bear the imprint of Tilden and most regard interpretation as an educational activity (see, for example, Beck and Cable 1998; the Wikipedia entry for heritage interpretation; and the definitions offered on the websites of the Association of Heritage Interpretation and the Interpretation Association of Australia).

However, Tilden wasn't the only influence operating in the emergence of a consensus discourse about heritage interpretation. The public museum sector had, since the nineteenth century, regarded knowledge formation as central to its mission of collecting, documenting, conserving and presenting material culture (Hooper-Greenhill 1992; Schubert 2009). More recently, museums have increasingly identified with education and learning (Hein 1998; Falk and Dierking 2000; Hooper-Greenhill 2007). Consequently, when personnel across different heritage sectors began to interact with each other in the 1980s and beyond, Tilden's ideas happily co-existed with the educational role of the museum. Today, the distinctions between natural and cultural heritage(s) and tangible and intangible heritage(s) have blurred (Smith 2006) and furthered the momentum towards a heritage interpretation consensus discourse.

While the disciplinary frameworks for explaining heritage sites and places were overly restrictive, and were often about protecting disciplinary knowledge and power, the education definitions 'threw the baby out with the bathwater' by relegating disciplinary knowledge to a more marginal position. Today, in heritage interpretation the 'experts' are the educators, communicators and designers, not necessarily the specialist curators or the archaeologists or the historians or the architects or the conservators. In saying so, I'm not harbouring a complaint about the move away from disciplinary knowledges, but the now pervasive education paradigm in heritage interpretation is stifling and restrictive in its own way. Although, having said this, the disciplinary basis of heritage interpretation has in fact not altogether gone away, but has simply shifted its centre of gravity. No longer is it ethnography or history or ecology or archaeology or architecture or art history or science and technology that dominates the form of interpretation, it is now psychology and the critical questions relating to informal learning, visitor motivations and attitudes, effective communication, behavioural change and assessing communication techniques. Naturally, I'm not suggesting these things are unimportant, they clearly are and the recent history of heritage interpretation cannot be ignored. Rather, I'm suggesting the emergence of a heritage interpretation orthodoxy has reached a type of limit that, in effect, has been exposed by firstly,

digital media and digital technologies and, secondly, advances in thinking about the heritage/tourist experience. It is now possible, I would contend, to think about heritage interpretation differently (cf. Ablett and Dyer 2010).

Anecdotes: rethinking heritage interpretation

Over the past two years I have been collecting anecdotes for this book. Originally, I perceived them as small examples and case studies to be quoted throughout the text, but now I regard them collectively as an assemblage of narratives that provide a cogent and compelling case for why rethinking heritage interpretation is necessary. The anecdotes are presented, in the first instance, with little commentary. Each of them is suggestive and each of them illuminates something of the complexity of the interaction between people and heritage places and objects or, in a less binary tone, the embodied engagement of places, objects, monuments and landscapes.

I

I remember sitting on the edge of a high peak in Doi Inthanon National Park in northern Thailand. It was much cooler than I had expected but as I looked across the ridges of mountain peaks blue and misty, the crispness in the air was refreshing after the much warmer streets of Chiang Mai whence I'd travelled. I was lost in two worlds. One was visual: a world where the clear pale watery sky of early morning mingled with the mountain-cradled mists across vast distances both upwards and outwards from my vantage point. This boundless envelope of air and remote terrains completely dwarfed me. The other world was aural. The volume of my iPod had been turned up and I was listening to the second movement of Beethoven's Emperor piano concerto, the achingly beautiful and poignant conversation between the lilting sounds of the piano and the opulent and velvety orchestral accompaniment. The fused visual and aural experience was exalting: all affect and no language; deeply sensorial and without thought.

It was here that I had a type of epiphany. That moment of mountains, vaporous sky and the elegiac sounds of the piano and orchestra was more powerful and more aesthetically arresting than all the information that I had passed by on my morning climb to one of the mountain peaks. I had passed through an information centre with maps and pictures and diagrams that explained the ecology of the park and the lifestyle of the Hills-tribe people who lived there. I had passed by signs that explained, in Thai and English, features of the terrain and the flora and fauna of the mountains. I had carried a guidebook that told me that this was where the great Himalayan mountain range finally petered out and the place of my reverie was the tallest peak in Thailand. My epiphany was thus: in an age of relentless information overload, what mattered was not the considerable interpretation (that just seemed like 'more information'), but what I felt, the 'purity' of the moment. It was the feeling of exaltation that I had sought and, now in this memory, I recall with affection.

II

The day was far from pleasant, grey and windswept with a chill coming off the harbour. It was a relief to finally skip up the wet steps of the Art Gallery of New South Wales and find shelter. I'd promised my nephew, aged 16 and a Swiss citizen, to take him on a quick tour of modern Australian art beginning with Grace Cossington Smith's *The Sock Knitter* (1915). We were discussing the late arrival of modernism in Australia and, more generally, the influence of Paris on the early moderns in Europe. I knew Smith had been in England just before the outbreak of World War I, but I couldn't recall whether she'd travelled to Paris.

Suddenly, my nephew pulled out his iPhone and plunged into Wikipedia and within moments he had discovered she had not, apparently, gone to Paris on that particular trip. Using the Wikipedia entry external link, he found the National Gallery of Australia's website devoted to the Grace Cossington Smith retrospective mounted in 2005. One hundred and thirty-five of her sketches and paintings were available for viewing as both thumbnails and larger details and so there we stood comparing these with *The Sock Knitter*. I moved us on to some of her other works on display that day. My nephew was particularly taken with her painting *The Curve of the Bridge* (1928-1929) depicting Sydney Harbour Bridge during construction. We compared the Art Gallery of NSW picture with the more famous *The Bridge in-curve* (1930) from the National Gallery of Victoria collection displayed on his iPhone screen. Still on the NGA website, he found an essay by Deborah Hart, the curator of the exhibition, and read out aloud a couple of passages.

After our tour we retired to the café for a pot of tea. While I was reading an art magazine I had picked up, my nephew was busy typing away on his iPhone keyboard. And what was he doing? Writing a story on Facebook about the construction of the Sydney Harbour Bridge and oblivious to all copyright rules, and thanks to Google Images, had pasted a picture of Grace Cossington Smith's *The Bridge in–curve* into his story alongside his own photos of the bridge. On that cold wintry Sydney day, Web 2.0 caught me with a jolt. That which was somewhat extraordinary for me was simply matter-of-fact for my young companion.

III

I was trying to walk along Thanon Mahathat heading towards Thommasat University on my way to the National Museum in Bangkok. Thankfully, I wasn't in a hurry. The crowds were pressing in on me from every side, all of us jostling to make a way forward but crammed onto the footpath by the road traffic moving along slowly, accompanied always by its incessant noise and the belching of heat and exhaust fumes into the already humid monsoonal air. It was hot, maybe 34° centigrade. But the moist heat was not overly daunting. Despite the traffic smells and the discomfort of the crowd, I was seduced by the sensorial journey along the road: by the intoxicating aromas of food being cooked and displayed; by the endless stalls selling drinks, statues of the Buddha, amulets, vegetables,

pharmaceuticals, dentures, shoes, books, stationery, pirated CDs and DVDs, newspapers, glasses frames, umbrellas, jewellery and so on. The chaos of this footpath 'supermarket' and its slow-moving crowds with the cacophony of sounds and the exquisite and not so exquisite odours, had a living intensity that was addictive. I loved this vibrant street with its shop-house terraces on one side and the Buddhist University on the other; with the mingling of locals and students from three major universities, including orange-robed monk students; with the glimpses of the Chao Phraya River beyond the small *sois*, or lanes, that run down to Bangkok's major waterway.

On this particular day, I stopped at a small shop-front restaurant that specialized in food from the *Isan* region of northeast Thailand. I squatted on a four-legged stool and ordered *om gai* and sticky rice. *Om gai* is a heavily herbed and spicy chicken soup that is thick with spring onions, lemongrass, chilli and dill weed. It's one of my many favourites. The tangy flavours of the soup – the rush of chilli heat on my tongue and in my throat – perfectly matched the mood of the street.

Not long after my light meal, I arrived at the National Museum. The contrast with Thanon Mahathat couldn't have been greater. The grounds of the museum were relatively quiet despite the traffic on the busy road outside the gates. On this day there were few people around. The ticket seller appeared barely awake. After lodging my backpack with an attendant, also dozing, I stepped into the history pavilion of the museum. I was immediately surrounded by dioramas and cases of objects as I traversed a familiar narrative: a history of Thailand chronologically arranged and presented via the twin loci of the four successive capital cities of the Thai-speaking peoples and the monarchs who ruled over these cities and their kingdoms.

After the intensity of my walk along Thanon Mahathat the inanimate presentation of Thai history and culture seemed perverse, as though all the vibrancy had been leached out. The static dioramas seemed particularly lifeless. The objects, although quite beautiful, were nevertheless mute. The stillness of the pavilion's atmosphere, so carefully choreographed for the visitor, was somnambulistic. Something vital was missing. As I read the text panels and looked at the many displays, I wished, somehow, to be back in the chaotic world of Thanon Mahathat.

Some days later, I took the riverboat to Tha Tien and then ambled along, heading towards another museum. After the shock of the pungent smell of dried fish in the small market beyond the ferry landing, I turned into Thanon Mahathat, the very same road I had walked along to the National Museum, but this section, some distance away, ran behind Wat Pho. I dallied at the shops selling herbal medicines and bulk grains. I especially liked the assorted array of rice types, the wild black varieties and the familiar commercial varieties. The grocery shops were particularly special as I had little idea about most of the wares 'hidden' under shapes, textures and colours that lacked familiarity and 'hidden' under labels in Thai script or Chinese characters, neither of which I could read. As I approached the River Books bookshop I forced myself to delay a visit and instead headed through the back entrance to what was once the Commerce Department Building,

a carefully restored 'colonial' building with its long, deep and open verandas on each of the front-facing levels. This was the home of the new Siam Discovery Museum opened in 2008.

I was greeted by a young PhD student who was investigating the impact of new media on museums and heritage presentations in Thailand. I bought my ticket and we were almost immediately ushered into an auditorium with intriguingly curved screens. The lights were dimmed and an evocative and all-embracing soundtrack, that seemed to be both Thai and Western at the same time, surrounded us as the first images brought the space alive. The narrative of the presentation, across the multiple screens, introduced us to seven characters, each one having both a contemporary persona and an historical persona. The film narrative dissolved the distinctions between past and present and we were provided with a visual feast of Thai landscapes contemporary and historical blended with dialogue that gently and indirectly asked us to reflect on the questions of what it is to be Thai and what is 'Thai-ness'?

The film over, we began the one-way journey through the many rooms of the museum. Each room was aesthetically different, so the impression was of entering a series of quite distinct atmospheres with its own distinguishing colour scheme, its own distinguishing architecture and design features, varying lighting states and strikingly contrasting soundscapes. The moods ranged from the inquisitive (archaeological remains, ancient ritual practices and the problem of an ancient death) to the suggestive (the historical landscapes of Siam) to the meditative (Buddhism in Thailand) to the playful (modernity and pop culture in Thailand). This was not as alive an experience as walking down Thanon Mahathat, but it was equally memorable. And perhaps the reason could be found in the crescendo of visual and aural effects created in each room. Interspersed throughout thematically designed galleries, were screens that, once activated, played short films involving one of the characters we had met in the introductory presentation. These film narratives were produced using every 'trick' of contemporary cinema – detailed sets, designs and costumes within panoramic landscapes, a narrative arc, immediately engaging characters, clever and often humorous dialogue and fervid soundtracks. We were effortlessly transported into the cinematic world being created and within the space of five minutes, felt as though we had indeed travelled in time back to some earlier place in Thailand's past.

As we stepped out into the sultry monsoonal atmosphere of Bangkok, the clouds threatening rain, I left the Siam Discovery Museum thinking of the title of Andrea Witcomb's book *Re-imagining the Museum: Beyond the Mausoleum* (2003). Was this the type of museum space she had in mind? And so, separated by just a few days I had been to the National Museum (object dense, interpretation dense, serious-minded and ideologically positioned) and the Siam Discovery Museum (object light, interpretation rich in a highly orchestrated and intensely evocative multi-media environment that made for a memorable experience). The National Museum looked and felt like a 'traditional museum'. The Siam Discovery Museum looked and felt like a close cousin of 'new media'.

IV

In a class on material culture, I showed my students pictures of the present day archaeological site of Mycenae in the Peloponnese (southern Greece). I told them two stories and also provided some online notes on the history and archaeology of the ancient city, inscribed onto the World Heritage list in 1999. The two stories I told were thus: (1) The origins of the Trojan War as recounted by Homer in *The Iliad* (accompanied by images of the site today and interspersed with images from the Wolfgang Petersen 2004 film *Troy* starring Orlando Bloom, Eric Bana, Brad Pitt, Diane Kruger and Peter O'Toole); (2) Heinrich Schliemann's excavation of the site in 1876, his life, his passions, his archaeological methods, what he found and how he interpreted the finds. The Schliemann story was supported by images of the 'treasures' of Grave Circle A and archaeological reconstructions of the palace.

Several days later, I asked the class to recall the history and archaeology of Mycenae. A few 'bits' of information were eventually strung together but, to use a common metaphor, it was as 'painful as drawing teeth'. However, overwhelmingly what was vividly remembered were the two stories and in quite considerable detail; and this was despite the fact that very few of the class had seen the movie.

V

The Chateau de Prangins is a modest eighteenth-century manor house with connections to the family of Napoleon Bonaparte (it was occupied for a time by his brother Joseph) and set within the village of Prangins overlooking Lake Leman, in Switzerland. It is quite near Geneva. The building and its contents, now one of the campuses of the Swiss National Museum, are not the only parts of the Chateau of significance. The formal garden connecting the Chateau to the village is particularly important as many of the botanical specimens are direct descendants of the original eighteenth-century plantings and make up an invaluable archive of plant DNA. Beyond the formal garden there are wooded parklands surrounding the buildings and appearing to stretch down to the lake beyond.

On a beautifully warm and sunny Sunday in early autumn, the museum held a picnic day. Inspired by Manet's 1863 painting *Le dejeuner sur l'herbe* (luncheon on the grass) in the Musee d'Orsay, the idea was to stage a fair/picnic/fete that would provide a scenic setting for a family picnic on the grass. The café provided hampers of bread, cheese, pâté, salad, champagne and chocolate. Local produce growers, craft makers and cooks sold vegetables and produce at stalls dotted around the forecourt. Games were provided for children and the museum was open with free entry. Tours of the collections and the gardens were also available for those gathered. The eighteenth-century clavichord, part of the collection and recently restored, was played, filling one of the galleries with eighteenth-century music. Throughout the day well over 2,000 people attended this sparkling and joy-filled occasion.

VI

While watching the BBC documentary *Stephen Fry in America* (2008) I was alerted to an interesting possibility. As Fry was taking the ferry over the Delaware River, the same river George Washington crossed with his army on Christmas Day 1776, on the way to defeating the British at the Battle of Trenton on Boxing Day, he whipped out his iPhone to look at the famous painting by Emanuel Leutze, *George Washington Crossing the Delaware* (1851), now hanging in the Metropolitan Museum of Art in New York. As Fry crossed the Delaware, rugged up on a gloomy grey and wet day, he looked and connected with the legendary historical crossing, the picture literally at his fingertips. He noted the freezing weather and compared the ice-filled Delaware in the painting with the autumnal version he was experiencing.

This got me wondering. Do people load up their iPhones or iPods with pictures of famous artworks or photographs connected to sites they intend visiting? Not long after, I discovered an intriguing blog that explained this phenomenon exactly.

The first blogger described her enthusiasm for the art of Canaletto, the prodigious eighteenth-century recorder of scenes of Venice. These pictures were early examples of travel souvenirs, the patrons of the pictures often being young British aristocrats on their 'grand tour'. The blogger, however, was fascinated by the topographical accuracy of Canaletto's compositions. She had downloaded onto her iPhone a number of Canaletto views of Venice and then spent her time in *La Serenissima* tracking down the locations of the scenes so she could reproduce them in her photographs. She added to the delight of her discoveries by listening to the music of Vivaldi, a Venetian contemporary of Canaletto. The Vivaldi was also loaded onto her iPhone. From her blog, her joy was obvious, her mission well accomplished.

I can so vividly imagine what may have been one of her rapturous moments: she stands on the deck of the *vaporetto*, the Venetian waterbus, gliding up the Grand Canal towards the Rialto Bridge. She glances down at her small screen to look at Canaletto's painting of the scene and marvels at how much of the landscape in Canaletto's depiction is before her eyes some 250 years on. To the strains of a Vivaldi concerto – could it be 'Spring' from the *Four Seasons*, perfectly chosen to match the spring day of her travels? – our traveller photographs the scene before her. She has 'replicated' Canaletto's painting and now as the boat draws nearer to the famous bridge she can compare the 'real' scene with her photograph and the painting accompanied, not by the cacophony of canal sounds, but by an effervescent Vivaldi concerto.

A fellow blogger described a similar project. He was 'in love' with the Impressionist painters' views of Paris, and would be enchanted by looking at the paintings on his MP3 player as he walked the streets of Paris. Another tells of her 'addiction' to Google images and her collection of photographs of Sydney prior to the 1960s. Like the Parisian traveller, she 'loves' walking about the harbour city and comparing the views of contemporary Sydney with the photographs. She

described her mixed feelings: of an uplifted sense of 'progress' as the city was 'transformed' into what it is today and her 'pride' in its 'cosmopolitanism' but, simultaneously, a 'profound nostalgia' for what once was. Her explanation of the latter had more to do with a feeling of 'sadness' about those who lived and died – and often struggled – in Sydney before it became the city of the twenty-first century, rather than any desire to 'return to the past'. Although she did register a 'type of despair' about how much of the 'old architecture' had been 'lost to development' and momentarily compared, somewhat wistfully, her home city with European cities.

VII

During Stephen Fry's amble through the 50 states of the US – for it seemed like an amble, but to cover so many states during a one-hour programme exposed the illusion – a number of things caught my attention. The first was the wonderful segue from the iPhone picture of George Washington crossing the Delaware River to Fry's arrival in Washington DC and his subsequent interview with Jimmy Wales, the co-founder and de facto leader of Wikipedia. The clever conjunction was exactly right!

The second was Fry's visit to Gettysburg battlefield and cemetery. As the camera gently panned over the headstones a solo trumpet played a mournful tune of elongated notes, a musical riff long associated with US patriotism and duty and with places of remembrance. Americans have made the solo trumpet something terribly poignant. I am always moved by these melancholic reveries. The years of American movies and documentaries that have used the haunting trumpet solo have readied me for this emotional response: it is so many things simultaneously – sad, nostalgic, symbolic, stirring. I wonder about how soundtracks so determine our emotional responses to film. And I wonder about how it is now possible to create soundscapes for heritage encounters. Maybe, they will be purpose-filled – music and sounds that are of the place or evoke the place. Maybe – and more likely – they will be music created for the moment by the visitors themselves; sometimes purpose-filled and particular, sometimes accidental and sometimes the result of the shuffle button.

Recently, at a faculty meeting deliberating about the marketing of our university educational programmes, we were considering cheeky, off-beat slogans. I suggested 'can you eat heritage?'. I could have gone for 'can you hear heritage?'. Now I wonder, not about intangible heritage some of which is eminently tasty and lyrical to the ear, but the importance of linking intangible heritage with physical heritage. Chris Wood the director of a very successful Australian outbound cultural tourism company, is renowned for creating soundtracks of music related to particular places which he plays as the buses of travellers traverse European and North African landscapes. In Stephen Fry's travel across the US certain sounds are immediately geographically located: the solo banjo in Kentucky, the jazz riff in New Orleans, the edgy torchlight ballad in New York. Yes, they are predictable

and stereotypical but they are also great signifiers of place and the effect is immediate and deeply evocative. It relies on a learned association built up over years of exposure to American cinema and television or, in the case of places in South East Asia, the result of exposure to travel documentaries and marketing and the travel experience itself. The BBC series *Classical Destinations* with Simon Callow mixes travel, place, history and music. What the series reminds us is the way we associate geography with particular music, in this case, classical music. It's an exploration of place via music: Salzburg and Mozart, St Petersburg and Tchaikovsky, Handel and London, Haydn and Beethoven with Vienna and so forth.

Increasingly, I'm aware of the use of soundscapes in museum exhibitions. Increasingly I'm aware of the number of people plugged into their iPods as they traverse heritage sites. And increasingly I'm aware of how much I like the music-place intersection even at the expense of the language-place intersection.

VIII

Finally, let us consider in some detail *A Day in Pompeii*, an exhibition staged at the Melbourne Museum (Museum of Victoria) in 2009.

Prologue The word 'Pompeii' is a powerful image-evoking utterance: volcanoes, the sudden and cataclysmic destruction of a city, horrible deaths, remarkable archaeological finds, an eerie walk through the ruins of an empty Roman city in the twenty-first century. Today, the images conjured by Pompeii conflate with the media images and stories of recent events: the Indian Ocean tsunami of December 2004 in which over 230,000 people perished in 11 countries; the hurricane Katrina in 2005 that killed 1,836 people and flooded 80 per cent of New Orleans; the Sichuan earthquakes in China in August 2008 that killed 69,227 people (with 18,222 missing) and left 4.8 million homeless; and, seared into the memories of Melbournians, Saturday, 7 February 2009, and the bushfires that killed 173 Victorians. The Japan earthquake and tsunami of 2011 took 16,000 lives (with 5,000 people missing) and left the world riveted by television images of the wave of destruction. The narratives of these events are remarkably consistent: unexpected and disastrous devastation wrought by natural forces; death and destruction on a scale not easily comprehensible; harrowing personal stories of grief, loss, survival, tragedy and heroic rescue.

There is also the aftermath: images of desolate and bereft landscapes, silences, the sense of hopelessness, the scale of the destruction, the reflections, the bereavement, the pain. And accompanying these images are the questions. In the face of impending disaster, should people go or stay? Were there warnings? Were they heeded? Who is to blame, the gods, human nature, the power of nature, governments?

Apocalyptic visions run deep in Western culture. The archetype is, of course, the New Testament account of the end of the world that is, in turn, linked to the final reckoning of the souls of individuals. Despite the horrendous images of

the end of time, the message is hope and salvation (or to quote another Western myth, out of the ashes, the beautiful phoenix will rise). Over and over, events – real and fictional – have been linked either explicitly to the Apocalypse (like the Black Death in Europe in the middle of the fourteenth century that killed between 30 per cent and 50 per cent of the population within two years) or implicitly by employing the language and imagery of the Apocalypse (like the descriptions of trench warfare in World War I or the destruction of Hiroshima and Nagasaki by nuclear weapons). At the heart of all these stories, whether Pompeii or the Indian Ocean tsunami, are questions about our mortality and the fate of the world. Such ponderings are given added piquancy as the planet wrestles with climate change.

This, then, is one of the cultural contexts for arriving at the Melbourne Museum to see *A Day in Pompeii*.

The Exhibition The entrance is into what the designers have called the atrium. Maps locate Pompeii and present its street configuration along one wall, a huge reconstruction of a wall fresco of a lush, bird-filled landscape dominates the opposite wall and in a glass case in the centre of the space is a marble statue of Venus, goddess of love and beauty. As the protecting deity of the city, her place outside the exhibition's walls of the town is appropriate. Next to the entrance corridor that leads into the town is a stark reminder of Pompeii's story – a mosaic of a skull. While in Roman times the skull signified the fickleness of fortune, its placement at the beginning of the exhibition immediately conjures what we already know about Pompeii and its fate. Here, then, is an exhibition where the basic narrative is well known by those who pass through its gates and, consequently, an exhibition that builds upon this narrative knowledge. As we enter the lively town section of the exhibition, we know what hovers over these representations of this vibrant urban municipality of perhaps 12,000 living souls. And, to make the point even more dramatically, above the skyline of the townscape we have entered is a huge mural of Vesuvius with its telltale plume of smoke.

The market is encountered first. Pompeii was close to the Bay of Naples and the marine connection dominates the market place with its fishing tackle. The objects in glass cases – coins, a jug for *garum* (fish sauce), scales – are set against walls with short descriptive panels and graffiti. We learn from the latter that 'profit is happiness'. It's not long before the visitor is aware of the cries of seagulls and other market sounds. And, intermittently, we hear the ominous boom of a volcanic eruption, an intrusion into 'daily life' that is a startling reminder that on the day of the eruption, life went on blissfully unaware of what was to come.

Moving into the shopping street, it is clear that the town is both a visual and aural experience that sketches and prompts us towards accepting something that approximates walking in the streets of Pompeii, except the ghost-like feeling of the 'real' Pompeii is here replaced with bustle and a sense of urban vibrancy. This illusion is extended by the presence of the exhibition visitors milling around to look at the objects. The shopping street consists of a row of small businesses – a laundry, a bar, a restaurant, a bakery – constructed as a series of lean-to

shop-fronts that frame a painted scene that depicts the activities of the particular business. Opposite each shop is a glass cabinet containing objects pertaining to the reconstruction – *amphorae*, pots and serving dishes. Each shop has its own distinct soundscape. We are invited into a world of activities. The exteriors of the shops are scrawled with graffiti (in English and Latin) and include text panels that describe the social conditions of such a street. This is not the social milieu of the rich and powerful Roman elite. It is the combination of sound and visual reconstructions that are immersive and by being thus, the objects in the exhibition are contextualized in a manner that does not require detailed prior knowledge. The visual and aural associations make the necessary links. Text panels are subservient to the experience and offer additional information rather than essential information. The shopping street ends at Pompeii's amphitheatre. A large mural of gladiators fighting in the arena is accompanied by the metallic sounds of the clash of metal and augmented by actual objects: a gladiator's helmet, greaves and a shield. The perspective used in the mural is extreme and so the oddly placed rows of citizens in the seats of the amphitheatre, shouting and gesticulating, add to the dynamism of the scene. The visual contextualization of the objects is compellingly effective. It is extremely difficult not to be fully engaged by the painted scenes of the shopping street precinct of the exhibition augmented by the soundscape and the intermittent far-off guttural boom of Vesuvius erupting.

The entrance to a villa is via huge wooden doors facing onto the street. To the left of this part of the exhibition we are drawn to two small screens. One is a computer-generated recreation of the House of the Vine. This virtual tour of a typical Pompeiian dwelling allows many alternatives for the viewer. One video sequence explores the whole house and its internal environment. There is no commentary, just a visual 'tour' of the building, its rooms, its decoration, its furnishings, the atrium and internal garden. Many of the objects displayed in the exhibition are highlighted in the video and so the viewer is immediately shown both spatial placement and function within the house. A lyrical and quite haunting music soundtrack of plucked and blown instruments is augmented with sounds of water in the fountains and birds in the garden. As with any cinematic representation, the music and the images conjure the 'magic' of the mimesis. The video is three, minutes long and is worth more than one viewing. It is also online. Other options allow more detailed investigations of the rooms and the objects being displayed depending on the interests of the viewer. After time spent in the 'virtual villa' the exhibition space becomes an extension of this experience, the context of the objects in the house part of the exhibition now firmly contextualized: the fragments of wall frescoes, columns, metal furniture, the exquisite jewellery, the household shrine, the lamps, the statues and the kitchen utensils. The capacity of digital reconstructions like the House of the Vine is obvious: so much can be communicated with images and music alone.

At the centre of the exhibition is the 3D cinema. Donning 3D glasses we sit in the semi-darkness waiting for the beginning of the eight-minute presentation. A text appears on the screen accompanied by quite eerie electronic music:

'24 August 79AD' (sic) and, after a pause, 'started like any other day'. The words fade and are replaced by a giant '8am' that hovers in 3D space. The time disappears and is replaced by a view of Pompeii. The sunny summer day has already dawned. A cock crows. We are looking down on part of the city and before us is a villa and its garden and next door a small temple. Beyond the buildings, in the far distance, we catch a glimpse of the Bay of Naples and dominating the scene and towering over the city is the silhouette of Mount Vesuvius. Suddenly this placid scene is interrupted by tremors. Dogs bark and people shout. Tiles on the roofs shake loose and the first plume of smoke appears from the mountain. The scene fades and '1pm' hovers into view. The sounds of the eruption dominate. Huge plumes of smoke give way to a dense and rapidly rising eruption column. Babies cry. Tiles begin to shake and shatter and slide off the roofs. People cry out in alarm. Fade. '3pm.' The ominous rumbling continues. We feel the sound vibrations. Dogs whine and bark as rocks of pumice rain down. The sky has darkened and Vesuvius has disappeared. Ash is beginning to fall on the city and roofs have turned white-grey. The pumice rocks falling from the sky break up the tiled roofs and create a horrendous din. Fade. '5pm.' Flames flicker. Fireballs burst from the sky with tremendous crashes. They set the buildings on fire. Violent flashes of lightning flare from within the eruption column. The city is on fire. The remaining roofs collapse and explode as the fireballs release their destructive power. Fade. '8pm.' As the sun sets, the landscape is bathed in a strange orange glow. Many buildings have been destroyed. Much of the sky is covered with dense black clouds. The thunderstorms persist. The temple collapses. Fade. '1am.' The only illumination is in the distance. The glow of lava is accompanied by fearsome thunderstorms that continue to rage as the eruption column is transformed into a giant cumulo-nimbus cloud. And, far in the distance, rolling down the side of the barely visible volcano is a pyroclastic surge. Fade. '6am.' As 25 August dawns, we witness the utter destruction of the city. Few buildings, except some walls and some clusters of columns, have survived. The city has been obliterated. Out of the gloom that surrounds and completely hides Mount Vesuvius a pyroclastic flow appears. It passes over the remains in a wave-like motion that gets closer and closer. Then, in a sudden violent and cataclysmic rush, engulfs what was once a city. Daylight now establishes itself. Where the stood is now only white ash. The volcano too has gone, the cone having been completely destroyed. A strange and uncanny wind blows over the landscape. Steam and white clouds continue to belch from the vent. We sit in a state of numbness as a text emerges in two parts: 'By the end of 25 August the landscape around Mt Vesuvius had been changed forever. Vesuvius was a crater, the river and the port were gone.' 'Pompeii had been completely buried. Within a few years no one could remember where the city had once stood.'

Quietly, lost in our own thoughts and emotions, we emerge from the theatre into a corridor lined with ceiling to floor photographs of Pompeii post the eruption and post excavation. The silent and empty ruins contrast effectively with the life-filled city we had encountered in the first part of the exhibition. At the end of the corridor we turn into another corridor devoted to the science of vulcanology and the

science of Vesuvius' eruptions. Unlike the pre-eruption part of the exhibition, the interpretation is dense with diagrams, photographs, illustrations and text panels. It is hard to focus after the film of the eruption but the giant, wall-size Google Earth-style photograph of present-day Mount Vesuvius surrounded by dense settlement and the city of Naples tells its own disquieting story. We hurry on, drawn to the blue glow in a room at the end of the corridor.

In the middle of a circular room, around which we can walk, is a raised circular mound. On this mound are the plaster casts made from the cavities created by those trapped and unable to escape the eruption of AD 79. The bodies – human and animal – covered in ash, eventually decayed, leaving behind a near exact impression of the moment of death. There is something surreal about this staging: the plaster-cast figures lying in a carefully composed variety of poses, some peaceful and some twisted in a final agonizing last moment; the blue light; the plaintive solo violin soundtrack. The figures are rough, impressionistic and smaller than perhaps anticipated. What gives these 'sculptures' their poignancy and sadness is the realization that we are, unusually, seeing the actual forms of people who had once lived so long ago. People from nearly 2,000 years ago are sometimes names in a text or perhaps portraits or sculptured likenesses and sometimes skeletons but, in the main, they are and remain completely anonymous to us. But here, in this blue-lit room, they are not cinematic representations of ancient Rome or imaginative pictures (digital or otherwise) but come as close as possible to being 'real'. They hover somewhere between reality and representation: they are plaster casts but the form relates to people and animals that had experienced the AD 79 eruption of the volcano and the horrific destruction of Pompeii. It is their existence betwixt and between that makes them simultaneously surreal and an apprehension so profoundly moving.

The last part of the exhibition briefly tells the story of the archaeology of Pompeii. A simple timeline, with copies of significant books published about Pompeii in display cases, is set against a wall covered with fragments of fresco paintings. It is a suggestive representation of the fragmentary nature of archaeological remains and their investigations. This final section of *A Day in Pompeii* hints at the absorption of the 'discovery' of Pomepii and its archaeology into the popular imagination and as a source for various new cultural productions, everything from academic painting to contemporary tourism. The latter is presented as 'Postcards from Pompeii', a slideshow of highly aestheticized images accompanied by a gentle soundtrack of wistful electronic music harnessing the sounds of the harp, the lute, the keyboard, the violin, the zither and various woodwinds. The images linger on panoramas and exquisite details of the material culture of Pompeii: compositions, shapes, textures, colours, designs, atmospheres and ambience. Pompeii is transformed into *Vogue Living* or *Gourmet Traveller*. The irony is delicious: as we are enchanted by the seductive sounds and images, we ourselves become an inescapable part of the commodification of Pompeii and its histories and its archaeology as we meditate on our journey through the calamitous tragedy of 24 August AD 79 and the immense natural devastations in our own times.

The intricate relationships between contemporary heritage and leisure, and our role in this choreography of postmodern culture, is fully realized as we enter the bookshop with its bountiful displays of books and objects and all things Pompeiian on our way to the al fresco, purpose-built restaurant, Piazza Museo, to savour modern Italian food and wine in the Melbourne style.

Over lunch the conversation ranges widely but it is to the exhibition that we return over and over. Have archaeological objects from Italy and under the auspices of the Soprintendenza Archeologica Napoli e Pompei been subordinated to the context? Has the integrity of the archaeological objects been affected by the spectacle of the exhibition? Does the blurring between museums and theme parks and the influences of cinema and multimedia matter? Is the emphasis on visual interpretation (with language-based interpretation in a secondary and supporting role) a response to the view that visual culture has become the dominant mode of communication in the twenty-first century? Have museum curators been sidelined by exhibition designers? What are the implications? Does it matter? What does the enormous appeal and popularity of the exhibition reveal, especially when in the last week opening times were extended from 10.00am until 10.00pm on Thursday and Friday and on the Saturday from 6.30am until midnight? Is it 'pure luck' that this exhibition can knowingly resonate with and conceptually respond to the recent spate of devastations that have become media spectacles? We ended lunch agreeing that these were complex and ineluctable issues and that, for better or for worse, the 'ground rules' for museum exhibitions and the presentation and interpretation of heritage objects/places was changing.

As I wrote these lines, I had open on my screen the virtual exhibition of *A Day in Pompeii* on the Museum of Melbourne website and repeatedly watched and listened to the Vine House tour, the 3D film and the slideshow of Pompeii today. The music, especially, conjured the moods, the emotions and the memories of a previous visit to Pompeii and my visit to the exhibition. I smiled to myself. While the mood was the residual and dominant connection I had to the exhibition, the music was a concoction of the twenty-first century because no musical sounds from Roman antiquity have survived across the centuries. We have pictures and descriptions of music-making, but the music of Ancient Rome will forever remain mute.

Intensities and paradox

What are the threads running through these accounts? There is the sense of a constant *reflexivity* accompanying travel and the heritage experience, however defined (cf. Minca and Oakes 2006). In each vignette there is an ongoing quest to understand myself within whatever space I'm creating/occupying, whether watching a BBC documentary, visiting a museum, walking down a street or in a landscape, interacting with others. The reflexivity is multi-dimensional: a persistent reflection about *being (t)here*; an intimate awareness of my own

sensorial responses to how I am in this place, how I react in this place, how I feel in this place, how this place enters me and how I enter into it; the relentless sense of not being at 'home', of being somewhere that is not my usual habitat, of the 'otherness' of experiences as a traveller. And the fact that this sense, although perhaps more precariously, carried over into watching Stephen Fry in America from my couch at home or, for that matter, when I was reading Robert Dessaix's *Arabesques* (2008) or Denis Byrne's *Surface Collection: Archaeological Travels in Southeast Asia* (2007) or Geraldine Brooks' novel *People of the Book* (2008).

There is an *intensity* about heritage experiences that also has multiple sources. The framing of places, their being marked out as 'heritage' or 'World Heritage' or a 'national park' or a 'museum' is both a response to and a product of a series of representations and discursive conjunctions (travel media, scholarly discourses like history or archaeology or art history or natural history, documentaries, cinema, fiction and so forth) (Waterton and Watson 2010). On the whole this 'framing' is inescapable. Our visiting is a focussed one where our looking is *particular* and where we register this attentiveness in a number of ways – in our photographs, in our social interactions, in our communications with those present and those absent. Even when we may be reluctant visitors or in a distracted mood the 'place' we visit is still 'marked out' and, as such, impinges to some degree on our responses (cf. MacCannell 1999; Horne 1992). When our travels are purposeful and highly motivated, then the intensity may be greater. The addition of heritage interpretation – reading a guidebook, using an audio-visual device, reading signs, following a guide – can magnify the intensities already operating. Intensity is reinforced by the interplays within the sensorial experience. Food is a powerful presence as are smells. A visit to Ayutthaya or Florence or the Blue Mountains, near Sydney, is associated in my mind with very pleasurable eating experiences and the vigorous flavours of regional dishes. The means of mobility, the occasion of arriving and departing, all contribute to the intensity of the visit (De Botton 2002; Leed 1991).

The paradoxes that emerge while being at a heritage site are also conducive to intensity. On one level, the heritage visit is spontaneous, improvised, chaotic, exploratory and sensual. It is a place of both anxiety (newness, wonder, being detached from 'home', different, 'otherness') and potentiality (creativity, inventiveness, self-fulfilment, discovery, knowledge). On another level, the heritage visit is about solidity and solidifying, order and ordering, about making difference the same, about over-determination, about tailored encounters, about fixing meanings in authorized and pre-conceived interpretations, about abstractions. The paradox lies in the impossibility of the latter. Any fixing, ordering, solidifying is momentary at best and possibly illusionary: the illusion of solidity, of ordering, of fixing meaning in a dynamic world where social significance is always an unfinished project (Byrne 2007; Byrne, Brayshaw and Ireland 2003). As Zygmunt Bauman has so graphically and powerfully said, we live in 'liquid times', we have moved from 'the 'solid' to the 'liquid' state of modernity' (Baumann 2007: 1). There is an associated paradox. Heritage conservation and management is about documenting, classifying, mapping, studying – all processes which attempt to fix

the object – and yet the current rhetoric about heritage is often under the rubric of 'living heritage' which places heritage and 'heritage making' in the context of people and communities emphasizing the social and cultural dynamism of use and signifying practices (Dicks 2003; Byrne, Brayshaw and Ireland 2003; Smith 2006; Byrne 2007; Harrison 2013).

Another paradox is that associated with heritage restoration and conservation. Paul Eggert in *Securing the Past* (2009) vividly describes an exquisite dilemma: restoration claims to be about the recovery and the revealing of the 'original', true to the author or artist or architect's intention, but this exacting task of empirical science occurs in an age that recognizes, in the light of cultural theory, the problematic nature of such claims. This paradox produces a tension in the presentation of heritage sites and places that cannot be resolved and in many ways possibly adds to the allure of objects and places. Another paradox is to do with the nature of the history enterprise. The past is irretrievable and yet its 'presence' is pervasive and often extremely powerful. However, this 'presence' only exists as *a representation of the past in the present*, irrespective of whether the representation is an act of the imagination or attached to material culture or history in its written form or history as a television/DVD documentary or history as cinema.

A further paradox is one produced by two co-existing perceptions and two conceptions that emerge from these perceptions. 'Common sense' encourages the perception (and the conception) of heritage places and heritage visitors as being ontologically separate. Visitors go to pre-existing sites; visitors are temporary occupants of heritage spaces/places; heritage places/sites/objects precede the visitor visiting. However, the recent work on the sociology of mobility (Urry, 2007) and the sociology of the tourist experience as performative (Baerenholdt et al. 2004) produce an alternative perception/conception. In this conception of embodied experience, space/place/mobility/performance are inextricably interwoven. Heritage places are *produced* by the interactions and engagements of the visitors; the place and the visitor cannot be separated because both only have meaning in relationship with the other. In other words, the critical feature of heritage visitation is not going to a heritage place but the 'particular ways of relating to the world … and being in the world' (Baerenholdt et al. 2004: 2) and, to paraphrase, it is the *way* visitors perform and engage that makes a place 'heritage'. By placing the emphasis on the performative, heritage interpretation is changed. Rather than being a matter of communicating something to a (passive and temporary) visitor, it is the production of meaning by the visitor in their interaction with the place. In this conception – and contrary to the 'common-sense' one – the visitor is the author of meaning(s), not the site.

Finally, there is heritage interpretation itself. When the orthodox definitions of interpretation are considered, several things become apparent. The consensus discourse that has congealed in the last three decades describes heritage interpretation as an educational activity that communicates the heritage significance of places and sites and monuments and objects to the visitor in order to increase awareness, deepen appreciation and increase an understanding of themselves

and the world they live in (cf. Wikipedia entry for heritage interpretation and the definitions proffered by national associations of heritage interpretation, at: en.wikipedia.org). Often implicit or explicit in the description is the idea that visitors will become ambassadors for the heritage conservation cause in some form or other. What strikes me in relation to the anecdotes I have presented is how narrow in focus this description is. The particularity of such a definition is achieved by corralling the description and excluding many other dimensions of the heritage experience, indeed, to such an extent that only a very narrow band of the inter-relationship between visitors and heritage sites gets to be considered. The sheer complexity of the intersections between heritage, place, tourism, meaning making, communications and media, the contexts of modernity/postmodernity, knowledge formations, ideology, vision and visuality, embodiment, cultural difference, performativity, geography, identity politics and so on is either completely lost, put to one side or acknowledged but then, in effect, sidelined.

This is one of the limitations of the consensus interpretation discourse that I have alluded to; it has become an exceedingly technocratic discourse. Reasons are not hard to find. Heritage interpretation has become relatively narrow in conception because practices and techniques have, over time, had a determining effect on the conceptual scope of interpretation. Many heritage interpretation manuals and guidelines, for example, focus on the implementation of guiding or audio-visual presentations or signage or story telling or activities, in other words on the techniques of communication and their effectiveness. The definition proffered by ICOMOS in its 2008 *Charter on the Interpretation and Presentation of Cultural Heritage Sites* is a case in point. In its preamble it describes the need for 'standardized terminology' and in the definitions section of the document it is technologies that are paramount. But standardization has come at a price: a narrowing of the focus and of the way we conceptualize heritage interpretation (cf. Ablett and Dyer 2010).

Interlocking themes and meditations

And so we come to the contours of the book. What follows is a series of interlocking meditations that try to encapsulate the complexity that surrounds and suffuses heritage interpretation. If I was asked to 'position' the meditations, I would suggest they constitute a cultural study of heritage interpretation. I have not aimed at consistency in these musings because I wanted to give full play to tensions and contradictions both in the subject itself and within my own thinking. Is there an overall argument? In retrospect there is a certain kind of logic to the arrangement of the essays and this does produce an argumentative arc. This arc can be represented thus. The arrival of digital media platforms (and especially Web 2.0) has driven a wedge into the way(s) heritage interpretation has been currently understood and practiced. It is not so much that the twentieth-century idea of heritage interpretation (both the theory and practice) was deficient but that events have overwhelmed it.

(Nevertheless, as I made clear at the outset, I do believe the emphasis on learning over experience had already and increasingly become an issue within heritage interpretation by producing a consensus discourse.) The increasing recognition of the autonomous meaning-making of visitors (as a reality in the new media environment and as a democratic function of heritage places) (Chakrabarty 2002; Cameron 2008) has also contributed to both uncertainty and a re-assessment of the role of heritage interpretation. The parallel contemporary shift within heritage and museum thinking, especially in Anglophonic contexts, whereby the emphasis has moved from objects to what the objects represent (Smith 2006; Waterton and Watson 2010) has also had an impact on recent conceptualisations of heritage interpretation.

In the last two decades, global tourism and its attendant characteristics have created increasingly fraught challenges at heritage sites (Staiff, Bushell and Watson 2013). Some of these challenges involve cross-cultural translation and the legibility of heritage sites to visitors who do not share the same primary cultural affiliation with the site and its associated communities (Staiff and Bushell 2003b; Saipradist and Staiff 2007). In the face of these cultural challenges, plus the rapid expansion of digital media along with the claims that images, in an unprecedented fashion, have become a primary mode (perhaps *the* primary mode) of communication (Wright 2008; Burnett 2005), heritage interpretation increasingly presented itself as ripe for a conceptual examination. A starting point for such a re-imagining is the visitor experience and the visitor experience cannot be isolated from nor restricted to the moment of arrival at a heritage site; rather, it needs to be linked to the tourist experience more generally, and the way(s) this has been recently theorized in terms of mobilities, embodiment, affect and performance (for example, Urry 2007; Baerenholdt et al. 2004; Coleman and Crang 2002).

While writing an early draft of Chapter 3, I read Geraldine Brooks' 2008 prize-winning novel *People of the Book*. What follows is a reflection on heritage interpretation that emerged from this deeply satisfying engagement with a story of the saving and conservation of a priceless object of cultural significance, a reflection that now serves as a conclusion to this chapter and an entrée to some of the themes in the rest of the book.

The narrative of the novel is constructed with just one object at its centre: the Jewish prayer book, the Sarajevo Haggadah. This rare, brilliantly illustrated medieval manuscript created in Spain in the fifteenth century CE survived the centuries to be rescued by a Muslim librarian in war-torn Sarajevo. Brooks has the young highly accomplished book conservator, Hanna, an Australian from Sydney, work on the early conservation of the Haggadah in Sarajevo under trying conditions. Hanna's detailed inspection of the manuscript, along with her interventions to stabilize the condition of the book, reveal a series of fascinating clues: the missing silver clasps once used to close the book; a wine stain (that turns out to be blood) on one page; the presence of salt crystals on pages that showed water damage; the expensive materials – gold and silver and lapis lazuli – used in the illustrations; an enigmatic Latin inscription dated 1609 written in

the Venetian style; a tiny fragment of an insect wing in the book's binding; and a fine white hair, tinged with yellow, caught in the threads of the binding (and identified as belonging to a cat). The story of Hanna's conservation of the book and its subsequent display in a specially furbished room of the National Museum in Sarajevo is interspersed with the uncovering of the stories behind the clues Hanna had documented. These are presented to the reader back through time so the story of how the insect wings came to be lodged in the binding is a tale set in Sarajevo in 1940 and comes first. The story of the cat's hair with yellow pigment, set in Seville in 1480, the year the illustrations were painted, is the last tale to be told. Hanna's conservation, set in 1996, and the story of the book's display in 2002 allow Brooks to ponder upon the book's effect on those closest to it; on the nature of conservation; on the nature of history and tradition; on the tangled web within which the threads of culture are spun; on the porous and insubstantial foundations of ethnic identity; on cross-cultural intercourse and on gender.

Brooks' novel can be viewed as an illustration of the way heritage interpretation can be constructed. There is first and foremost the primacy of the object and the ways it is made to mean. These are the stories attached to the object as a physical-visible entity. Then there is the secondary but essential role of contextual representations of the object: the history of the materials, the people in the book's 'life', the story of its making, the subsequent stories of its various owners and how it came to survive. Finally, there is a third dimension of interpretation: the historical object in the contemporary world of war, conservation/restoration debates, technology and scientific analysis, cultural and ethnic conflict, the politics of museums and object display, historical objects and the research/academic community and so forth (cf. Staiff and Bushell 2003a).

However, beyond the possibilities the novel offers for heritage interpretation, there is also Hanna's personal story. She is the narrator in those sections of the novel that relate to her involvement with the Haggadah. This raises an interesting question in relation to the object being investigated and for heritage interpretation: what exactly is the role of the personal stories of those involved in the interpretation 'business'? One of the reasons guides at heritage sites enjoy some success, if they are good at what they do, is the way they weave themselves into the interpretation and become part of the story. This is not necessarily manifested as intimate details of a guide's life, although this might be the case, but is mostly expressed as a passionate connection to the place/object/site. It is an enthusiasm that can be infectious. As with any memorable performance, it is not necessarily the 'content' that is recalled but the emotional intensity of the communication. This is a commonplace observation that is made in the context of live theatre, media interviews, classroom and lecture-theatre teaching, speech-making and so on. Brooks' character Hanna reminds us of the importance of emotional and passionate engagement and the importance of our own emotional involvement with Hanna as readers. The story of the Haggadah becomes deep and personal because of the powerful way we enter into both the fictive space and the historical spaces she activates in our imaginations. This is not just plot-driven.

We come to care about Hanna and the characters associated with the history of the book. And yes, we are immersed in the puzzle of the book (Why the blood-stain? Why salt water? Why a cat's hair?), however, it is more affectingly the human hopes, loves, despair, tragedies and foibles of the 'people of the book' played out in vividly described and often threatening environments (the Inquisition in Venice; the defeat of the Moors in Spain; the Nazis in central Europe; poverty in late nineteenth-century Vienna and war-torn Bosnia) that absorb us so intensely as we 'live' the story.

Chapter 2
Tilden: beyond resurrection

Heritage interpretation and representation

One of the guidebooks available to a visitor to Sicily is called *Ancient Sicily: Monuments Past and Present* (Messineo and Borgia 2005). The book's appeal lies in the reconstructions of the many archaeological sites in Sicily. Present-day photos of ruined temples and palaces are overlaid with a transparency upon which is printed a visual reconstruction so that an architectural remnant is transformed into a 'complete' temple or palace or amphitheatre. For example, with the transparency in place, the baroque façade of Syracuse Cathedral and the surrounding street disappear under a cloud and a series of steps, and, instead of the Cathedral, one sees a painted image of the Temple of Athena, the ancient monument that preceded the building of a church and, in the seventeenth century, its facade.

As a representation, the pictures of Syracuse Cathedral and its reconstruction in the guidebook have their own properties. As pictures, they are entities in their own right and can 'stand alone', yet they are also, at the same time, meshed with Syracuse Cathedral, the physical structure. This complex relationship between actual physical objects – in this case a church/temple – and pictures (whether the ones in the guidebook or mental pictures we may have) demarcates part of the system of representation into which we insert ourselves and within which we are active participants as producers and consumers of meanings. We can experience Syracuse Cathedral as an embodied response to being there, but we can also experience the Cathedral via the pictures and descriptions in the guidebook (or the countless other pictures on Google Images). We can also experience Syracuse Cathedral as a mental concept, an imagining, that is not reliant on the stimulus of the actual building or the guidebook's pictures. The three experiences can be separate or take place together in the same time/space moment.

Thus representations have a 'life of their own' separate from the things they represent. Further, photographs and paintings used in the guidebook belong to a tradition and a technological practice that has its own history and reality. We recognize the pictorial reproduction of Athena's temple because we understand what a realistic painting is. We know what the image of Syracuse Cathedral is because we know what a photograph is.

If we ourselves were asked to draw the remains of another temple in Syracuse, the Temple of Apollo, our immediate reference would be other drawings/paintings and the 'language' of drawing/painting and not the ruins of the building before our eyes. Only after we have chosen the pictorial tradition within which we will craft our drawing (Realistic? Impressionistic? Expressionistic?) do we attempt to

translate the building into pictorial form on our blank page. Our eyes alternate between the scene before us and the drawing we are making. If we are good at drawing, we may choose to depict the remnant walls of the temple and its associated buildings in a heavy, dark and highly textured sketch while including the modern buildings that now surround the ruined temple – a church and houses – as a light silhouette without details, so that the 'modern' and the 'ancient' stand in contradistinction. At the outset we would have decided what materials to use – pencils or watercolours or pastels, for example – and whether it would be in black and white or in colour. The choices would have affected the way we proceeded and would have consumed much of our attention as we juggled the twin visualizations: the looking at the temple before us, and the mental process of conjuring the characteristics of a Western drawing. If, instead, we had been asked to write a description of the ruined Temple of Apollo the issues would have been much the same. We would have immediately recalled how language has been used to describe objects. We would have been as much absorbed by the *craft of writing* as the remains of the temple.

Whether in words or pencil or framing a photograph (and getting it 'right'), representing reality depends on a knowledge of systems of representation and how they work: using a pencil to make a sketch, a pen or keypad to write a description, a camera to get a 'perfect shot'. Within all systems of representation, there are two things being simultaneously referenced: the entity being represented and the type of representation being used. The two are intimately connected but they are also separate; and so representations can have a powerful affect and be part of the process of understanding that is independent and disconnected to the act of their making and independent and disconnected to the heritage object they depict.

A visitor to Syracuse may have bought the guidebook *Ancient Sicily: Monuments Past and Present* and used it while looking at the exterior architecture of Syracuse Cathedral and marvelling at the way the Greek temple had been transformed into a church with a baroque facade. But the guidebook may also have been purchased from Amazon.com and read by someone living in Australia who had never been to Syracuse but was interested in the antiquities of Sicily. A collector who was interested in books that used transparencies to reconstruct things may have bought the guidebook in a bookshop in London. And perhaps, a traveller recalling with affection a trip to Sicily some years ago, borrowed the guidebook from a library. In all these scenarios, the reading of the Sicily guidebook is going to be very different, as is the emotional and intellectual response to the book. What is important here is that a physical disconnection is possible between a representation and its subject, in this case archaeological sites in Syracuse. This 'gap' between representation and reality (irrespective of whether the reality is an imagined one, a memory or something actual) is a constant as is the co-implication of representation and reality. All interpretations of heritage are representations and all of them have the characteristics associated with the description of the Sicilian guidebook. Heritage interpretation has a 'life' independent of the material object or place it represents.

Stuart Hall's edited book *Representation: Cultural Representations and Signifying Practices* (1997) provides a useful introduction to the notion of 'representation' and its relation to culture and meaning-making. Hall and his co-authors present an explanatory system for the relationship between representation, the physical world, the world of the imagination, our cultural affiliations and the shared meanings that we create and attempt to communicate with each other. This is how I want to 'position' heritage interpretation: as a system of representation.

In the not so distant past, objects and things – archaeological ruins, paintings, buildings, forests or landscapes, for instance – were deemed to have their meaning somehow crystallized within. Interpretation was regarded as a way of teasing out the meaning already embedded in the object (for example, the writings of Kenneth Clark, in particular the script for the 1969 BBC television series *Civilization*, or Howard Hibbard's 1983 study of the Italian painter Caravaggio). It is easy to see why this seemed to be 'common sense'. Michelangelo's *David* (sculpted between 1501 and 1504), now in the Galleria dell'Accademia in Florence, is a good illustration. The sculpture is well known and distinctive. It is the object of the attention of thousands of visitors every year. The stories of this statue seem to be carried by the material objecthood of the *David*: the artist and his creation, his patrons, its style, its iconography, its various functions within the city, its evolution as a masterpiece of genius and so on. None of this would seem to make sense without the object itself and so it is easy, within Western thinking, to envisage the meaning of the *David* to be synonymous with the physical object and that the essence of Michelangelo's *David* lies within the sculpture.

Such thinking has a long and venerable history in both Western and Eastern thought. In the West, it is often associated with Plato and Aristotle (although differently) and the powerful expression of this idea in other arenas, for example, within Christian theology. However, as Hall's book describes, such thinking is problematic on a number of levels. Michelangelo's *David* is literally a block of marble that has been carved into a shape. The meanings we ascribe to this block and its particular form are not inherent in the marble but are part of the world of Western culture. It is the shared meanings of Western viewers – their understanding of the carved marble as representing a historical and Biblical figure called 'David' – that make the inert marble mean something. To a non-Western viewer without any context, the subject of the *David* may be completely or partially illegible. Similarly, Western viewers when faced with say the Luang Prabang Buddha, a distinctive carved image of the Buddha found in and near the World Heritage city of Luang Prabang in Laos, have only a few cues within their cultural repertoire to understand the significance of these indigenous sculptures. Meaning, therefore, resides outside of the physical object; it resides in the symbols, signs, stories, rituals and so forth that we, the viewers, attach to the shaped marble and, in the twenty-first century, we presume a similar set of symbols, signs, stories and rituals were accessed and used by Michelangelo when he began attacking the marble block with his tools. Indeed, the decision to sculpt a 'David' immediately galvanized a set of quite specific ideas that, to a degree, restrained Michelangelo.

David and his life were described in scripture. In late fifteenth-century Florence David was associated with a political discourse. There were other statues of David in Florence, particularly the already famous bronze nude of the boy David, shown with his foot upon the head of Goliath. This work by the sculptor Donatello had stood in the courtyard of the Medici Palace and would have been well known to Michelangelo. The critical point here is that this dynamic meaning-making occurred *outside* of the slab of white marble and *inside* people. This process was at the heart of how Florentine Renaissance culture constructed meanings.

And so it is today. The interpretation of the *David* as meaning-making is a cultural and social *activity* between people of which the statue David is a part. It is humans that decide this particular sculptural shape is David and not Apollo or an anonymous nude man or some other historical person; that it had religious, political and civic significance in Florence at the time of its unveiling in 1504; that it is a feat of artistic and technical brilliance; that it is a symbol of the tourist Florence; that it is a masterpiece of Western art; that the pose relates to a specific moment in the biblical narrative. Consequently, interpretation is also a representation; the representations of what we mean by the *David* (in language and in photography/visual media).

The one aspect of the *David* (and indeed, the Luang Prabang Buddhas) that I have not addressed here is the aesthetic response of the viewer. This too is part of a cultural process but for the moment I want to leave aesthetic responses aside and concentrate on the meanings we ascribe to objects and the status of these meanings as part of a system of representation (see Chapter 3).

Systems of representation are far from stable. The very multiple meanings we can attach to the *David* indicate that the relationship between physical heritage objects/places and their representations is constantly in flux. Many visitors who see Michelangelo's statue may have no interest in or no understanding of the Biblical account, nor necessarily have an interest in the life and times of the artist and his native city, or have any interest in the sculptural process, but they may be fully engaged by the *David's* size, his masculinity and his nudity because within the arena of tourism encounters in the twenty-first century, it is hard to avoid the sheer sensuality of the subject, indeed its eroticism. The eroticism of the *David* may not have been an especially important response in the early sixteenth century, but such meanings are now attached to the sculpture. Accounts in gay travel-writing, for example, make these associations explicit (Aldrich 1993; Staiff 2010). What I'm describing here is a ceaseless production of meanings that constantly jostle with each other. If this is the case, then notions like an 'authoritative interpretation' or the 'definitive meaning' of the *David* must be substantially qualified; in reality, such claims exist within a sea of possibilities that range from the scholarly to the personal. It is nigh impossible, therefore, to control the meaning-making process.

This does not imply that there are no boundaries to meaning-making. As Stuart Hall makes clear, if that were the case, we could not have shared meanings. The representational system while fluid, nevertheless works within parameters that can be defined. These include a shared culture which itself includes a shared

language, a shared visual culture, shared social conventions, shared ideas and beliefs, a shared epistemology and so forth. The boundaries are best explained when we compare, for example, the operations of Western culture with Japanese culture and/or Australian Indigenous cultures. I will return to the mechanics and the boundaries of meaning-making in another place (Chapter 7).

Why is a consideration of where meanings reside, inside or outside of material objects, so important to heritage interpretation? Why is meaning-making as a representational system important to heritage interpretation? If we take as *a priori* my claim that heritage interpretation is representation, then certain things flow from this: the indeterminacy of interpretation; the constant flux of meaning-making; the centrality of the 'reader' or 'viewer' (that is, the visitor) in representational systems as active meaning-makers (that can create meanings that may be well outside of the 'authorized' meanings sanctioned by site custodians); that didacticism is extremely difficult in a system characterized by flux and constant shifts in meaning. No matter how tight the attempt to control meaning-making by those with a vested interest, there will always be subversions and/or the undoing of such meanings or that logically impossible meanings will happily co-exist (cf. Ablett and Dyer 2010).

Michelangelo's *David* illustrates this. The consideration of the *David* as an erotic and sensual subject or the use of the *David*'s penis or buttocks in tourism postcard production (both as eroticism and as crude satire) is way outside the 'authorized' accounts of the subject matter (compare the postcards with the Wikipedia entry on the *David*). Such interpretations displace the narrative of the slayer of Goliath poised with his sling at the ready and, to an extent, displace the narrative of Michelangelo as artistic genius. At the beginning of the twenty-first century the contemporary erotic response overshadows the narratives about the historical significance of the statue. However, the two stories are not mutually exclusive for many viewers, despite them being somewhat incompatible. Viewers can easily entertain more than one narrative: an erotic response can co-exist with the traditional iconography of the *David* and the historical explanations of the statue. A viewer may appreciate the art historical narrative, the story of the transformation of a sixteenth-century sculpture into a Western masterpiece, the political nature of Michelangelo's creation *and* be deeply affected by the sensual and the erotic responses the *David* has and continues to produce. Some contemporary commentators, alert to 'modern' reactions, argue that the erotic charge and the sheer sensuality of Michelangelo's works underpin the historical iconography: it gives the biblical story its power by fusing sensuality with masculinity and the heroic struggle of David against Goliath and his threatening forces (for example, Saslow 1999). Heritage interpretation cannot *manage* this level of complexity without radical editing of the content or unsatisfactory and ethically suspect reductionism. What heritage interpretation can *attempt* is a facilitation of multiple meaning-making and meaning-making as a dynamic process within systems of representation (cf. Ablett and Dyer 2010). With these thoughts in mind, the writings of Freeman Tilden emerge as considerably problematic on many levels.

Does Tilden really make any sense?

Over fifty years ago, in 1957, Freeman Tilden first published his *Interpreting Our Heritage*. In 2007, the fourth edition was published with Tilden's additional later writings about interpretation. It also included an extended introduction by the editor R. Bruce Craig, Tilden himself having died in 1980 after the publication of the third edition in 1977. It is quite an astonishing feat to have a book in print for over fifty years and running to a fourth edition, especially one that still attracts considerable praise. The former Director of the US Parks Service, Russell Dickenson, in his forward to that edition approvingly refers to a comment Tilden made in 1972, that interpretation should be used to 'foster sound environmental morals' (Tilden 2007: viii). It's a neat clue to the attitudinal and behavioural characteristics of Tilden's philosophy. In the introduction, Craig refers to the continuing importance of the book because its concepts, ideas and philosophy are 'timeless'; that the book is '*the* interpretive primer'; that it is a 'masterpiece' and provides 'a philosophical underpinning for [the interpreter's] art and craft' (Tilden 2007: 1-21). These are all extraordinary claims. In the face of the changes wrought by digital technologies and practices, the time has come to reassess Tilden's book and to examine more closely the philosophical frameworks that inform Tilden's opus: do they stand up to critical scrutiny? The short answer to this question is quite simply, 'they do not'.

From the very beginning of *Interpreting Our Heritage*, Tilden (1977) privileges the term 'interpretation' and, while recognizing that interpreters have existed across time and across cultures, by separating *heritage interpretation* – as an educational activity for visitors – from interpretation more generally, he produces a false dichotomy. Is there a difference between any of the following?

- a scholar's interpretation of Pablo Picasso's famous 1937 oil painting *Guernica* (now in the Museo Reina Sofia, Madrid);
- a news media's interpretation of an event like the election of Barack Obama to the US Presidency;
- a reader's interpretation of Geraldine Brook's 2007 novel *People of the Book*;
- Baz Luhrmann's interpretation of wartime Darwin in his epic film *Australia*, released in 2008;
- the interpretation of the data that gave rise to the discovery of the HIV retrovirus in 1980-1981;
- the interpretation of the role of Hamlet by a director and an actor working with the Royal Shakespeare Company in Stratford-upon-Avon;
- the interpretation of a Sylvia Plath poem in an English Literature class;
- playing, on a modern piano, Murray Perahia's interpretation of a Johann Sebastian Bach harpsichord concerto;
- an interpretation of the Book of Genesis by a feminist theologian.

None of these interpretations is in any way fundamentally different to what Tilden called 'heritage interpretation'. They all involve *representations* and they all involve meaning-making, knowledge formation and dissemination. Despite Tilden's insistence that heritage interpretation was a 'new kind' of 'public service' (Tilden 1977: 3 and 9), it is in fact just one activity along a huge continuum of activities that arise because of representation and the urge to make meaning. Heritage interpretation is nothing special and by insisting it is, the discourse becomes peculiarly estranged from other forms of interpretation and the theoretical insights offered by the likes of Umberto Eco, Stuart Hall and Edward Said to arbitrarily name but three scholars who have made a major contribution to representation studies (see, for example, Said 1985; Eco 1987; Hall 1997).

One of the crucial claims by Tilden is the idea that behind 'facts' and 'appearances' (or the materiality of objects, something he describes as the 'Thing Itself') lies something that can be and should be 'revealed' (Tilden 1977: 3). In his second principle he states that interpretation is 'revelation based on factual information' (Tilden 1977: 9) and that interpreters are 'revealers' (Tilden 2004: 5) who 'reveal meanings and relationships' (Tilden 1977: 8) and the 'revelation of a larger truth that lies behind any statement of fact' (Tilden 1977: 8). Further, he proposes that what is revealed is also 'the beauty and wonder, inspiration and spiritual meaning that lie behind what the visitor can with [their] senses perceive' (Tilden 1977: 3-4). There are several problems here. The idea that there is something 'hidden' behind what humans perceive as the material reality of the world has a long history in Western and Eastern thought. In these traditions of religion and philosophy, we live, it seems, in a world of appearances and 'hidden' behind or beneath or within these perceptions of the physical world lay its 'truth'. Such a conception in Western thought, stretches back at least to the writings of Plato in fourth-century Athens. In *The Republic* (c.375 BCE), Plato explored the nature of representation in his famous cave simile. He proposed that representations were illusions and not reality (in other words, somewhat like shadows cast by a fire) and that if we were to live our whole lives within a cave where moving shadows were projected onto the wall, we would regard the shadows as real and not recognize our error until we had climbed out of the cave to experience the 'truth', the world outside, gloriously lit by the sun. Truth, for Plato, lay beyond perception and could only be apprehended through knowledge born of a critical philosophical analysis (Plato 1952). In common parlance, this idea of perception and reality lives on. A BBC World news report, about the arrival at the British Museum of the spectacular Anglo Saxon gold and silver treasures discovered in Staffordshire in 2009, has the Keeper of Treasures excited by the 'mysteries the objects contain'. Dan Brown, via his character Robert Langdon in the *Da Vinci Code*, has given it further life:

> As someone who had spent his life exploring the hidden interconnectivity
> if disparate emblems and ideologies Langdon viewed the world as a web of
> profoundly intertwined histories and events. The connections may be invisible,

he often preached to his symbology classes at Harvard, but they are always there
buried just beneath the surface. (Brown 2004: 16-17)

The appeal to truth and knowledge beyond physical reality has not only been
the hallmark of certain traditions of Western philosophy (and indeed Eastern
philosophies like Taoism) and major religions like Christianity and Buddhism,
but has had a secular counterpart in science although not, obviously, so strictly
metaphysical. The scientific discoveries of the nineteenth century increasingly
focussed on entities and processes that could not be perceived with the naked
eye: atoms, subatomic particles, energy and cellular biology all contributed to the
idea of there being a 'greater truth' beyond everyday perception (Crary 1990).
Looking at a forest did not explain ecology; observable bodily symptoms did not
explain disease; ruins did not explain history; animal classification systems and
taxonomies did not explain evolution.

For Tilden, the 'hidden' and 'greater' truth of what our senses cannot perceive
can be illustrated and understood by focussing on the 'whole rather than the part'
(Tilden 1977: 40). This is a seductive argument. It involves imagining standing
on the Acropolis in Athens and focussing only on individual blocks of marble
or even the Parthenon itself without any reference to the site as a whole, to the
world of fifth-century BCE Athens and its devotion to the goddess Athene, to the
city-state's victory over the invading Persians who burnt down the earlier temple
on the Acropolis, to the annual ritual of the Panathenaic festival and procession
depicted in the sculptural frieze of the Parthenon, to Pericles and Phidias, to the
Elgin Marbles controversy and so on and so forth. The dichotomy that Tilden sets
up between the 'whole' and the 'part' is not only an arbitrary one, it gestures to the
notion of complete and perfect knowledge that is concealed beyond the horizon
of the perception of the senses. I think Tilden is wrong. 'Facts', as Tilden defines
facts, do not and cannot exist outside of the explanatory frameworks within which
they become legible and knowable. The issue is not whether the 'parts' or the 'facts'
can have meaning outside of the 'whole', but whether or not the visitor knows the
informing frameworks within which the parts have meaning. It is not about the
'greater truths' behind the facts, but about the epistemological and disciplinary
schema involved. Tilden's conception of facts and theories, so fundamental to his
thinking, deserves particular attention and will be dealt with below.

Tilden belongs, therefore, to a mode of thinking that is both pervasive and
problematic. The problem is this. Plato and his heirs represent only one way of
perceiving and apprehending reality. As the existential phenomenologists have
argued, it is possible to produce knowledge and meaning that is not dependent
on metaphysics (Moran and Mooney 2002). Subatomic physics and molecular
biology are realities in their own right: they are phenomena that can be observed
and described and analysed. Reality does not need to be conceptualized as a binary,
the visible and the invisible, with the latter somehow more important in the scheme
of things. And whether his use of the term 'revelation' arises from science or
philosophy, it is difficult not to detach it from its religious usage: the disclosing or

making clear or revealing through the communication with a deity or supernatural being. I think of two paintings by Caravaggio, the rebellious and tempestuous seventeenth-century Italian painter: his 1602 oil painting of St Matthew writing his gospel, with an angel inspiring the saint, in the Contarelli Chapel, San Luigi dei Francesi in Rome and the 1601 painting, now in the National Gallery, London, called *Supper at Emmaus*, in which Christ dramatically reveals himself to his disciples post the Resurrection. The religious connotation of 'revelation' is quite explicit in Tilden.

Tilden's use of 'revelation' also has other disquieting features attached to it: it maintains a hierarchical power relationship between the 'expert' and the non-expert, between those with 'the knowledge' and those 'without the knowledge'. He is unequivocal in chapter XII of *Interpreting Our Heritage*. Tilden assumes ignorance on the part of heritage visitors. Interpreters, like the priests of ancient religions, are conceptualized as being able to 'read the signs' for those without such a capacity. If, as I have strongly suggested, meaning does not lie crystallized within physical objects, within architecture like the Arch of Constantine in Rome, but is a cultural process of human invention, and, as a representation of a monument like the Arch of Constantine has a 'life' of its own, then it is difficult to accept the foundational assumptions Tilden makes. His idea of a 'universality of mind' that 'instinctively' seeks beyond the 'body of information to project the soul of things' (Tilden 1977: 5) is questionable in the extreme and there are echoes here of the ideological fantasy and/or desire for totalizing knowledge arising from a Eurocentric magisterial gaze.

Related to Tilden's idea of revelation is a closely allied belief in the power of interpretation to change visitors by determining the interpretation experience. Because Tilden began with the assumption that heritage interpretation was an educational activity, then the rationale for such education becomes paramount. Tilden, as a historically situated writer, was imbued with a liberal humanist belief in an enlightened citizenry. In his own words:

> Generally speaking, certainties contribute towards human happiness; uncertainties are a source of spiritual loneliness and disquietude. Whether or not he is conscious of it, Man seeks to find his place in nature and among men – not excluding remote men. Primitive parks, the unspoiled seashore, archaeological ruins, battlefields, zoological and botanical gardens, historic preservations – all happen to be exactly the places where this ambition is most likely satisfied. (Tilden 1977: 13)

Putting aside the very questionable claims about certainties and uncertainties, this process of self-knowledge is achieved, according to Tilden, through empathy and the ability to understand that all humans are 'brothers-under-the-skin' (Tilden 1977: 14). Excusing for a moment the gendered language, Tilden conceives of interpretation as an act that erases difference so that 'the strangeness and unexpectedness … disappears' (Tilden 1977: 16). The process of making difference the same is part of Tilden's explanation about why heritage interpretation needs to

connect to the values, beliefs and knowledge of the visitor. However, instead of this being the basis of visitor empowerment and a vehicle for the expression of cultural difference and cultural identity (as we find in the interpretations produced by many twenty-first-century museums), the expunging of difference is about an attempt to ensure a shared (and perhaps hegemonic) sense of history and culture (something that reverberates with assimilationist and imperialist ideologies). The 'universal citizen' ideal masks (and suppresses?) identities formed and lived around and through a host of differentiating discourses and representations – gender, race, ethnicity, geography, religion, sexuality, class, age (and so on) – some or all of which can have significant associated politics. While heritage interpretation in the twenty-first century is far more likely to embrace and work out of cultural difference and to recognize visitor empowerment as an end in itself, the remnants of Tilden's evangelical streak continue on in those who advocate changing visitor attitudes and behaviour. Given the nature of representation – and recalling that I'm assuming, a priori, that interpretation is representation – this is a most doubtful endeavour.

One of the more curious aspects of Tilden's book is his description of science, research, facts and knowledge. From the outset he positions meaning against factual information: that interpretation is revelation based on factual information but is itself not factual information (Tilden 1977: 18). When this dictum gets translated into interpretation manuals and later commentaries, it is assumed that he means that facts and figures about an object or place or monument do not constitute interpretation but that incorporating facts and figures into some other explanatory framework (and/or narrative) *is* interpretation (for example, see Beck and Cable 1998). The problem with Tilden and the later commentaries is that they perpetuate an indefensible ontology. 'Art', 'science', 'narrative', 'facts' and 'interpretation' are deemed separate entities; interpretation cannot be 'art' and 'science' – 'they are not compatible' he writes (Tilden 1977: 26) – and 'facts' are not 'interpretation'. As I have already indicated, facts are both tied to interpretation and are themselves an interpretation. To state that the Bayon, the Khmer temple in the Angkor complex, was built during the reign of Jayavarman VII at the end of the twelfth century CE and is characterized by the 'baroque' style of temple sculpture is to immediately absorb the material entity into and represent it through a series of discourses: history, archaeology, heritage, art history, nationalism, orientalism and so on. The so-called 'facts' only have legibility and meaning in the context of the discourses within which they exist. As a list of pieces of 'information' they *do* interpret the temple and transform the stones into something other than their materiality. To name *is* to interpret. A date sets up a powerful set of references. In this case, for a Western reader, familiar with medieval history, the late twelfth century CE may evoke an image of Notre-Dame in Paris (quite a powerful comparison) or it may annoy the reader because it subsumes Angkor into Western historical epistemology (as does the term 'baroque'). The dichotomy between facts and interpretation is a false dichotomy. Of course a list of 'facts and figures' may be *inadequate* interpretation, but that is altogether an issue to do with quality and effectiveness;

it does not support the maintenance of a dichotomy between them. So, to reverse Tilden's principle, I would argue information *is* interpretation because it cannot escape being a representation of something.

And so it is with 'art' and 'science'. Both art and science depend on representation; both art and science are implicated with each other – think of the work of Leonardo Da Vinci that refuses such distinctions or the way the work on the BBC television series *Walking with Dinosaurs* (1999) altered palaeontology's understanding of dinosaur motion/mobility. Art and science are immersed in discourses that often give the appearance of being separate 'worlds', but the distinctions are, at the same time, always under threat. Even a most cursory examination provides numerous examples of the intermingling: environmental science, climate change, art conservation, inside science and technology museums and in cinema and digital media (see, for example, Dutton 2010). Tilden's conception of science is that of the positivist and his view of art and science, by someone beholden to Cartesian thinking where objectivity and subjectivity are regarded as inherently separate. In the twenty-first century it is not possible to maintain such clear distinctions or categories. The distinctions between the categories Tilden writes about are arbitrary. Sometimes, under stated conditions, it makes perfect sense to view science, for example, as an autonomous entity, but sometimes not at all. As Trinh Minh Ha memorably wrote, 'categories always leak' (Trinh 1989). Ontological separation often makes no sense or is actively refused, something multidisciplinary research illustrates so well. Tilden, it seems to me, maintained the fiction of his discrete categories, particularly the opposition between 'factual information' and 'interpretation', because of the way he defined heritage interpretation and, in so doing, artificially separated it from the many other forms of interpretation like the ones I outlined earlier (the interpretation of data, of a novel or film, of a musical composition and so forth).

Other binary terms that should cause concern include: instruction versus provocation (education surely involves both); 'first-hand experience' versus representation (you can't have one without the other); ordinary/useful/technological versus beauty (here beauty is transcendental and subjective, a strongly contested proposition); cognitive knowledge versus embodied knowledge (the Cartesian dualism between mind and body); the viewer and the viewed (the Cartesian split in another form). None of these oppositions can withstand scrutiny and in the next chapter where I examine the 'heritage experience' the reasons will be clearer. Such binary pairings are historically and geographically situated in the context within which Tilden wrote his book. They are culturally inscribed and epistemologically specific (in this case, a Western cultural inscription and a Western mode of knowledge production). They are all provisional in that such distinctions may have a validity under given circumstances but not as essentialist positions. They are unstable terms: we cannot know outside of our bodies; beauty is neither innate nor transcendent but part of a historically conditioned and culturally specific environment of responses, language, feelings and visuality, something Umberto Eco's study *On Beauty* (2004) abundantly illustrates; and the viewer is part of

that which is viewed, not separate from it. An analytical strategy to decouple such pairings begins to seriously unravel the principles Tilden espoused and challenges a great deal of his argumentation.

The problems with Tilden in practice

On a recent visit to London, I spent some time in art galleries. Two paintings I saw are in the Tate collections: John Constable's 1816-1817 work *Flatford Mill* in the Tate Britain, and Georges Braque's *Clarinet and Bottle of Rum on a Mantelpiece*, painted almost a century later in 1911, and now in the Tate Modern. Paintings immediately create a problem when using Tilden's idiom. Constable's *Flatford Mill* is simultaneously a 'first-hand experience' (of the painting in the gallery) *and* a representation of a place (Flatford Mill) *and* an interpretation (a sunny, picturesque afternoon with radiant banks of clouds in the sky). The perspective of the painting invites me into the picture so that my experience is both viewing the picture in the gallery and entering the landscape world Constable has created. As a bodily experience, the painting cannot be separated from my cognition of it and my sensorial responses. This particular painting unleashes a depth of reactions: memories of an earlier visit to study these works as part of my doctoral research, memories of a visit to East Anglia and 'Constable country', the 'Englishness' that has been attached to Constable's landscapes (and in contrast, my notions of the Australian painted landscape), reminiscences about my own rural upbringing and a remembrance of carefree summer holidays spent by a river, Constable's techniques of painting and his intense interest in atmospheric conditions and the luminosity of visible surfaces. These all jumble about (along with a myriad of other responses) as I stand in the gallery aware of a group of small children sitting on the floor painting their own landscapes, helped by an education officer with a trolley of art materials. And what of the beauty of the picture? I smile. Which aesthetic response do I employ? That which I have learned about in relation to early nineteenth-century aesthetic tastes and the romantic sensibility? The neo-romantic responses that continue to percolate within Anglo-European twenty-first-century culture and mostly perpetuated in photography and cinema? An anti-aesthetic aesthetic of postmodernity where I focus, not on the bourgeois tastes of the picture, but on the hard life of the workers shown on the side of the river disconnecting the grain barges from the towing horse? Or do I conjure a sense of repulsion by this 'chocolate-box scene' of English nationalism and sentimentality that hides much more than it discloses?

The Braque picture only deepens the conundrums of a Tilden typology. This 'classic' of Cubism is, like the Constable, a 'first-hand experience', a representation and an interpretation all simultaneously. Perhaps, in modern art, the fusion of 'first-hand experience', representation and interpretation is never more apparent along with the impossibility of disentangling them. None can exist in isolation or as discrete entities. One of the intellectual motivations driving

Cubism was the quest to break up the physical world of objects (the subject of the painting) into a multitude of perspectives that were then reassembled into an abstract composition that retained the various perspectives or viewpoints. In this way, objects rather than 'standing out' against a background, melded with the background indistinguishably, a reminder that objecthood and context are given 'presence' or are 'marked out' by a studied and articulated purposeful gaze (much like all heritage places and heritage objects that are marked thus). In Cubism the Cartesian split between mind and body was challenged and shown to be an artifice (that is, of human invention) rather than a 'property of nature'. Cubism also acknowledged the 'constructedness' of art and of all the perspectives that go into art and its spectatorship. And what of beauty? The aesthetic qualities of Cubism are shown for what they are: a learnt response. Historically, it was the 'beauty' of form and colour in the abstract (and not the beauty of an object/subject per se) that was declared, but now after a century of modern art, all sorts of aesthetic responses have come to be played out in front of the Cubist paintings of Braque and Picasso. Some viewers have experienced the transcendental and seen in 'pure form' something beyond the materiality of physical objects (a spiritual response); some have experienced a sort of anarchistic sense of freedom where no rules (apparently) apply; some have had existential moments where beauty is in the dislocated parts of things rather than in the whole or where the beauty of the world can be apprehended in the discordant rather than the harmonious; some have found beauty in the association with 'primitivism' and the art of Africa and Micronesia (a source for Picasso and Braque during their Cubist experiments) in opposition to the 'cultivated tastes' of the bourgeoisie of Western Europe; or where the ordinary or the useful – a bottle of rum, a clarinet, a mantelpiece – are not ever perceived in opposition to beauty, but are seen as a basis for creating beauty.

Last words – Tilden, aesthetics and gadgetry

I want to bring my commentary of Tilden to a close with two more areas of concern, both of which point to the subject of later chapters. The first is to do with aesthetics and feelings and the second to do with what Tilden calls 'gadgetry'. In Tilden's text there is an acute awareness of the power of feeling and aesthetic responses to heritage places. In the editions of *Interpreting Our Heritage* that came after 1957, he added a chapter on 'Vistas of Beauty'. Even in the first edition of the text, Tilden recognized that there was a powerful way visitors responded to heritage places that was somehow 'outside' of his view that they were curious to understand the story of the place. He attempted to encapsulate this in his chapter on 'the mystery of beauty'. In this earlier statement he hovers between recognizing the potency of feeling and beauty as both some sort of elusive quality *in* things and yet subject to enhancement. Of feelings he writes, 'We should not attempt to describe that which is only – or – better to be apprehended by feeling' (Tilden 1977: 86). But this is not to suggest Tilden thought feelings were an end in themselves in a visitor's

response, only that verbal descriptions of beauty could not compete with beauty as an experience. Indeed, in an earlier statement he suggests that beauty was a 'path towards reverence and understanding' (Tilden 1977: 34) and clearly not an experience that is enough in itself. However, at the same time, the beauty of a heritage place, he insisted, could be enhanced by creating scenic viewing points and establishing a 'sympathetic atmosphere' (Tilden 1977: 85). In other words, he tried to reconcile aesthetics as both an integral quality of what was being viewed and something that could be constructed.

Perhaps recognizing that this earlier statement about beauty and feelings was inadequate, he addressed it more fully in the added final chapter of *Interpreting Our Heritage*. He begins by being more insistent that beauty relates to something that is 'absolute' within the physical world and when humans perceive beauty they perceive only an outward manifestation of 'Beauty' (Tilden 1977: 108). Further, the perception of beauty is transcendental. Such statements bring us back to the territory of metaphysics. Thus, he claims axiomatically, that 'natural beauty ... needs no interpretation: it interprets itself' (Tilden 1977: 110). He goes on to separate 'natural beauty' from the beauty of an artefact. Made beauty is seen as different to 'natural beauty' because it is the subject of individual taste and fashions and here interpretation is deemed more appropriate because it involves the description of taste as a socially conditioned response. The ambiguity Tilden expresses, when he allows aesthetics into his frame of reference, is quite deconstructive. He opens up the possibility of (1) the power of feelings and the role of the sensorial experience of heritage and (2) visitor empowerment and (3) interpretation as a social construction. However, having slightly opened this door – which potentially unravels many of his principles of interpretation – he quickly closes it by suggesting that the appreciation of beauty is, in the final analysis, about 'moral growth' and 'a program of education' (Tilden 1977: 115). For me, sensorial and aesthetic responses, subjectivity and the possibility of visitors empowered by their own meaning-making are compelling and worthy of greater exploration. Rather than trying to contain feelings and aesthetic responses within interpretation as education, my interest is their 'outsider' status in Tilden's scheme of things.

Perhaps nothing dates Tilden more than his discussion of 'gadgetry'. In the 1950s, and at the time of the publication of the second and third editions of *Interpreting Our Heritage*, communication techniques involving audio-visual components, and the like, were pre-digital. In other words, communication used analogue media. However, in the 2007 edition Tilden's exposition of technological enhancement of interpretation makes little sense. The creation of a Web 2.0 environment has altered the relationships between both visitors and communication technologies, and heritage sites and communication technologies. Today, his descriptions bear little relationship to the current situation and their associated analyses. The critical issue is whether or not the evolution of digital media has fundamentally reconfigured heritage interpretation (Chapter 6). However, before we can address this question it is important to (re)consider the heritage experience.

Chapter 3
The somatic and the aesthetic: embodied heritage experiences

By the Lake

What does it mean to be 'connected' to heritage? The question is more accurately a sub-set of another question: what is it to be 'connected' to place? Or, in order to avoid the binarism of place/person, how is this place me and how am I this place?

I was thinking about this while living in Lavaux, a World Heritage cultural site inscribed by UNESCO in 2007. Lavaux on the shores of Lake Leman – sometimes called Lake Geneva – consists of a series of steeply rising stone-terraced vineyards and a number of small villages built variously from the Middle Ages through to the nineteenth century. In turn, these villages were built upon Roman ruins. The Roman remains are largely hidden, but sometimes they have been exposed like the excavations in the crypt of the church in St Saphorin. Monks, who were attached to various Benedictine and Cistercian monastic houses in the region, originally built the terraces of Lavaux. The terraces and the villages have an additional feature: from almost any vantage point the view across Lake Leman is spectacular because of the French Alps that dominate the views rising magnificently as they do to the south and the Swiss Alps soaring up behind Vevey and Montreux to the east. Every photo of the lake and the mountains replicates a romantic painting and gives sustenance to the historical memory of nineteenth-century Romanticism, travel, mountains, lakes, health and those like the poets Shelley and Byron who spent time here.

For the whole of her life my host has lived, studied and worked around Lake Leman. Her identity is, in part, this place. Her family, her childhood, her memories and her work cannot be separated from the geography of Lake Leman and its environs. Part of the way she articulates the meshing of her self-place is through her knowledge of history, art history, architecture and the culture, more generally, of the region. It frames and informs the way she speaks about herself and the region. She sees her knowledge, her fusion with the physical – swimming, walking, boating, looking, photographing, travelling by car or train – and her lived experiences of the cultural dimensions of the Lake as a constantly deepening way of being. She will 'drop everything' to watch the sun set over the Lake from the terrace of her house. Perhaps she's seen thousands of sunsets and yet she never tires of this spectacle of sky, mountains and water, clouds, light, colours and reflections.

Her husband experiences an entirely different place/person embodiment. Even though living here for some thirty years, his childhood and early adulthood were

spent in southern Australia. His (dis)placement is the result of always feeling like he is apart from the immediate. His life is a grafting onto this place, and, in turn, this is always thought of in comparison with 'home', with Australia. Classically, he lives the life of the immigrant, suspended between two worlds that jostle and construct Lavaux as something that is not like that his wife's Lavaux. Surfaces rather than depths are far more apparent to him.

They have three children, two of them teenagers, and all three have only lived in the family home along the lake, although they are well travelled and have visited Australia numerous times, SE Asia several times, north Africa and within various parts of Europe. For them, Lavaux is not signified as 'World Heritage'. It is not a place that they experience as 'steeped in history'. It is the everyday: the daily routine of catching trains to school and university, of playing sport, visiting friends, of weekends skiing in winter or swimming and boating on the Lake in summer, of chores around the house, of homework, of constant screen interfacing, of burgeoning hormones, of dealing with parents. Their world is not marked out or experienced in anything quite like the way Lavaux is for their parents. Yes, there must be intersections but these are tangential to each other, movements across and away in different psychic directions.

As a visitor, also from Australia, my relationship to the environment of Lavaux is articulated in a different register produced by the superimposing of three perceptions (among others). One is historical. One is visual. One is to do with identity and imagination. The historical relates to a long interest in European history and culture, especially, in more recent times, the Roman world and the medieval world. The place resonates with these pasts and I get a precarious thrill from being in a place where the past has sculptured the physical and built environment of the present. Beneath my feet is a Roman road. Across the road and beneath the church is a Roman villa. I stand in the vineyards and look down on the village of St Saphorin with its Romanesque church. The world of medieval Europe, monks and workers toiling to bring in the harvest and press the grapes, is within my grasp. During one walk along the terraces, I purposely accentuated my medieval fantasy by playing plainchant on my iPod, the music of the medieval monastery suffusing with the scenic like a movie soundtrack. The landscape spectacle of lake and mountains enthrals. The aesthetic response is deep, layered by a lifetime of representations of mountains and lakes in the European imagination. The physical hardships that such an environment would have offered in the past have been erased by modernity: now it is a place of beauty experienced in comfort. I am able to recall the aesthetic responses of the past that continue to resonate in the present: the romantic landscape, the sublime landscape, the topographical landscape. Art, literature and music mediate my responses.

As a child, living in rural southern Australia but connected to Europe through my maternal grandparents (English) and my paternal grandparents (Bulgarian), my imaginative world was European: the Secret Seven, Robin Hood, the Kings and Queens of England, picture books from Bulgaria and England, maps of the 'Old World', calendars with pictures of Somerset and school projects about

Great Britain. As an adolescent, the associations expanded: Shakespeare, Austen, Dickens, Orwell, Keats, Wordsworth, Owen, histories of Greece and Rome, the Renaissance, the Reformation, Revolutions in France and Russia, and in my music studies, the mostly European classical repertoire. Consequently, in those days long past, my identity, in part, was Europe in another place, Europe in the Antipodes. Walking in Lavaux activated all these things and therefore fashioned this place in my own image.

My Lavaux was not that of my host or that of her husband or their children. We operate in parallel realities that intermingle but remain separate and known to each other as inadequate translations. To therefore ask the question about how we connect to heritage places is to entertain extreme complexity.

A conceptual terrain of 'heritage experience'

In the last chapter I argued that heritage interpretation is about representation, but representation tied up with time and Euclidean space. However, historical time and geometrically conceived three-dimensional space does not capture the molten intricacies of the heritage experience. Certainly representations, like the accounts of those living or visiting Lavaux, can indicate dense and differing responses and the impossibility of singularity, but how do they capture the ineffable?

Heritage interpretation *assumes* the horizon of Euclidean space, a horizon that fixes things in their place. The sky and the earth, buildings, mountains, roads, rivers, towns, forests, farms and so on, all fixed in a relation to the horizon. The horizon is, and represents, a type of perceptual grid and a conceptual apparatus where flux and dynamism is dampened or ignored so that space, time and phenomena are positioned in a relationship that is stable. Once 'tied down', as it were, interpretation can begin: objects and categories and entities reinforce each other as something fixed; fixed in themselves (as solids – in other words, as architecture, as a geological formation, as a sculpture and so on), fixed in their relationships, fixed in the past rather than the present or future (the language of heritage interpretation is invariably the past tense), fixed in their meaning and significance, fixed in systems of representation (in diagrams, in narratives, in pictures, in statistics) and fixed for viewing and photographing. As Merleau-Ponty explained, the horizon holds things together and makes possible a logical conception of things (Merleau-Ponty 2002).

In Western culture, especially since the Italian Renaissance, the horizon has been fundamental to Western notions of perspective that, in turn, create points of view (visually and rhetorically); the world composed as a scene or as an exhibition (for meaning-making, for consumption, for reproduction) (Mitchell 1989 and 1994; Bennett 1995; Dicks 2003).

But what is a horizon? While it is commonly understood as the line formed by the earth and the sky where they seemingly touch, it is in fact a perception (the sky does not, in a sense, 'touch' the earth and nor is it simply a line). The horizon

is a construction (taught for example in Western landscape drawing), an invention (the divide between the visible and the invisible, a necessary line that creates spatial depth and makes measurements possible). In reality, the horizon cannot be a fixed entity because there is no stable point between a sphere (the earth) and the spherical envelope of air that surrounds the sphere (the sky). And movement, as we know, constantly recalibrates the horizon. We *assume* therefore, rectangles and triangles of Euclidian space but in truth it is all about spheres.

If the horizon is an invention, then consequently objects and their inter-relationships are not fixed and so the connections between what are regarded as static things and their associated properties, whether spatial or epistemological (and often both), are only ever *relational*, or to use a more theoretically inclined term, they are only ever provisional. The embodied experience of space is not Euclidian and stands in contradistinction to horizons, perspectivalism and Cartesian detachment (unless, of course, it is an act of will, the intentional employment of horizons and geometric perspective by the senses, especially vision).

The philosopher Elizabeth Grosz has written, memorably, that 'outside architecture is always inside bodies' (Grosz 2001). She could have been writing about heritage places, monuments or objects. What is a heritage place without people? Material culture and nature's domain have no presence, purpose, or capacity without human interaction, without the human subject. Indeed, without human engagement, Uluru is simply a large rock in a desert and Sukhothai in central Thailand is no more than crumbling ruins, severely eroded by centuries of an alternating wet and dry monsoonal climate. In the twenty-first century, Van Gogh's sunflower paintings have no meaning outside the act of creation if there is no one looking at the picture, in other words, no spectatorship. As we saw in Chapter 2, meaning does not reside in the objects themselves. Meaning arises in the interaction between humans and the material and the natural environment.

The interaction between people and heritage places is foundational to any consideration of how they may mean, and *ipso facto*, to a consideration of heritage interpretation. But how can the bodily experience of a heritage place or object or landscape be described? What, exactly, is a 'heritage experience'? This is a complex question and my attempted answer is more a sketch than a fulsome analysis. What follows is a series of 'dialogues' with a number of writers in the hope for an emerging 'cartography of understanding'.

When Grosz suggests that something is happening in bodies, what is it that should be drawing our attention? Is it simply interiority? On routine walks to my local shopping centre, along roads and laneways I've trodden hundreds of times, interiority is quite a dominant part of the experience even to the point of not remembering parts of the journey so locked am I into what's happening within, especially in my head. But interiority, while crucial, is not enough. On a recent visit to Dennis Severs' House in Folgate Street, Spitalfields, London I was highly sensitized to other sensations, especially touch (running my fingers over fabrics and wooden surfaces, over cold porcelain and glass, picking up old parchments, stroking the black cat asleep near the fire in the front parlour) and smell (cinnamon

and nutmeg, wood fires, perfume, scented tobacco, candle grease) and hearing (the creak of the wooden stairs, half-caught whispered conversations, a horse and carriage in the street, the crackle of the hearth fire) and of course, seeing, but above all, the sense of my body being in this place (and out of my 'usual place') (cf. Witcomb 2010b).

Juhani Pallasmaa, the Finnish architect and architectural theorist, writes in his book *The Eyes of the Skin: Architecture and the Senses* (2005) of the centrality of our skin to bodily experiences – skin, such an amazing organ that both separates us and at the same time joins us to the exterior 'world'. The hapticity of skin is more than merely touch; it includes all the senations of heat and cold, of the sun and of shadow, breezes and the wind – or lack thereof – sweating and, of course, touching, the bodily contact with the exterior world and by our own constant touching of ourselves as well as that which we pass by or use (the keypads on my computer for instance) or consciously reaching out to touch. But also our senses of smell, hearing and taste are haptic: the rush of air into our nostrils or the sharp intake of chilli fumes as we stand near a wok or the delight of smelling violets or a particularly potent rose bud; the sensation of our mouths and of food, saliva, tastes and flavours, of sucking whether a chocolate delight, licking an icecream or something much more erotic; the sensation of hearing not just as 'music in our heads' but the swoosh of water over our eardrums as we swim or surf, the gentle vibrations that constitute sound. Even seeing is haptic: the flutter of our eyelids, the moisture levels of our eyes, the physical impact of strong light, of squinting, of peering into darkness, of shutting our eyes. And then there is the whole arena of sensations to do with the interior of our bodies: physical pain, hunger and thirst and being satiated, our heartbeat, our breathing (relaxed or strained), feeling fatigued, coughing, stomach rumbles and sexual arousal. And so while we may live at a time where vision seems to be the dominant sense, as Pallasmaa writes (after Montagu, the anthropologist), touch is the 'mother of the senses' (Pallasmaa 2005: 11). Or, to use less gendered language, the body is the locus of experience: memories, referencing, emotions, imagination, knowledge, dreaming, temporal/spatial mobility and being are all bodily.

Embodied encounters

Another way of expressing these more extended dimensions of the heritage experience is to compare two images. I've chosen two nineteenth-century Western landscapes by way of illustration, both of which hang in the National Gallery, London. The first, painted in 1821, is the widely known and much admired *The Haywain* by John Constable and the second is J.M.W. Turner's 1842 painting called *Snowstorm*. Constable's picture belongs to the realities of historical time and Euclidean three-dimensional space. Constable has created the illusion that we could enter into the picture and walk around in this place of fixed objects. We could, in a rather distracted almost objective way, observe the cart, play with the

dog, wet our feet in the stream or visit the cottage. The picture's immediacy is driven by a semiotic imperative as we begin to play with possible understandings: the rural idyll, the sense of harmony, the cosy and rustic interior evoked by the smoke lazily drifting from the chimney of the thatched cottage, a sense of a time gone by, the goldenness of the summer's day, the moisture-laden clouds and the verdant fields. The picture reminds us of the way we arrest time and space in our own photographs of heritage places and how we can be 'mere observers' of a scene or monument. Constable's *The Haywain* inhabits the world of the heritage experience mediated by representations, and thus interpretation (cf. Waterton and Watson 2010).

The Turner painting is so utterly different. Nothing is substantial; instead we are caught up in swirls of circular movement and swirls of colour. Nothing is fixed; nothing is located. What is sky and what is sea? Where is the horizon? Is there a horizon? There is an indeterminacy of space and time. Even the urge to signify is interrupted by the kinetic frenzy of the scene. (But is it a scene in the way we understand 'the scenic'?) The paddle steamer at the centre of the composition is barely distinguishable from the swathes of darkness surrounding it. There is no rest, just perpetual motion. Our eyes cannot focus and so we give in to the visual experience much like we may give in to a wild storm at sea in a movie or a wild storm as we stand on a lonely beach somewhere, our faces whipped by wind and rain, our ears assailed by rumbles of thunder and giant crashing waves and our hearts beating strongly, our bodies sensate, our emotions put to the fore. When looking at the Turner painting we are confronted not by legible objects in relation to each other and to us as viewers – the logic of Western perspectival pictures as in the Constable – but with the ineffable, that which escapes description. The conservative art historian Kenneth Clark, who was director of the National Gallery in London from 1933 until 1945, in attempting to analyse the picture by using the language of art history was forced, ultimately, to write of 'chaos', 'confusion', 'unpredictability', the unleashing of the 'power of the unconscious' and described *Snowstorm* as 'an uncomfortable, even an exhausting experience' (Clark 1960).

For me, in the context of the heritage experience, the Turner painting acts as a metaphor for the embodied co-mingling of self and place. I'm left with two questions. Which is the more powerful experience, the Turner or the Constable? Which picture inhabits the domain of heritage interpretation? Undoubtedly, the Turner is the more powerful experience because it involves so much more of the self than just the apprehension of a place always, already bound by historical time and Euclidian space. The Constable picture shares the domain of heritage interpretation: objects fixed by relations, by perspective, by horizons, by discourse, by a viewer viewing. This begs another set of questions. Can the two experiences be reconciled? Should they be reconciled or is it a matter of one – that touching on the ineffable – being always outside of interpretation regimes? I think there's something amiss if we can accept the power and significance of the sensorial, of complex non-directional self-place embodiments, and then discount them in heritage interpretation imaginings.

Material heritage and excess

Elizabeth Grosz, in her ruminations on architecture *Architecture from the Outside* (2001), writes of *excess*. Buildings, monuments, places are always something more than their physical materiality and it is this 'something more' which she terms 'excess':

> Outside architecture is always inside something else ... Outside of architecture may be technologies, bodies, fantasies, politics, economics, and other factors that it plays on but doesn't direct or control. (Grosz 2001: xv and xvii)

The excess is that which is beyond the physical entity. Not only is this excess uncontrollable, it constantly breaks down the boundaries/borders between the physical entity and itself. Excess is more than an entanglement of inside and outside, it is an inescapable condition of materiality. In heritage it is the discourses and technologies and systems of regulation and the way things and places are valued, felt, experienced, internalized, consumed (and so on) that constitute this excess, that which is outside the materiality of the object, monument or place and which gives the physical its legibility, its aura, its power, its intimacy (all of which occurs inside bodies). At the same time, excess indicates potentiality, places of experimentation, of improvisation, of cultural formations, where heritage is a mode of relating to self, to the world, to *communitas*, to whatever. Excess, then, has the potential to create connections (or even disconnections). However, excess also harbours what some would regard as 'negatives' and others as struggles: memories of pain, fear of the future, fear of death, over-consumption, zealotry, unfettered libidinous desire, destruction and exploitation. What Grosz's remarkable essays alert us to is this: little within the universe of the materiality of heritage things can be controlled or determined. Excess denotes things defined and undefined, the expected, the unexpected, without limits and borderless, an open-ended, non-determined interplay of places and monuments with people. Turner's *Snowstorm* generates excess – outside (the painting) is inside something else. There is an incredible irony in all this. So much of heritage is about attempting control through legislation, through charters and standards of conservation practices, through management regimes, through discourse and so on. I am not arguing against these things but noting why they are probably so time-consuming: the attempt to bring rationality and systems to phenomena that are always dynamic, always changing, always fluid. It is like trying to make the Turner *Snowstorm* into the Constable *Haywain*!

David Crouch ponders upon these ideas a little differently. He writes of 'embodied encounters' where the visitor's body is both mediation and mediator, where 'there-ness' (being *there* at a heritage place) is a dynamic interplay between sensory feelings, imagination, sensuality and desire, expressiveness and meaning-making (Crouch 2002). He argues against the idea of the visitor and the place of visitation as being detached from each other and ontologically separate. Rather,

he offers a description of tourist spaces/places, and *ipso facto* heritage spaces/ places as not pre-existing and objective entities already inscribed (by systems of representation like conservation theory and practice, disciplinary knowledges, heritage discourse, legislation and so on) but as spaces/places *in play*. The heritage visitor does not decode pre-existing inscriptions as a disinterested/detached viewer across what Crouch calls 'inert spaces' and something akin to looking at Constable's *The Haywain*. Rather, as with Turner's *Snowstorm*, the viewer is 'caught up' in the 'there-ness' of the encounter so that heritage objects and places and monuments are necessarily mediated by the body of the visitor. The whole of the space is 'alive' as is the way the visitor is 'caught up' within his or her 'there-ness' where 'there-ness' is not a quality of inscription, but a quality of the senses, the chaos and erotics of presence or, as some have described it, a 'poetics of practice'. The heritage experience conceptually is not well served by notions of historical time (everything already embedded and legible via chronological time) and Euclidian three-dimensional space. What's needed is something more akin to how we experience places. 'The sensation of space is one of engulfing, surrounding volume' where we 'the expressive self' is 'engulfed by space' (Crouch 2002: 213), not as pre-existing but as existential, in the here-and-now.

In summary, the arc of the argument goes like this. Heritage interpretation, as currently conceptualized, breathes the air of a particular John Constable painted landscape, *The Haywain*. An object, place or monument, already inscribed and defined, awaits the arrival of the visitor who decodes or is assisted in decoding what they experience as they enter a world of established relationships and established discourses and representations (although the representations invariably precede the visit). The visitor is empowered in this world to the extent that he or she can manipulate what is on offer or what they bring with them in terms of the emotional and intellectual responses to this already given 'staged' or constructed set up and in terms of the meaning-making and knowledge productions that can conceivably occur. The heritage visitor and the heritage place are considered as separate ontological entities. The 'body' of the visitor is assumed but understood as an absent static viewing/seeing entity rather than a fully present and mobile producer of place or, as Brian Massumi would argue, the moving body as 'never present in position, only ever in passing' (Massumi 2002: 5).

Such a conceptualization avoids, or indeed ignores, a more complex analysis that can be metaphorically regarded as breathing the air of J.M.W. Turner's landscape *The Snowstorm*. In this much more difficult abstraction, the embodied sensations of the visitor become an analytical locus. Involvement, as Ross Gibson describes it, arises through a sense of wonder activated by 'sensory power' and 'somatic responses' (Gibson 2006). In this way the body is not separate from place but registers *in place* as a fluid continuum of self and enveloping space, the self being the located sensate self, historically, geographically, sexually and culturally (and so on). In this conception heritage interpretation, currently understood as an educational activity, runs into difficulties. It seems to have little traction. Is it possible, therefore, to re-imagine heritage interpretation in the context of visitor

immersion, flows, desires, being enwrapped, embedded and surrounded, where action and awareness are merged (Harrison 2001); where the visitor and place, past and present, inner and outer, self and other, real and imagined all dissolve into the continuities of the lived body in motion (Rountree 2006)?

To be honest, I think that both conceptions of heritage interpretation can exist as parallel universes although ones in constant tension and in a paradoxical relationship. To meaningfully communicate anything requires a temporary condition of provisional fixity and the whole heritage enterprise encourages the fixing of objects and places in scholarly discourses, in conservation processes, in charters of principles and practices, in legislation, in management, in narratives. In Western culture, the Constable landscape is available to me just as the Turner landscape is available to me. I can recognize that Turner's conception is far more complex and difficult to grasp but equally, a far more powerful personal experience (and one much closer to how I experience heritage places, objects and monuments); but I also recognize that, by fixing heritage places, however artificially, there are alternate ways of perception and knowing available to me even as I recognize the limitations. What I am insistent upon, however, is not some sort of hierarchical relationship between varying imaginings of heritage interpretation, but a considerable broadening out of our thinking that goes way beyond the educational paradigm and acknowledges the embodied relationship of the object/place/monument with the visitor who 'creates' such places *in motion, in play.*

Robben Island and affect

Robben Island, the World Heritage site just off the coast of Cape Town, South Africa, exemplifies these quite difficult logics. The week before my visit, I had been at the IUCN World Parks Congress in Durban where I had sat in an auditorium mesmerized and moved to tears by the presence and the presentation of Nelson Mandela. My pilgrimage to Robben Island had much to do, of course, with Mandela and his most remarkable story of eighteen years of incarceration on the island, but it was also intensely personal. In 1962, in a primary school in rural southern Australia, the arrival of a handsome 'new boy' from South Africa was 'news'. Eventually, the new boy (and his sisters) had names and in senior secondary school, some years later, family stories and quiet discussions began to take on an immediacy that linked the 'new boy' to media events. His name, I discovered, was a well-known Afrikaner name, a name closely linked to a key figure in the establishment of the Apartheid apparatus. But the family of the 'new boy' were English-speakers who had left South Africa in the wake of the 1960 Sharpeville Massacre where 69 Black African protesters, rallying against the infamous 'pass laws', were shot by police. It sparked nationwide demonstrations and riots and the declaration of a state of emergency resulting in the detention of some 18,000 people.

In 1966, my English teacher was prompting us to take a closer look at the news and television coverage of events in South Africa. Particularly memorable was the declaration of District 6 as a 'white precinct'. District 6 had been a vibrant 'coloured' suburb of Cape Town, a community of 'mixed races, Coloured and *Bantu*', to use the lexicon of the regime. The resistant local population, resident in the area for generations, was forcibly removed as the bulldozers began destroying the suburb. It was illegal for them to remain in a 'white suburb'. This was the first time in my short life that I felt political anger, something fuelled by the discussions I was having with the 'new boy' with the sexy accent. The media accounts and the television images deeply disturbed me and the emotional responses were intensified by my friendship with the English-speaker from South Africa with the famous Afrikaner name. A couple of years later, at university, the anti-Apartheid movement was like a beacon calling and activism followed. In my honours year in history, I took a course called 'Race Relations in South Africa'. My reading of Alan Paton's *Cry the Beloved Country* (1987) and Nelson Mandela's *No Easy Walk to Freedom* (1965) deepened my profound emotional responses to events in South Africa. The day Nelson Mandela was released from prison was a day that had me working in front of a television screen in Melbourne so that I wouldn't miss the 'historic moment' of his liberation from 27 years of imprisonment.

Until the opportunity arose for me to travel out to Robben Island, my responses to the Apartheid story, although passionately felt, were much more like being ensnared in a series of complex intertwined representations. Cape Town the place and Robben Island the place were psychic, emotional and knowledge based projections of images I carried around in my head, projections largely informed by the media and photographs in books. They were, if you like, fixed places with a fixed sense of both geography and history. In my head and in my emotional responses, I walked around these places as though walking around a theatrical set. Everything was pre-given. But going to Robben Island was nothing like this. From the time I paid my fare at the Nelson Mandela Gateway and entered the waiting room for the ferry at Victoria and Albert Waterfront in Cape Town, I was agitated. All around me were large black and white photographs of some of the inmates of Robben Island during the Apartheid years and now, almost miraculously, many of them were government ministers. There were audio-visual presentations available, but I could not avail myself to any of these pre-visit 'invitations'. I was restless and impatient and exhilarated. I was also apprehensive. What if my pilgrimage, because it certainly was a pilgrimage, was disappointing or lacked the immediacy I believed I would find there? Had Robben Island been so transformed into a historical monument by becoming a World Heritage site that the 'monument-ness' would take precedent?

As the ferry sailed out of the harbour, the famous, cloud-hugging Table Mountain of Cape Town revealed itself in all its resonating majesty. Once, Cape Town had a quite special place in the mythology of Australia and for those of us who were schooled into a particular history of Australia's colonial past, Table Mountain was one of the engrained symbols of this story. On board the ferry, a

video was playing about the history of Robben Island, not just its Apartheid past but also its ecological past and its various colonial uses. I was not paying attention. Instead, I was watching the distance grow between the looming island and Cape Town behind us; I was imagining being cut off from the rest of South Africa, from one's previous life, one's family and community and political and social networks for not just a few years, but decades. And yet I knew, also, that the great passage of cold and storm-prone water between the mainland and the island was porous. Communications did occur, messages got in and out, new inmates brought fresh news, prison guards in their comings and goings were a vital link. The feelings I had, as the island grew ever closer, were viscous.

Arrival. We went ashore and the first thing I was aware of was a huge mural of a photograph of the same jetty with a boat pulled alongside and the boat is full of political prisoners arriving at the island under the ever-present surveillance of white prison guards. The similitude felt spooky. All around me was the hubbub of visitors chatting as they walked up the causeway. I was glad I was alone and travelling in my own head. The breeze of the ocean was brisk, cold, biting, salt tangy, but the sun was bright. We were herded onto coaches. I sat by a window. A young girl in her late teens from Canada sat next to me. I was intrigued. She would have been maybe seven years of age when Mandela was released from prison and eleven or twelve years of age when the first multi-party elections were held and Mandela became South Africa's first post-Apartheid President in 1994. We chatted. I asked her about her visit to Robben Island. She told me she thought Nelson Mandela and the Dalai Lama were the greatest living human beings on the planet. She was working on a volunteer project in South Africa and was having a week's holiday in Cape Town. We chatted about our accommodation and compared breakfasts, hers minimal and awful, mine a feast of fresh fruits, yogurt, breads, jams, hardboiled eggs, ham, cheeses and superior coffee. We laughed.

Suddenly the coach stopped and the engine was switched off. Our breakfast comparisons died in the moment. I looked out of the window and saw nothing but scrubby trees and bushes. Silence descended. Had we broken down? And then it began. The sound system crackled to life and we were addressed from the front of the bus in the lilting musical tones of Cape Town English. We were told we needed to know the Apartheid story. Now, writing this many years later, what I most vividly recall was the tears. Here was the story of racial segregation by a woman who had lived nearly all her life enclosed within an unforgiving system of brutality, harshness and injustice. And here I was, *in* South Africa listening to her story as a witness and not as something I was reading or seeing on television. The 'there-ness' of it all. The emotions were strong, the story so familiar I didn't need to really listen, but listen I did, letting the words pierce me and, as her body swayed with the passion of despair, little hope and finally freedom, I couldn't hold back the tears. In some weird way, I too had lived this story but so differently, so distantly as though seeing it all from afar through a telescope. But here in this bus her passionate retelling fused with my own particular story and in that fusion all I could do was cry. And I wasn't the only one. The Canadian girl too, had tears rolling down her cheeks.

After the coach had travelled into the limestone quarry where the prisoners had to spend countless hours of back-breaking work chiselling stone and travelled past the remnants of the World War II fortifications that seemed so misplaced in this abode of Apartheid brutality, we arrived at the prison camp. As I stepped down from the coach I recalled my earlier apprehension about this visit and how ill-judged it now seemed. After being broken up into small groups, we were introduced to our guide. I no longer recall his name but the first piece of information he gave us about himself would become etched into my mind forever: he had been a political prisoner on Robben Island for some seven years and was one of the last prisoners to be released. Throughout the tour I felt impelled to stand close to him. The prison camp, in all its severity and all its banality and with all its dehumanizing rituals (different rations for different racial groupings), was strangely objective – just a building with rooms but lacking the vital presence of overcrowded human-filled spaces. Without the stories of the guide, *his stories of being there*, there was no sense of these rooms full of men living cheek by jowl in appalling conditions for endless days and months and years and yet, at the same time, thrown together in a way that strengthened their political solidarity, their learning together, their planning for a future South Africa, their highs and their lows, their personal struggles. Thus my compulsion to stand close to this man who had endured so much and, luckily, had lived long enough to be part of a triumph, not only the end of the Apartheid system, but the triumph of him telling his story day in and day out in the very place of his darkest hours and as part of a quest that the story not be lost or diminished. I took very few photos that day. A shot of the ferry and the wharf, the entrance into the prison camp, the stretch of water separating the island from Cape Town, the quarry from the bus window, the ration list for different racial categories and the exercise yard outside one of the cell blocks. It was my peripheral vision that dominated – darting across surfaces, rarely at rest, suffused with emotion – not a focussed seeing where the world resolved itself into views to be photographed.

In a way, the visit to Nelson Mandela's cell was slightly anti-climactic. The pictures of the cell were widely known and so it was more like a visual verification than a highlight. The jostling crowds trying to take photographs in such a confined space made seeing it a bother. And by then I was emotionally exhausted. In fact, I recall very little of the rest of my visit. The aura of the place I had invested in so intensely began to fade. I was aware of physical tiredness as well and was eager to get back to the ferry. I'd had enough. By the time we were walking back down to the jetty, I had tuned out completely and on the return journey to Cape Town, I slept, quite depleted by the experience. As I left the Nelson Mandela Gateway, back at the Victoria and Albert Waterfront, my body felt as though something had been consummated. I wasn't quite sure what, but it was the feeling I had; something important, something elemental, something beyond words.

Jouissance and other somatic embodiments

I include this reminiscence of Robben Island because it is a failure! It fails to capture so much of the visit as a sensorial journey and an embodied experience precisely because what I have written is a representation and as such it cannot communicate that which lies outside of representation: desire, pleasure, affect, the ineffable, *jouissance*. I like the use of the French term here because it is untranslatable in English; it gestures to something *beyond* bliss, desire, pleasure and ecstasy with orgasmic vitality (and yet pertaining to all of them). With *jouissance* we are back in the arena of Grosz's 'excess', something that can't be contained and described and yet powerful as both potential and kinetic energy. I wanted to capture the sense of Robben Island, the place, in motion and in play, but language as I write it and as I often read it has a stillness about it (the stillness of composition, the stillness of silent reading) and language is linear. And therein lies the paradox and the challenge: heritage interpretation fixes and gives order, sequence and coherence to experiential phenomena that in the moment of 'there-ness' are not fixed or ordered or sequential or coherent. It was in retrospect that my reminiscences gave the experience of Robben Island *shape*. In the lived-in, constant spiral of moments, such shape was neither an over-riding concern nor possible (except in the most fragmentary and often elusive of ways).

One of the qualities I tried to communicate in my description of my visit to Robben Island was the sense of 'passing through', of being a mobile subject and, as such, seeing the place as constantly 'in motion'. Motion through a site is nothing like looking at a picture or poring over a map or looking down on a model. The view in motion is from within rather than from without. Crucially, nothing stays still as we move through a heritage place or landscape or through a museum exhibition. At Angkor, for example, I'm most acutely aware of the difference between a static perception of a monument (as we arrive we stop and photograph it because it is already composed into a 'frozen' scene) and the effect of moving within temples like Ta Prohm and Preah Khan but also the Bayon and Angkor Wat. It is the same in the medieval centre of Florence. One is enveloped by the urban fabric of the streets, catching glimpses down alleyways or into buildings, constantly moving and being aware of the movement, cobblestones beneath my feet, half-caught fleeting views of people sipping wine in a small bar, the sky overhead, the temperature, the 'procession' of facades, the crush of crowds, the sounds and smell of the traffic, the aroma of coffee and the hiss of the expresso machine, and the bouquet of other more substantial dishes. I'm constantly in motion and within. By 'within' I don't just mean 'inside'. I mean moving in and around a structure that has continuities with other structures, with its surroundings and with me. The outside of architecture can be just as much 'within' as the inside. Movement means constant changes of perception and perspective, constant changes to me in relation to the material, the interplay between pre-epistemic and epistemic vision, changes in mood and tone, shadow and light, textures, colours, smells, air movement and sounds. In a sense, when we visit a place like Ta Prohm

we dance with it, a choreography of our own design but one that partners us with the architectural intricacies of the space. This is not just an attempt to lasso the work of sociologists like John Urry on mobilities (2007) and Zygmunt Bauman on liquid modernity (2000, 2007) into the conversation, although, as it happens, both of them alert us to the problem of regarding society as a static environment of structures with definable relationships and, instead, point out the importance of an analytic of motion. I will have more to say about this in the chapter on digital technologies (Chapter 6). My interest here is the way heritage interpretation, as presently delivered, works against and is contrary to the way visitors move through and within a heritage precinct or monument or place.

The only sign I recall stopping to read (and photograph) at Robben Island was the rations list in one of the cells. In Angkor's temples, there is almost nothing in the way of signage as one struggles through narrow passageways and stumbles over fallen stones and walls. In art museums there is a conscious minimal use of signage in the belief that the power of the art works should be allowed to communicate unmediated. One reason I highlight these examples is because stopping to read a sign or guidebook or to listen to a guide changes immediately the relationship between the visitor and the environment within which they are moving. According to Brian Massumi (2002), it interrupts affect. How? Firstly, heritage interpretation takes the heritage place out of the existential experience of the 'here-and-now' and repositions it in an abstract space – usually semiotically infused with 'the past' – where the place encounter is re-animated with mythical and historical narratives. When we stop reading (the sign or the guidebook) or stop listening (to the guide or the audio presentation) we are returned to the 'here-and-now' of motion, sensation and affect. Secondly, heritage interpretation introduces a constant tension between these two ways of being in place and of place; between the unpredictable and anarchic realm of 'there-ness' and the focussed attention of overly determined reading/listening, an act that momentarily banishes 'there-ness'.

Brian Massumi's 2002 study of movement, affect and sensation puts the scientific case for movement/affect as preceding sensation, emotion and the signification of the body and the embodied. His argument is variegated and complex. Based on a series of visual experiments using images, Massumi illustrates that affect is autonomous, is a powerful bodily response that is outside of understanding in the semiotic sense; it cannot be articulated because the instant it is, it is no longer affect but an effect of affect (representation). Significantly, the experiments showed that content-signification (the addition of factual material to the visual stimulus) dampened intensity/affect and physiologically interfered with the images' effects. The addition of emotional cues to the factual account of the visual stimulus didn't interfere in the same way because the emotional cues enhanced the images' effect by registering an already felt bodily affect.

What to make of all this? There is only a weak presence of affect in descriptions of the heritage experience and interpretation. Writers like Andrea Witcomb, Ross Gibson and David Crouch have constantly alerted us to the importance of affect in the tourism/heritage/museum context (Gregory and Witcomb 2007; Gibson

2006; Crouch 2002). There is certainly a lack of adequate theorization of affect in the context of heritage interpretation. Following Massumi's argument, language-based heritage interpretations 'dampen' intensity/affect and displace it as a powerful embodied response to an experience. As we have already seen, heritage interpretation relates and assumes a world in stasis, of things in arrest, whereas visitors are mobile, their bodies in motion. The current location of heritage interpretation (as education and as 'informal learning') accounts for none of this and consigns 'wonder' (that is, affects and emotional responses) to that of *context* – a powerful context *to* learning. Instead, affect should be properly regarded as an embodied physiological effect that *is of itself* and is a fundamental dimension of experience that leaves much more long-lasting impressions.

Massumi's description of embodied affect opens the way to a more complex appreciation of the heritage experience as being more than meaning-making (or world-making); as more than sensorial; as more than experiential; as more than a response to desire (for freedom, knowledge, leisure, exoticism, the past, romanticism or whatever); as more than sociality; as more than performance and ritual (of patriotism and/or citizenship and/or *communitas* and so forth). The heritage experience is all of these (and more) but one of the primary intensities of the experience – affect – is displaced by such understandings. Once again we are faced with what I'm describing as an inadequate imagining of heritage interpretation. Again, I think of *jouissance*.

Aesthetics and experience: culturally inscribed responses

Beauty is a historically situated concept. In other words, the meaning and the cultural operation of beauty have a history and that history has produced a number of varying understandings of the term. Originally – in its ancient Greek formulation – beauty was associated with goodness. While the ideals of beauty and virtue, as being linked, have contemporary echoes, it is foreign to the idea of beauty as related to sensuality, or erotic beauty. In contrast, beauty as something to behold and contemplate, has a long history and the idea of contemplating beauty has had currency throughout Western history (in varying degrees and in various permutations). The relationship between beauty and art, on the one hand, and beauty and nature on the other, has not been a historical constant, each having been in and out of vogue at various times (Eco 2004: 9-10).

So why is beauty being considered in the context of heritage interpretation? One of the ways the somatic is conventionally considered in heritage interpretation is in relation to aesthetics and aesthetic responses. Tilden we recall felt bound to deal with 'beauty'. In heritage discourse, 'scenic values' have a place in natural sites and 'aesthetic values' have a place in cultural sites when determining significance. The heritage concepts of 'integrity' and 'authenticity' relate in a more general way to aesthetics and an aesthetic sense. Not only are heritage places sometimes protected for their aesthetic values – especially as examples of particular

architectural styles (for example, Roman Baroque, French Romanesque, British Neo-Classical, Australian Neo-Gothic) – it has long been recognized that aesthetic appeal is a feature of the attraction of visitors to heritage places. Tilden thought aesthetics didn't need to be interpreted; enhanced, yes, but not explained (Tilden 1977). Some writers like Alain de Botton give aesthetics an important role in travel, where he links aesthetics to somatic responses of destinations whether imagined or 'real' (de Botton 2002). John Urry, in his book on the tourist gaze, also thought aesthetics was important because it acted as a framing device in the way travellers 'see' and make meanings about places, especially heritage places (Urry 1990). For travel writers like Robert Dessaix, and I'm thinking particularly of *Arabesques* (2008), aesthetics is a quest, a companion, a seduction, a powerful energizer. Indeed, it is hard to disassociate aesthetics from a genre like travel-writing. The representations of heritage places rely extensively on aesthetics, especially and most obviously, in the way they are pictured. The examples are vast in number and include the ongoing, almost endless production of visual representations of Venice, the Athenian Acropolis, Siena, Delphi, Uluru-Kata Tjuta, the Alhambra in Granada, Chartres Cathedral, the Great Barrier Reef in Australia, the Canadian Rocky Mountains, the Lavaux cultural landscape in Switzerland, the Taj Mahal, Himeji Castle, Sukhothai, the fjords of Norway and New Zealand *ad infinitum*. It is difficult to think of a heritage place that does not attract an aesthetic response of one kind or another, positive or negative. Heritage sites, the world over, have been aestheticized into a vivid and memorable Western iconography of place that draws on a deep European tradition of landscape and cityscape image-making – paintings, drawings, prints, photography and film. The fusion of the aesthetics of representation and the direct perception of the aesthetics of a place contribute, in a continual process, to the aesthetic response of the visitor.

If aesthetics is a major part of the experience of heritage places (and of the visitor's response), then no further justification is needed as to why it properly belongs to the domain of heritage interpretation. However, 'unpacking' aesthetics in the context of heritage interpretation is not so simple. One way to do this is through the Western concept of beauty and I have chosen as my guide Umberto Eco's edited book *On Beauty* (2004). (Such a statement does not exclude an Asian or an African concept of beauty, to name but two; rather, it reflects the cultural orientation of the authors, Eco and his contributors, and myself.) Another way of regarding aesthetics would be though Denis Dutton's controversial thesis in *The Art Instinct* (2010) where he links aesthetics to the instinctive, to pleasure and to human evolution. However, for the purposes of this book, I'll let Eco be our mentor.

Understanding the dynamics of beauty as an embodied encounter, makes it possible to discern beauty's capacity within heritage interpretation. In some cases it may be a matter of unlocking the aesthetic qualities of a site by stimulating an aesthetic response and/or explaining it. In some cases it may be about enhancing the aesthetic values of a place. Playing music during a visit, or looking at artworks or photographs associated with a place, immediately come to mind. But there

are many other ways in which aesthetics becomes knitted into the heritage experience: performances at heritage sites, light and sound shows, food and dining experiences in heritage places, the use of film and video and, crucially, the way visitors photograph places. The digital media, heritage site, visitor melding is also, obviously, aesthetically mediated.

Deep historical-cultural resonances and how Westerners respond to beauty

The Ancient Greeks

Eco explains that the ancient Greeks had complex ideas about beauty. They recognized it as being linked to love and to what pleased the senses; they associated it with harmonious and symmetrical proportions. But they didn't think it was related to truth. The Greek philosophers were, on the whole, rather suspicious of beauty recalling the calamities wrought on them by the 'beauty of Helen of Troy'. The connection to the pleasure of the senses suggested beauty as something that could enchant. The Greek concern for moderation – nothing in excess – revealed an interesting twist to their aesthetic ideas. Pleasure and enchantment were forces that were thought to lead to chaos (something ruling the passions like those associated with Dionysus, god of chaos, wine and the theatre), and so ideal beauty, in contrast, was perceived in the stillness of perfect forms, especially in classical sculpture and classical architecture (under the patronage of the god Apollo). And so arrived the division between Apollonian beauty and Dionysian beauty. This division was to be rehearsed over and over in Western history: the beauty of calm, distant contemplation (of objects for their own sake) versus the beauty of terror, possession, madness and the lack of restraint (Eco 2004: 32-58). It would be incorrect, however, to assume that these ideas arrived in the twenty-first century CE from ancient Greece in an understandable form. How we recognize something like the Apollonian and Dionysian division has everything to do with our own culture and little to do with Greek antiquity. That we still find a resonance in the idea of beauty as proportion and harmony, or within excess, acknowledges our own understanding of beauty.

Medieval Europe

Medieval Europe – if we take the paintings, literature and architecture as a guide – responded to light and colour as the fundamental dimensions of beauty. Everywhere to behold was the use of dazzling primary colours. Light seemed to emanate from lavishly coloured illuminated manuscripts. Coloured light streamed through stained-glass windows in gothic cathedrals. The glittering mosaics in Byzantine and Italian churches yielded ethereal effects. Sumptuous clothing, shimmering jewellery and precious stones, and sparkling armour can all be seen in paintings. The Limbourg brothers' *Tres Riches Heures du Duc de Barry*

(1410-1411), extravagant in its rich imagery, is an epitome of such paintings. Treatises were written on colour, light and beauty. In the commentaries, light was often associated with God, who was seen to not only manifest Himself in the physical play of light across coloured surfaces, through windows and from within holy pictures, but inwardly as a spiritual light. Both divine and earthly beauty was, in medieval Europe and the Byzantine East inextricably related to light and colour (Eco 2004: 99ff).

Medieval aesthetics of light and colour was underscored by a not insignificant attention to ugliness, to monsters and to the Devil. As Eco writes, such ugliness was a 'requirement for beauty' (Eco 2004: 148) because the images of demons, fantastical beasts, monstrous deeds and frightening events made the beautiful more beautiful. They were not necessarily seen in opposition but rather as partners in creation, as in life. The beauty of light in a thirteenth-century church was part of the same world as the landscape of fear, dark forests full of grotesque and frightful creatures and spirits, and nightmare-inducing images of hell and damnation. These co-existing realms can be glimpsed in the sculptural decorations of Romanesque churches on the pilgrimage routes of France. Light streaming through narrow windows, perhaps setting the apse aglow, induced a sense of the divine presence, but to walk into this heavenly sphere required passing beneath images of the Last Judgement and the terrors of hell mounted over the doorway or painted on the rear wall of the church (Eco 2004: 131ff).

How do medieval concepts of beauty contribute to our understanding of aesthetic responses to places in the twenty-first century? The answer lies in the particular vocabulary that was introduced into European culture and which continues to resonate in our aesthetic responses today. This was the vocabulary of affect. Medieval aesthetics was rarely about a distanced contemplation of beauty – although contemplation itself was important – but was almost entirely about producing strong somatic reactions in the viewer. Both the divine effects of light in a church, for example, and the monstrous images of hellish worlds were not there to simply instruct and communicate a moral lesson (although they did and were used in this way) but more particularly they were designed to cause a strong emotional response. Arousal was critical and the 'success' of artistic enterprises was often measured in the efficacy of images and places to cause physical manifestations: to feel fear, suffering, repugnance, horror in the same places where the beholder could also feel elation, pleasure, grace, wonder and rapture.

Today, we experience such ecstatic reactions – delirious pleasure and sheer horror – in the cinema or at theme parks or bungee jumping or reading fiction. What's significant is the contemporary aesthetic somatic affect triggered by horror and action movies or in our reactions to walking in dark places. The language we use and the manner of conceptualizing such experiences re-invents something that resonates with medieval notions of affect. More importantly, the 'revival' of such aesthetic responses within the project of late modernity and scientific rationalism is simultaneously a critique of reason and progress and a celebration of the irrational and its deep-seated cultural appeal. The Harry Potter novels and movies and the

Lord of the Rings cinematic trilogy remind us of the power of our equivalents to medieval aesthetics: the visceral feelings of pleasure and fear – and so forth – in 'manufactured' aesthetic experiences that rely on imaginative engagement. Both in medieval Europe and in contemporary Western society these artefacts of affect are about excess and therefore the possibility of unpredictable response. Control is the antithesis of an aesthetic of the passions.

The Renaissance and the Baroque

Centuries after Europe had moved on from what is now conveniently called the 'medieval period' of history, the artifice of affect, of excess and abundance in representation designed to produce a visceral viewing experience 're-emerged' in another conveniently named period of history, 'the Baroque'. I write 're-emerged' because, of course, emotional responses to life and within life's experiences didn't disappear in the fifteenth century. Indeed, the clarity and geometry of art and design during the Renaissance was aimed at increasing the intensity of the relationship between the viewer and the object of the gaze – whether a religious painting, a religious or civic ritual or the ornately designed religious dramas of important feast days (Baxandall 1988). Perspective broke down the boundary between illusionistic space and the 'real' space of the viewer enabling a more ardent and more corporeal connection with the sacred. Masaccio's *Holy Trinity*, a fresco in the church of Santa Maria Novella in Florence, and dated 1425-1427, typifies this use of aesthetic effects: a painted image being a portal to the divine and inducing an intense spiritual/bodily affect (Bennett 2001) through its illusionism. In a sense the European Renaissance invented the viewer – or, as Norman Bryson memorably wrote, the art and architecture of Renaissance Italy 'incarnated the viewer' (Bryson 1983). All over Europe, Christianity in the fourteenth and fifteenth centuries was characterized by an obsession with the corporeal: with the sufferings of Christ, with greater realism in religious art, with a focus on the Eucharist, with an ever-increasing emphasis on ritual and on the miraculous. Leo Steinberg called it 'incarnational theology' (Steinberg 1996).

As part of the seventeenth century Catholic Counter-Reformation, the employment of representational excess to produce stronger aesthetic and spiritual affect (for they were fused) as part of the vocabulary of religion and the experience of religion was taken to new heights. It is impossible to avoid the Baroque in Rome and this constant eruption of baroque ideas of beauty into the twenty-first century reminds us about how the past is mined, celebrated, mythologized and evoked in the present. Two examples of baroque beauty are inadequate given the diversity and the complexity of the seventeenth century, even within one city, but they provide us with a taste of how beauty worked.

The first example is Andrea Pozzo's grand ceiling fresco (1685-1694) in the Jesuit Church of Sant'Ignazio. The technique Pozzo used was known as *quadratura* where the architectural elements of the church are meshed with painted illusionism so that it is almost impossible to tell where the 'real' architecture starts and ends

and where the painting starts and ends. Although painted on a flat ceiling, the extreme use of perspective creates a masterpiece of illusionism and the effect for the viewer is a heavenly vision that whirls and soars into infinity with figures dramatically hovering in mid-air amongst the clouds. It is meant to amaze. It is meant to surprise. It is meant to be dramatic and theatrical. The divine vision, the apotheosis of St Ignatius, is palpable and it's breathtaking.

The second example is a sculpture by Gian Lorenzo Bernini, *Apollo and Daphne* (1621-1622) now in the Galleria Borghese. The god Apollo, smitten by the beauty of Daphne, chases her in an attempt to satisfy his lust. As he reaches her and stretches out his hand to catch her, she calls for help from her father who transforms her into a laurel tree, no doubt much to Apollo's surprise and consternation. Bernini depicts the exquisite moment where Apollo catches Daphne but already her hands and arms are becoming branches and leaves and her legs the trunk of the tree. Apollo's face is serene – the transformation that we see, he does not yet register – and Daphne's face is frozen in fear and horror. Like the Pozzo ceiling, it is the dramatic and theatrical nature of the piece that forces our attention. Here is the penultimate moment of the story frozen like a photograph or a freeze-frame in a film. The surprise of the piece is enthralling and the tension between its absolute sculptural stillness, on the one hand, and its thrilling turmoil on the other, is transfixing. Angela Ndalianis has written a fascinating and important book called *Neo-Baroque Aesthetics and Contemporary Entertainment Media* (2004). In it she charts the ways seventeenth-century Italian aesthetic effects have been reconceptualized, recontextualized and re-invigorated in the contemporary, especially in cinema, computer games and theme parks, and, significantly, how the Baroque continues to provide a conceptual language and a palette of effects in the present.

Nature, landscape and aesthetic responses

The history of Western landscape art is a vast and intricate one involving so many places, so many traditions of representation and so many quite different ways of seeing and conceptualizing 'landscape' that no easy summary is possible (see Andrews 1999). However, in tracing the way aesthetic responses have become foundational to the heritage experience, certain parts of the Western landscape art story need to be highlighted and these include the panoramic, the neo-classical landscape, the sublime and the romantic landscape.

The panoramic landscape has enjoyed success in many historical contexts and in many cultures, east and west, north and south. Each time the perceptual machinery that gave rise to such representations was vastly different and it is of little value trying to seek overarching patterns. (One only has to compare a Chinese Ming Dynasty landscape with a twentieth-century western desert Indigenous Australian 'dot painting' landscape and a sixteenth-century Italian landscape to get an idea.) My interest is in the conceptual endurance of the panoramic across time and space and into the present and the associations this concept continues to perform. One

of the persistent characteristics has been the sense of scale, vast distances and spaces condensed into sometimes very small pictorial space. But the condensing does not reduce the enthralment of vastness and the smallness of the viewer so often dwarfed by his or her surroundings. The panoramic aesthetic continues to function this way: the feeling of being enveloped by the natural and the human-made world, the thrill of the vastness of panoramic views laid before us. The panoramic landscape continues to structure our feelings and emotional responses even when the historical impulses that can be traced in such responses may be completely absent. I think the current workings of the panoramic owe much to the Dutch landscape art tradition of the seventeenth century and the paintings of artists like Salomon van Ruysdael, Jacob van Ruisdael and Philip de Koninck. They established a visual and descriptive language that still has wide currency.

Neo-classical landscapes/places

The neo-classical landscape of the eighteenth century and the way it intersected with beauty is difficult to describe because of the number and variety of discourses criss-crossing both Europe's geography and the decades. What follows is therefore a very generalized idea of some of the themes that clustered under the term 'neo-classical'. Neo-classicism was not a hegemonic aesthetic response but co-existed with and was entangled with other aesthetic regimes in the eighteenth century, particularly Romanticism but also the Rococo. As the name implies, it sought inspiration from the classical aesthetic ideals of ancient Greece and Rome. Partly, this was to do with the emerging power of observational science in the eighteenth century and the application of science to the past with the development of classical archaeology. Partly, it was the application of an understanding of beauty in classical art as being about restraint, harmony, proportion, geometry, order, austerity and the rational. Partly, it was the resurrection of the ancient Greek idea of the beauty of nature and the beauty and pleasure to be found in nature. Put all these together and the aesthetics of landscape became associated with several ideas. Firstly, the aesthetics of ruins in the landscape, particularly ruins from antiquity (Greece, Rome and Egypt). This was novel in Western aesthetics and while it enabled a nostalgic response (dreaming of landscapes of the past in the face of evermore rapid changes brought about by industrialization and agrarian reform) it was also part of the scientific interest in documenting archaeological remains (Eco 2004: 249ff). Secondly, the topographic landscape, the pleasure and delight that arose from the recording and appreciation of topographical details rendered 'accurately'. This aesthetic response was particularly fuelled by the voyages of scientific discovery like those of James Cook and the desire to record and catalogue exotic and distant worlds (Smith 1989).

The antiquarian imagination of the eighteenth century, and its associated aesthetic power, has survived into the twenty-first century, albeit completely transformed. The presentation of cultural heritage sites is a good example of the reconstitution of an earlier aesthetic that provides a contemporary vehicle

for the visitor's aesthetic response. Today, many heritage places are a mixture of scientific conservation, infused with nostalgia for a past remembered fondly (but not often one we wish a return to), that emphasize details and objects and have a tendency to be presented as pristine or sanitized rather than messy lived-in environments. The 'ruin in the landscape' phenomenon is an aesthetic tradition that has been constantly reinvented in the Western imagination, whether in the Gothic landscapes of the nineteenth century, in horror stories, in the medieval fantasies of popular culture, as a powerful symbol of our mortality and so on. A visitor survey undertaken at Sokhothai World Heritage site in northern Thailand in 2004 revealed that the dominant response of Westerners to the site was the beauty of the ruins in the landscape. The phrase was used by 80 per cent of the 200 respondents without any prompting by the survey mechanism, but definitely prompted by guidebook descriptions of Sukhothai and travel blog descriptions (Lormahaomongkol 2005).

Romanticism

Like the neo-classical landscape, the romantic landscape defies easy generalization because of the variations across time and place, and the heat of academic argument about 'Romanticism' in many disciplines. I want to highlight a number of themes pertinent to the relationship between romanticism, beauty and the heritage experience. Historically, romanticism has been linked to the growing urban industrial middle classes who were the great patrons of romantic artists, poets and composers. Raymond Williams, in his classic study *The Country and the City* (1975), argued that in Britain industrial progress and innovation was seen as having its genesis in the natural world, the site of the resources that were sustaining industrialization (and therefore wealth generation) and the crucible of genius and inspiration. No wonder then, the happy relationship between 'nature worship', art and urban power. The art historian Bernhard Smith, considering the effect of the South Pacific on the imaginations of explorers and scientific expedition leaders, has also argued that the images and descriptions of exotic and idyllic societies set within lush tropical landscapes brought back to Europe a vocabulary that was immediately absorbed into romanticism (Smith 1989). So what is a romantic aesthetic? This is where it gets complicated because there are many strands of cultural production and reception that now bear the descriptor 'romantic'.

Eco's attempt to describe nineteenth-century romantic beauty begins in the following way. Romanticism was about giving free rein to the experience of contradiction and paradox by using, equally, reason and the emotions in an appreciation of the exquisite bitter-sweet and sensual beauty of the eternal tensions between the infinite and the finite, between body and soul, life and death, action and inaction, form and formlessness, heart and mind, good and evil, whole and fragment (Eco 2004: 329ff). The romantic experience was, in turn, itself characterized as involving opposites sometimes simultaneously and sometimes where one became the other and vice versa: joy and melancholy, humour and tragedy, the carnal and the spiritual, the macabre and the inspirational. Romanticism was a state of mind

that was triggered by an aesthetic contemplation of the world where the power of subjective emotions, intuition, feelings and imagination was deemed supreme.

Eventually, the movement in all its diversity embraced literature, the visual arts and music, and, perhaps most significantly, a way of being in the world. This is one of the reasons why romanticism has been linked to Western travel and tourism, not just because of the legion of writers and poets and composers and artists who travelled as part of their aesthetic explorations, but because of the way romanticism in the era of late European imperialism became a vehicle for the aestheticization of the exotic 'other', especially the peoples and places of north Africa, the Middle East, Asia and the South Pacific. One only has to look at the paintings of Jean-Leon Gerome (1824-1904) and Paul Gauguin (1848-1903) to get an idea of this process. In the twenty-first century these largely, but not exclusively, Western orientalist fantasies have been refashioned by the tourism industry and many heritage sites are not immune from the unholy alliance between romanticism, aesthetics and orientalism (cf. Winter 2007). Therein lies a considerable challenge for heritage interpretation.

In the visual arts, despite the enormity of the archive, I dare to select just one example of romanticism. In 1819, Theodore Gericault displayed in a Paris salon (now in the Louvre, Paris) his vast 491cm × 716cm painting *The Raft of the Medusa*, with its larger than life-size figures. At the time, it was a sensation. The picture depicts a harrowing story. The ship *Medusa*, had been shipwrecked off Mauritania with 400 people aboard, including 160 crew, but there were only 250 places on the lifeboats and so a raft was built for another 146. Seventeen crew members elected to stay with the *Medusa*. The lifeboats began by towing the raft but, not long after setting off, it was abandoned to its own fate with little in the way of supplies. After 13 days of starvation, dehydration, mutiny, murder and cannibalism, 15 of the original 146 survived. It was a despairing and tragic state of affairs. Gericault chose to paint the moment when, way on the distant horizon, a ship, the *Argus*, is spotted. The raft is shown to be dangerously low in the water, some of the figures seem barely alive, others sit looking out despondently, one body is half-submerged and sharks circle menacingly. Those on board, and still able, create a seething triangle of desperation, figures rising up to frantically wave a pathetic handkerchief in the seemingly vain hope of attracting the attention of the passing *Argus*. The hopelessness of the situation is without resolution and the futile gesture, frozen in time, extenuates the agony the viewer feels. Audiences in 1819 did, however, know that those fifteen survivors were, indeed, improbably rescued.

When we stand looking at the *Raft of the Medusa* in the twenty-first century it still has the capacity to trigger strong emotional responses, especially in the context of the Ang Lee movie *Life of Pi* (2012). The story of being stranded, set adrift, facing mortal danger, dealing with terrible circumstances is far from unknown, and equally understood is the way our emotional responses are structured by the experience. Our capacity to name how we feel is partly a debt to the aesthetic language we have inherited and partly a debt to the way aesthetic responses continue to be manufactured and consumed. The emotions are our own. What we

call them and how we describe them is something else. Today nineteenth-century romanticism has been recast many times by the experiences of the twentieth century, including the advent of cinema and popular culture. However, even in this brief and inadequate description we can glimpse the way nineteenth-century aesthetic sensibilities have travelled into the contemporary and continue, in their new guises, to inform and shape our own aesthetic responses. The 'romantic' still has considerable currency.

The sublime

The sublime was originally considered in relation to the experience of nature and has traditionally been regarded as a sub-set of romanticism. For Edmund Burke, the Anglo-Irish conservative politician and philosopher, the sublime was a sense of pleasurable terror. What he meant was fear, anxiety and terror experienced in a detached manner. The viewer was not expected to *feel* fearful or terrorized because the terror being apprehended was not one that could possess or harm (Eco 2004: 281ff). While nature experiences can still evoke such feelings, the sublime that Burke described is difficult to appreciate today. An equivalent is probably the rather detached way we watch dramatic and tragic events on television, the detached horror of watching, for example, the planes crashing into the World Trade Center in New York in 2001. The important point is not the particular formulations of the sublime, but the aesthetic responses to nature and the power of such responses: on feelings; on our sense of beauty (and ugliness); on our emotions; on how we think about ourselves in relation to the experience; on our ideas about 'nature' and so forth. But below, before and simultaneously with these significations is the power of affect (as described by Massumi) – *intensities* as physiological responses to the movement of the body *through* nature (Massumi 2002).

The sublime is still often evoked in travel promotional material and as an adjective for experiences. The critical question is whether an experience designated as sublime, needs anything more in the way of interpretation. In conventional heritage interpretation, an aesthetic response is often regarded as a powerful prelude or context to on-site learning rather than being an end in itself. Along with all aesthetic responses, the sublime is *already an interpretation* – and a deeply, culturally inscribed one at that. Anxious or even fearful feelings/ responses are usually considered negatively in terms of heritage interpretation, something to be counteracted by an experience that shifts the viewer-visitor from anxiety to an ostensibly more productive relationship. I am not convinced. Fear, anxiety, terror in terms of the sublime aesthetic are also considered pleasurable. It is the pleasure of the thrill of fear or terror. Bungee jumping and white-water rafting come immediately to mind. So too does Bell and Lyall's analysis of the accelerated sublime (Bell and Lyall 2001). These are complex relations to nature and connections to place. And such connections have a history of representation, some of which continue to circulate and continue to have considerable efficacy.

Democratization of Western aesthetics

Finally, via Eco et al., I want to touch on the democratization of aesthetics in the twentieth century. Like earlier 'movements', this is a vast, various and complex terrain that cannot be easily summarized and so I want to register this cultural process by touching on two Western loci. Firstly, the beauty associated with ingenuity, technological progress and design, knowhow, achievement, scale and speed. This aesthetic of enthralment is associated particularly with transport (ships, trains, the automobile and airplanes) and engineering feats (bridges, the Eiffel Tower, machinery). In many ways the aesthetic responses of earlier Western times and places has been re-invented, restructured and attached to 'new' phenomena emblematic of the viewer's 'times'. The thrill of trains speeding through the landscape or the awe felt gazing up at the Eiffel Tower draw on the conceptual language and structuring of feelings associated with the sublime, with romanticism, with ancient Greek ideas about proportion, with baroque ideas about affect and so on. The importance of this process lies not in their historical precedents, although I find such re-inventions and aesthetic restructuring fascinating, but in the social movement and distribution of aesthetic concepts from the language of the rich and powerful to that of a wider audience less variegated by social class, gender and geography in terms of *access* to this aesthetic architectonics.

Secondly, the beauty associated with the quotidian. There are several strands to the structuring of this aesthetic sensibility: the beauty of 'ordinary' architecture (houses, commercial buildings, civic buildings, sports arenas, theatres and so forth); the beauty of ornamentation and decoration linked to function, modernity, progress, technology and the mass produced (art nouveau and art deco, for example); and the beauty associated with celebrity (Eco 2004: 264ff).

The spread of aesthetic concepts and responses to an enormous array of objects and media signified a considerable de-coupling of aesthetics from the ideologies of wealth, capital, social status, acquisition and accumulation, cultivated taste and so forth. This is not to say that the beauty 'found' in photographs of Hollywood legends, pop stars or gay sex and race by a photographer like Robert Mapplethorpe, or associated with fashion, with advertising, with electrical appliances and furniture design, with the marginalized and the so-called 'Third World' (everything from Benetton marketing to the 'aestheticization' of poverty in National Geographic images and films like *Slum Dog Millionaire* (2008)) has been ideologically benign. This is clearly not the case. Rather, what is important has been the widespread application of aesthetics to an ever-expanding number of contexts without, I would suggest, aesthetic value losing its efficacy. I can be aesthetically aroused by a Mapplethorpe photograph, by *Slum Dog Millionaire*, by a Mozart opera, by a Cezanne painting, by a television advertisement for Qantas Airlines, by a view of a sunset as I sit in a café on the western shores of Sri Lanka, by an art deco lamp, by the Sydney Opera House, by a Eurostar train hurtling through a Tuscan landscape, by the Melbourne Cricket Ground, by Thai cuisine under the guidance of David Thompson, by a row of terrace houses in London or

Melbourne, by the interior of a Balinese hotel in Ubud, by a group of monks sitting under a tree in a Luang Prabang monastery, by a vase of orchids, by the fashion of Ikira Isogawa, the Japanese-Australian designer.

The democratization of aesthetics has been extraordinarily important to the history of heritage because now there is a language and a conceptual framework to inform, structure and describe the aesthetic responses to an increasing array of objects, places, monuments and landscapes. What Eco's analysis of beauty reveals is that aesthetic mediations are, simultaneously, a culturally inscribed resonance, a learnt way of describing feelings, emotions, relationships and understandings of the self/world embodiment, as well as being a process of structuring these embodiments. The heritage/aesthetics interface is not only complex and diverse, it is dynamic, open-ended and without any predetermined destination. The *power* of aesthetics cannot be underestimated (and certainly not ignored) and so any re-imagining of heritage interpretation that attempts to enfold aesthetics and the somatic into itself must necessarily enlarge its conceptual reach and its practices.

Beyond the logic of things

Many guidebooks to heritage sites gesture towards the sensory/aesthetic and express in a limited way what seems to be a struggle between sensation and cognition. The 2009 edition of the Lonely Planet guide to Sri Lanka, for example, describes a visit to the World Heritage site of Galle, the fortress town on the south coast built by the Dutch in the seventeenth century and extended by the British in the nineteenth. 'Galle', the authors write, 'is a town of colour, texture and sensation … an experience to savour, taste and touch rather than a list of prescribed sites' (Atkinson 2009). It's an interesting tension, but a false one.

The critical question is whether heritage is there simply to be understood. I think that, like works of art, heritage is not there just to provide knowledge in a direct way, rather it's about a whole series of interconnections and networks that encourage a multitude of responses and even deepened experiences, deepened reflections and a heightening of the senses. Heritage is more than logical things and more than the logic of things. In Chapter 1, I suggested it was about *intensities*. This is why I pay particular attention to the rhetoric of heritage interpretation when the word 'enhancement' is employed. Mostly, 'enhancement' is used in the context of disciplinary knowledge, enhancing our understanding or our appreciation or the significance of a site or monument or object or ecosystem. But such enhancement always moves towards things that can be learnt and measured or towards 'knowing the visitor', or both. For me, enhancement signals not learning but the embodied experience of 'conjuring' heritage *in play*, something somatic, sensual and desiring, something aesthetically engaging, something about a choreography of self *wrestling* with the materiality of places and objects.

In this way, heritage interpretation is part of other realms of experience, especially the visual and the fictive. And it is to these that we now turn our attention in more detail.

Chapter 4
Visual cultures: imagining and knowing through looking

Imagining and imaging heritage places

Imagine Venice. In Thomas Mann's acclaimed novella, *Death in Venice* (in German 1898, in English 1928)*,* the ticket seller at the port where Aschenbach buys his passage to Venice sighs, 'Ah, Venice. A splendid city!' (Mann 1998: 210) Ah, Venice indeed! To readers or listeners, what does the word 'Venice' do? Invariably, it immediately conjures a combination of sensations but one of the dominant aspects of the conjuring will be a visual one, even for those who have never been to Venice. It is the same for all those places that have a widespread distribution and consumption of their imagery. Think of New York or Paris or Jerusalem or Rome or Istanbul or the Pyramids of Gaza or Uluru or the Great Wall of China or the Grand Canyon. In a very real sense these places are 'iconic'. They have such a well known set of visual images associated with them they exert a type of pictorial power. The very use of the term 'icon' betrays an intended association with icons, the religious images that have such a central place in Orthodox Christian worship and ritual. In the Orthodox tradition, images of Christ, the Virgin and the saints are more than just a pictorial likeness, but an image connected mysteriously and powerfully to the prototype, to the person depicted. Thus icons are power-laden images, portals to a spiritual world. 'Iconic', in a heritage sense, is therefore meant to convey strong semiotic associations, strong emotional and sensorial responses, a pre-eminence that is the fruit of widespread recognition and identification. And underpinning all this is a strong visual idea of the place or monument or landscape or object. When we imagine Venice we 'see' something using our mind's 'eye' (McGinn 2004).

The conjuring of places, however, can fall very short when there is little or no imagery to access. But even when this is the case, a description will immediately stimulate a mental visualization. Robert Dessaix's book *Arabesques* (2008) describes places I have never visited and for which I do not have a strong visual set of references, and yet the combination of pictures, sketches and radiant descriptions in the book evoke a world that is both immediately visual and sensory. The reader grafts other recalled images onto what Dessaix provides and describes so that the act of reading becomes a way of intimately accessing a visual sense of North Africa, of Algiers and Morocco and, later in *Arabesques*, Normandy, the south of France and Naples. For me, this grafting involved a vivid mixture of images drawn from paintings, photography, cinema and television – everything from the exotic

and sensual orientalist art of Jean-Leon Gerome and the other Orientalists, to pictures in *National Geographic* or *Gourmet Traveller*, the Bernardo Bertolucci's 1990 film adaptation of Paul Bowles' novel *The Sheltering Sky* (and, of all things, one of the Indiana Jones movies), and a CD-Rom of photographs my brother took on a recent trip to Morocco. It is significant that this visual recall is not limited to the 'real'. Fiction plays its part.

Another book by Robert Dessaix, *Twilight of Love: Travels with Turgenev* (2004), begins in Baden-Baden. I knew nothing about Baden-Baden but the visual clues began immediately to produce a mental picture I could inhabit. A river, Germany, a railway station, 'blue-green hills', a cobbled street, 'crooked streets' and 'a castle on a crag'. It is enough to produce an image, however unlikely. I had no trouble remaining geographically ignorant while Dessaix described his wanderings in Baden-Baden because in my mind I invented an image of a place as I read his rendition. Eventually, after Dessaix's travels with the Russian writer Ivan Turgenev had moved on from Baden-Baden, I decided my ignorance was unacceptable and used Wikipedia to provide not only a location (southern Germany) and a short description but also a number of photographs. As a result, my own mental imaging was nourished by something more topographical but not to any great degree because the few photographs available were fairly nondescript. Interestingly, my mental picture of a 'castle on a crag' was far more architecturally exotic than the one I found in Google Images. My imaginative castle was a ruined Gothic confection perched on a precipitous cliff and, I suspect, influenced somewhat by the architectural fantasies of Ludwig II of Bavaria! Compared to the 'real thing' I could have happily stayed with my imagined picture of Baden-Baden.

Despite the sensorial experience I described in the previous chapter, and despite the criticisms that the visual has been over-played at the expense of the other senses in Western knowledge (the ocularism of the vision-knowledge relationship has enjoyed a pre-eminence in Western thinking) (Pallasmaa 2005; Foster 1988), it is hard to ignore the role of vision and visuality in both heritage discourse and in heritage interpretation. Indeed, throughout the preceding chapters, the visuality of heritage has been emphasized with numerous examples that depend on a picturing of places, objects and monuments and in quite a number of cases the object being discussed has been a painting, something that is both a heritage object and an image. John Urry's book, *The Tourist Gaze* (1990), was not, by any means, the first to explore the role of seeing, looking, viewing, observing, sight-seeing (and so on) in relation to travel (see, for example, Smith [1960] 1989), but it was the first widely read study that provided a bridge between cultural theory, visual theory, tourism and heritage and, in particular, the nexus between knowledge, power and vision within the context of tourism including heritage tourism. Looking at things, it turned out, proved to be neither naive nor benign. Given this, it is surprising how little attention has been given to vision and visuality in heritage interpretation. The 2008 ICOMOS *Charter for the Interpretation and Presentation of Cultural Sites*, for example, is completely silent about it. Certainly it mentions

visual displays, visual reconstructions of archaeological and historical sites and the use of multi-media, but on the role of vision and visuality in the interpretation of heritage, nothing. This is perhaps even more surprising given the rapid growth of visual culture studies in the Anglophone academy (see, for example, the visual culture reader compiled by Evans and Hall 1999). And visual cultures are but the beginning. Terence Wright begins the preface to his 2008 book *Visual Impact* with this far-reaching claim:

> In today's media age the visual image has become the predominant mode of communication. Indeed, for most people, pictures have become the primary channel through which we gain knowledge of the world. (Wright 2008: ix)

I want to begin by firstly exploring the conceptual language that has grown around the visual, terms like 'vision', 'visuality' and 'visual cultures'. This will provide me with a means of describing and analysing heritage as something circumscribed by visual cultures and, therefore, having clear implications for heritage interpretation.

Vision and visuality

What, then, is the distinction between vision and visuality? The arguments are theoretically quite dense (Foster 1988) but one way of regarding these terms is to distinguish between pre-epistemic seeing and epistemic seeing. Pre-epistemic seeing involves the way we use vision to navigate the physical world. This is an automatic and relatively unconscious connection between, for example, seeing and mobility where our eyes are linked to the motor functions of the brain. This allows us to navigate through the world of hard objects without bumping into them, to kick a football, to play tennis and so forth. It's the type of seeing that we use to walk around a museum or to wander around a heritage site. On the whole, I'm less interested in this type of vision/seeing in this chapter. Although, in saying so, I'm mindful of just how important it is and I'm not in the least underplaying its significance. Perception psychology in recent years, especially following the work of James Gibson (1979), has shown that pre-epistemic seeing is not only embodied but is organically linked to our other senses and that our eyes/bodies register phenomena directly and in a complex manner as our eyes dart about feeding visual information to the brain in a constant process of body/place interaction. Equally, Gibson's work illustrates that the distinction between pre-epistemic seeing and what I call epistemic seeing (see below) is conceptually significant because the separation produces an understanding of the various ways vision works and the inter-relationships between the visual outputs of human creation (pictures, photographs, films, graphic design, computer-generated images and so on) and the role of images and the visual environment in our understanding of the world (Wright 2008; Burnett 2005).

Epistemic seeing is the looking that we do with a question in mind: 'seeing how', 'seeing why', 'seeing that'. This type of looking is linked to knowledge, thus the term epistemic to describe it. Because of the linkages between knowing and looking, epistemic vision is culturally inscribed; that is, it is imbued with all sorts of cultural learnings and cultural assumptions or, as writers like Urry have said, it is a type of vision that is unavoidably through the prism of culture (Urry and Larsen 2011). The epistemic type of seeing is what produces visuality. Visuality is a term used to link together seeing, knowledge, power, culture, ideology, the observer and the observed, identity, subjectivity and visual representations. The latter, visual representations, is a crucial part of the process and is fused with this type of looking irrespective of whether the representations be photographs, paintings, films, sculpture, drawings, designs, cartoons and so on. But this is not to argue that perception precedes and controls representation, something that is clearly not the case as Norman Bryson has persuasively illustrated (Bryson 1983). Visuality is also the domain of the gaze, a word that has been so variously used in recent decades: the male gaze, the female gaze, the racialized gaze, the orientalist gaze, the Western gaze, the colonial gaze, the erotic gaze, the gaze of surveillance, and so forth. The gaze in its widest sense – rather than the more precise uses of the term by theorists like Michel Foucault, Jaques Lacan, Laura Mulvey (and so on) – is the attempt to describe a type of looking that is linked to power, knowledge and subjectivity. It illustrates that no purposeful looking is naive. Purposeful looking is always linked to powerful cultural forces that can be creative and/or destructive, liberating and/or subjugating, enlightening and/or intolerant, active and/or passive, the and/or signifying that we are always both looking and being looked at (see Brennan and Jay 1996). Recognizing this in the context of heritage spectatorship is, I would argue, quite critical (cf. Waterton and Watson 2010; Crouch and Lubbren 2003).

For a first-time Western visitor to South East Asia, going to a Buddhist temple, whether in Laos, Cambodia or Thailand can be an ocular experience that is extremely complex, as too would be a first-time Laotian visitor's visual experience of a Catholic church in Italy. For the moment we will assume both are heritage sites (for example a temple in the centre of Luang Prabang in Laos and a church within the city walls of Siena in Italy). The looking in each case may be characterized by awe and the triggering of aesthetic responses the visitors have learned; by a process of visual comparison where the 'new' is compared with the sacred buildings they are accustomed to; by a sense of powerlessness (of not understanding what it is they are looking at or feeling at a disadvantage in some way); of being conscious of the stares of the locals and therefore a sudden self-consciousness about their looks and their behaviour; by the rush of visual information (and the meanings of this information) that comes from an encounter with a 'new' visual environment; by emotional states induced by both seeing (and the other senses working in concert) and being seen.

In all of this we can appreciate the way culture, knowledge, our identities and the way these are embodied in the viewer/visitor are brought to bear in the

ocular experience. And in saying so I am not discounting non-visual experiences nor blindness but pointing out how, in contemporary heritage visitation, visuality is, generally speaking, a foundational way of engaging and negotiating the perception, the meaning of and the emotional responses to an object, a monument, a landscape (Waterton and Watson 2010). Heritage interpretation, as currently defined, addresses the visitor/knower rather than the implications of the visitor/ observer. Is there a difference? Yes, because 'looking' encompasses far more than educational activities and, unlike heritage interpretation, asks questions about how surfaces, objects, landscapes and places become visible, come into focus for the viewer, become legible and about the active role of culture in this interaction. While vision is universal, the processes of 'seeing how', 'seeing that', 'seeing why' are not (Wartofsky 1980). By regarding visibility as a culturally inscribed process, I am recognizing the critical role of visual perception in the heritage experience and in its cognition. Such an analytic also alerts us to the idea that, through purposeful viewing, perception and/or understanding and/or contemplation is not necessarily language-based. This is why visual interpretation is increasingly considered so important, especially in the age of digital media and in an age of global travel.

Visual culture is a much easier concept to define, despite the various theoretical ruminations on offer (see, for example, Mirzoeff 2002; Evans and Hall 1999). Firstly, visual culture pertains to the total visual environment: all visual media (paintings, drawings, prints, mosaics, photographs, sculpture, architecture, film, television, graphic design, digital images, poster billboards and so on), the technologies of vision and the techniques of observation (for example, cameras, telescopes, microscopes, computers and graphic software, pens and pencils, print-making) and vision and visuality (as already described and including the ways we learn to visually respond to the world – for example, aesthetics as a way of seeing, landscape as a way of seeing, cartography as a way of seeing). Secondly, it includes the study of the visual environment as a field of knowledge. This includes visual signifying processes, the relationships between image and text, the nature of visual representations, the production, circulation and consumption of visual entities, the history of scopic regimes, the institutionalization, the politics and the economy of visual material and so on. Together, all these things in their dynamic interaction produce a visual culture and, because these things are all situated temporally and geographically, then it is sensible to refer to visual cultures in the plural. It is not difficult, for example, to understand what is being referred to under rubrics like 'Nineteenth-Century Japanese Visual Culture' or 'Fifteenth-Century Italian Visual Culture' or 'Contemporary Australian Indigenous Visual Culture' (even taking into account the problematics associated with such categorization).

Although I have never seen the term, it is reasonable, therefore, to think about a 'heritage visual culture', not in an attempt to define yet another *type* of visual culture but to highlight a way of proceeding. Heritage places, objects, monuments and landscapes can be regarded as part of the visual environment, as a way of

'seeing' the world, as the subject of countless visual media representations, as the product of visual technologies, as part of vision and visuality, and as an incredibly powerful way of visual knowledge formation (cf. Waterton and Watson 2010).

Images, image-making and pictured vision

Heritage is, on one level, a scopic regime. Indeed, the whole heritage enterprise depends on forms of visualization. There is the mapping and pictorial documentation (images, diagrams and models) of sites and the ways these representations are analysed and become producers of knowledge (whether it is by archaeologists or architects or conservators). There is the history of these visual records so that today's Egyptologists facing increasing environmental and human degradation of sites refer back to earlier drawings, paintings, photographs, maps and diagrams in their work, especially the records of those who came with and just after Napoleon Bonaparte, and they note discrepancies and varying interpretations (see, for example, Fletcher 2004). To this archive is added the results of newer imaging techniques like satellite photography, digital scanning and computer-generated images. Visualization is, therefore, a way of knowing (the monuments of ancient Egypt) and also recording (these monuments). The various visual representations, in turn, create a visual ecology – a term I've borrowed from the perception psychologist and theorist James Gibson (1979), but used here very differently – within which material culture is given a particular visibility and visual identity. When we stand amongst the enormous columns of the Temple of Karnak our looking is a process informed and produced by our visual environment: pictures in our guidebook, the maps and diagrams we may have accessed, even perhaps the 1978 film *Death on the Nile* (with Peter Ustinov, Maggie Smith, David Niven and Bette Davis), the procession of images in tourism brochures and magazines, and the countless television documentaries over the years. Karnak has visibility; it is far from an unintelligible visual experience.

Marx Wartofsky, the photography theorist, has convincingly argued, although contentiously, that the world we 'see' (as in epistemic seeing) does not resolve itself into something legible and intelligible until that seeing is informed by representations that we understand and the representational technology that produced it (Wartofsky 1984, 1980, 1979). Wartofsky and others, such as the highly influential art historians Norman Bryson (1983) and Sveltana Alpers (1984), have shown that our Western vision is pictured. What they mean is that our looking is highly influenced by what we understand to be a 'picture' so that one of the characteristics of heritage visual culture is identifying heritage places and monuments as already composed pictures. Or, as Bella Dicks has more recently written, places must necessarily compose themselves into a scene if they are to be recognized, understood and be ripe for consumption especially photographing them with our digital cameras (Dicks 2003). This only happens because we know what a picture is. So the representational machinery informs the way we see and

helps us make sense of that seeing. We cannot understand a picture until we know what a picture is and does.

Similarly, as Gibson demonstrated, spatial depth in a picture achieved through geometric perspective systems, and after 500 years of use in Western picture-making, has become a concept for the way we *understand* depth in our seeing. (The two are actually quite separate and yet we erroneously use perspective to *explain* the optical experience of depth (Gibson 1979).) The same goes for maps, diagrams, graphs, films, X-rays, CT scans and so on. For a very long time, viewers had no idea what to make of the shapes at the end of a microscope tube until microscopic images were understood as such, then the shapes became intelligible. This is what Jonathan Crary called the 'techniques of the observer' (Crary 1990); we understand the visual because we understand the techniques we use to observe the world and the machinery of representations that brings the world into focus. So when the visitor has an 'ah-hah' moment of joyful recognition of the Temple of Karnak it is never a matter of simply seeing it in the physical sense of 'merely' using our eyes and it's not just a matter of visual recognition, it is because visibility works in a particular way within Western visual culture. And even if we had never heard of Kanak, as we sailed along the River Nile towards the massive structure, our techniques of Western observation would already be attuned to seeing an individual historical monument because our vision is always, already pictured. Or, as John Urry suggested, our looking at heritage monuments is 'framed', but not just by historical or orientalist or romantic or heritage (or whatever) *discourses* as Urry and Larsen write (2011), but also framed by our techniques and technologies of observing.

Nigel Spivey, in the fascinating BBC series called *How Art Made the World* (2005), and in his accompanying book, was interested in the ways visuality and visual representations came to work, the circumstances under which the technologies of vision and visuality entered into human history. For example, there is virtually no record of humans making images until about 35,000-40,000 years ago. This means human societies had existed for some 100,000 years before images contributed to the ways we inhabited our environments. In the twenty-first century it is impossible to imagine a world without images. The earliest rock art in South Africa (the work of the San people, now long gone, in the Ukhahlamba-Drakensberg Mountains, a World Heritage site) and Europe (the images in the caves of Spain and France, Lascaux being the most famous) seem to have not been visual records of the world around the artists – because to picture something requires a knowledge of pictures and picturing – but records of hallucinations arising from trances. However, once these records were made, then the idea of a picture was born. Humans were able to make pictures because they knew how to picture their seeing and in turn their seeing was 'pictured'. It's important, however, to realize the idea of pictured vision is also shorthand for the various other ways our observing-knowing of the world is culturally inscribed. Equally our vision can be described as cartographic or topographical or landscaped or that of the spectacle and so forth. So a reference to 'pictured vision' is equally a reference to these other types of visuality.

If purposeful seeing is 'pictured' then the 'picture' becomes a template for the visual perception and interpretation of that being observed. Consequently, an insight into the interpretation of images can provide an important insight into the visual interpretation of optic experiences. This raises the important possibility of heritage interpretations occurring as part of the operations of a visual culture that are, theoretically, independent of language-based interpretations. I say 'theoretically' because one of the complexities involved with epistemic or purposeful seeing is the mediation of texts and text-based knowledge. John Berger, in the book that accompanied his groundbreaking television series *Ways of Seeing* (1972) for the BBC, wrote 'Seeing comes before words. The child looks and recognizes before it can speak … the relation between what we see and what we know is never settled' (Berger 1972: 7). Michel Foucault memorably wrote that 'what we see does not reside in what we say' (Foucault 1973: 9) and, conversely, what we say does not reside in what we see. He, like Berger, was referring to the different epistemological frames of image and text. The referent in images is other images and the referent in text is other texts. In other words, when our pencil is poised to draw a sketch what we think about is images and when our fingers are poised above the keyboard to write a description we think about language and text construction. Nevertheless, despite this important observation about representational difference and the separation of visual meaning-making from textual meaning-making, image and text are forever entangled because of our propensity to use language to *explain* visual experiences. We email a friend a picture taken while visiting the Exhibition Building, a World Heritage site in Melbourne, Australia (or post it on a Facebook site), and we describe in words aspects of the picture, perhaps some information about the building or a note about the circumstances of the visit or a reflective description. However, even as we do this, we recognize that words cannot easily replicate the visual and vice versa. But together word and image work powerfully as a form of dual representation. Indeed the desire to translate the visual into language is part of an important characteristic and dynamic propensity of all visual cultures: the interpenetration of the visual with other performative modes of cultural expression. (Film is the obvious example but so too all the performing arts.) This propensity of image and text to work together is not to suggest a dependency of the visual on the textual and vice versa. To paraphrase Foucault, they are not the same order of things. With this in mind, let us examine the interpretation of images as *one* way of understanding the interpretation of optic experiences.

Visual art theory and interpretation

In visual art theory there are, very generally, two dimensions to understanding images and image-making. Firstly, there is iconography. Iconography is the term most often used by art historians to describe the interpretation of images. It literally means, from the Greek, to write (*graphia*) about likenesses (*eikon*) but, in the

course of the development of the visual arts as a field of knowledge, iconography generally relates to the subject matter and the meaning of images. Iconography also refers to the way images affect the viewer, how the subject matter can stimulate responses in the viewer (for example, see Nelson and Shiff 1996). Secondly, there is the image-making itself. For the purposes of the present discussion I will call this 'image construction'. The techniques of image construction include composition, materials, tools and techniques, colour, texture, design and so on. In visual art theory, the techniques of image-making are often treated separately to the subject matter of the image, its iconography, although they are very obviously inter-related and in the *practice* of image-making the two coalesce indissolubly.

Hanging in the Minnesota Institute of Arts is a landscape painting by Claude Lorrain the seventeenth-century artist who, although French, spent most of his working life in Italy. The painting is called *Pastoral Landscape* and was painted in his studio in 1638. Claude's fame was that of a landscape artist and he painted many pictures on the pastoral theme. John Barrell, in his *The Dark Side of the Landscape* (1983), a study of eighteenth- and nineteenth-century landscape painting, credits Claude with the formularization of European landscape painting techniques into a general schema that was to hold sway into the era of photography. Claude's *Pastoral Landscape* exhibits many of these characteristics. In constructing his image, Claude has used the following visual techniques:

1. The canvas he selected was rectangular in shape and therefore could be envisaged, metaphorically and symbolically, as a 'window' that positions the artist and the viewer as looking out of the window onto the scene before them. This device separates viewer from the viewed, as though the viewer (invisible but assumed) is external to that being looked at, something referred to as the 'magisterial gaze' because of the power relationships involved.

2. He has drawn a horizon line horizontally across the canvas about one-third of the way up the picture plane. This construction line, although now invisible, can be easily deduced from the line created by the lake's edge in the distance where it forms a horizontal line with the cliffs that rise up from the lake.

3. Two diagonal lines would have been drawn from the bottom-left and bottom-right corners of the picture to intersect with the horizon line. These can be gauged from the ∧ shape formed by the shores of the lake as they retreat from the shoreline in the foreground. The diagonals that meet on the horizon create the so-called vanishing point of the picture, the point in the distance where visibility is no longer possible because of the distance from the viewing position, a bit like two parallel train tracks seeming to fuse at a point on the horizon. The triangle Δ formed by the base of the picture and the diagonals creates the grid of perspective along which Claude controlled, precisely, the scale of objects as they receded into the distance away from the viewer.

4. The eye of the viewer is constantly drawn to the focus of the picture, generally the centre of the composition. This is done using a variety of techniques. Firstly, the left-hand side diagonal is made the stronger of the two diagonals (see 3 above) by emphasizing the line that extends from the sheep on the left through the base of the ruined temple and along the edge of the lake into the centre of the picture. Secondly, this direction to the viewer is emphasized by the gesture of one of the seated figures in the foreground seen raising his arm pointing vaguely towards the centre. Thirdly, the temple on the left and a clump of trees on the right frame the scene. This prevents our eyes, already moving from left to right, from wanting to move out of the picture frame on the right. The clump of trees halts this movement and forces the viewer's gaze towards the centre. Fourthly, the centre of the picture is painted in pastel shades as though the landscape is infused with light, while the foreground is in darker colours, in shadow and with quite textured surfaces, consequently our eyes are drawn irresistibly to the highly luminous centre.

5. Throughout the composition there is quite a pronounced zigzag effect. This counters the devices that drag the eye to the centre and forces the viewer to keep returning to the scene at the foreground of the picture, the pastoral subject of the landscape and, in this case, the two relaxing figures, presumably shepherds tending their flock of sheep and with one playing what looks to be a flute. The distinctly red hat of the flute player and the reddish coat of his companion is the only use of red in the picture and this also forces our eyes to return again and again from the illuminated centre of the picture and the distant hills of the scene to the two seated figures.

For over two hundred years this approach to landscape painting has informed Western art and while there were always exceptions and variations[1] the basic schema entered the visual language of Western painters and viewers. Indeed, mechanical devices like the Claudian glass were invented to help artists create this way of depicting the world. Eventually, in the nineteenth century, came the camera invented to mechanically reproduce the formula. This was a tipping point and the technology of observation associated with the camera perpetuated pictured seeing of a very particular kind. So ingrained are the scenic characteristics we now

1 Dutch art, especially from the fifteenth century to the seventeenth used a number of perspectival systems (see Aplers 1983). Cezanne in the late nineteenth century began to paint against perspective so that his landscapes began to look more and more two-dimensional and abstract. Other artists also experimented, especially with the advent of European Modernism. In Chinese painting, perspective was never mathematical and landscape painting, for example, was much more vertical in orientation. Artists like the renowned Japanese woodprint-maker Hokusai, aware of both European and Asian approaches to perspective, collapsed geometric perspective to heighten the drama in his most famous image *The Great Wave off Kanagawa* (1826-1833).

identify with Claude Lorrain and his artist compatriots they have become, at least in the West, interpolated with our way of looking. When we look at a heritage place, this structuring of our seeing becomes a way (although not the only way) of visually interpreting our looking. The pictured technique of looking is one of the reasons (among many) why photography has become so central to the way we interact with heritage places. Almost unconsciously, we seek the scenic and we 'capture' it with our cameras. This mediation is part of the way we interpret a place visually but it's much more than this because our 'pictured vision' is also part of the way we respond to places aesthetically and the way we personalize our connection to places. These responses, however, go beyond the visual techniques/ technologies of observing and image-making (and the visual schema we have inherited). They also have to do with iconography, the way the subject of our looking is embodied.

The painting by the Australian artist Tom Roberts called *A Break Away!* (executed in 1891) can be found in the Art Gallery of South Australia in the city of Adelaide. The large picture (137cm × 168cm) shows a drought-stricken and parched yellow-brown Australian landscape. Even the hardy gum trees are more yellow than green. The sky is the deep blue of the middle of the day (there are few shadows), the sun bleaching the land. Within this harsh environment two drovers on horseback, one way in the distance and the other in the foreground, are moving a large flock of sheep, probably in search of water and pasture, a seemingly bleak objective in such a dry place. But suddenly the thirsty sheep smell water and in desperation make a break, stampeding down the hill in a haze of dust towards a waterhole just visible in the bottom right-hand side of the painting. The frenzy of running and jumping sheep is beyond the control of the drover who, with his back to us, gestures in futility as he attempts to stay mounted on his horse caught right in the middle of the thirst-crazed charge.

Standing in front of this painting it is impossible not to get caught up in the drama of the narrative. It's quite an artistic feat to make a static image on a two-dimensional surface seem so full of energy and movement. We are used to the idea that such an image – like photographs – is a moment frozen in time. The excitement of this painting is anticipating the next part of the story, sensing the ongoing rush of the sheep towards their mostly obscured quarry. It's thrilling because we have to invent an ongoing narrative full of possibilities. Will the water in what looks to be a shallow pool be enough? Is this part of a grimmer story, momentary respite before the eventual tragic loss of livestock, victims of a drought? Will the drover in the centre of the picture stay mounted on his horse? For non-Indigenous Australian viewers other emotions are keenly felt. The parched landscape and the problem of drought have been an enduring part of the history and the experience of life in Australia. It's so easy to not only 'feel' the heat of the summer's day as Roberts has depicted it, but to reflect on the dire consequences of drought in our own times. As we stare at the picture, other images come to mind, media images of drought or our own visual memories of seeing a dry and dusty Australian summer landscape. What Roberts is part of, from the perspective of twenty-first-century looking, is an

iconography of drought imagery. Generally speaking, Australian viewers instantly recognize what this painting is about because of the visual repertoire of images we carry within and the experiential links we make to this memory archive of images. Images trigger complex semiotic linkages as well as emotional and sensorial responses. It is part of their seduction.

But there's something more. It is the realism of the painting that also conveys a visual power and produces affect and the effects I've briefly described. Realism and verisimilitude are highly problematic and complex ideas in visual theory and in the context of heritage interpretation this complexity cannot be ignored (Levine 1993). Let us consider a famous photograph, *The Falling Man* by Richard Drew (2001). *The Falling Man*, taken on 11 September 2001 in New York after the crashing of the planes into the World Trade Center, shows a man jumping to his death from one of the towers. He is mid-flight, falling head first with the height of the fall accentuated by the vertical rows of windows behind him. For those of us who can so vividly remember the events of that day, Drew's photo produces a range of emotions like horror, shock, poignancy, sadness and fascination, as there is something deeply disturbing about the way the figure is frozen in his death plunge and ironically immortalized just a very few seconds before his death. Even without the context of 9/11, it is a powerful and disturbing image.

The subject produces the effect/affect it does because of our belief in the commonplace notion that an image like a photograph faithfully represents something that is not itself, that the photo's veracity lies in its ability to record an external prior reality. In other words, photos have a counterpart; they are a mirror image of something. This belief in the realism and truthfulness of photographs is highly influential and is why they, along with the documentary film, are considered to have more fidelity and accuracy than even eyewitness accounts. The use of photographs for identification, as evidence in courts of law and in media news services underscores this assumption. Yes, the photographic image, documentary film and paintings like Tom Roberts' *A Break Away!* can indeed have a high degree of verisimilitude (indeed, why would photography be used in so much archaeological research and in so much conservation work if this were not the case). And yes, the aim to increase verisimilitude has undoubtedly motivated visual research developments like virtual reality and 3D digital cinema, but overall the idea that certain classes of images mirror an external reality is both highly problematic and a deeply Western conception of the image. Why is this so? Firstly, what about imaginative images where there is no one-to-one relationship with an external reality? The Tom Roberts painting likely fits into this category. Roberts probably did not paint an actual landscape nor an actual event, but an imaginative reconstruction of both. A great deal of science-fiction and fantasy cinema certainly fits this category, whether it's the Harry Potter films or James Cameron's *Avatar* (2009). And with Photoshop the veracity of the photograph is under constant challenge. A good example is another well-known photo, *Tourist Guy*, also related to 9/11, that shows a tourist posing for the camera on top of the World Trade Center but, ominously, also caught by the photographer is one of the

incoming planes about to slam into the building. It's a breathtaking picture but this fake image was created by Peter Guzli and the photo of him on the World Trade Center was taken in 1997 some four years before 9/11. Photoshop did the rest. Of course, the manipulation of images did not begin with Photoshop and the use of images to propagate messages and propaganda of many kinds has been one of its features for centuries (see Spivey 2005 for an insightful historical analysis). Thus alongside the belief in photographic veracity is also a deeply held scepticism about photographs underscored by the idea that the 'camera *can* lie'.

Secondly, on the whole, what gets photographed conforms to an understanding of the painted image – in other words, the sort of conventions associated with a Claudian landscape. When the photographer does not record in a painterly way, for example experimental photography, it is called 'art'. By 'painterly way' I mean portraits, landscapes, detailed genre studies like flowers and bowls of fruit, history paintings (including mythological subjects, political scenes, historical spectacles, war, revolution and so forth), religious dramas, topographical studies (including individual buildings, monuments and streetscapes), interior studies (including domestic settings and subject matter), animal studies and people studies. All these types of images preceded the invention of the camera and, interestingly, the camera is believed to be most truthful when it is used for these subjects. Therefore, only particular photos are considered documentary evidence; but, to achieve this, the photographer must be highly selective and conform to a series of visual conventions and subject matter.

Thirdly, what counts as 'realism' is forever changing with time and geography. When we look at photographs taken at the beginning of the twentieth century or films made in the late 1920s we immediately recognize that what we consider to be verisimilitude has shifted. I'm thinking of the US photographer and artist Alfred Stieglitz and images like his *The Hand of Man* (1905), showing a steam train in a railway yard, and a portrait, *Miss S.R.* (1905). A film that comes readily to mind is Fritz Lang's powerful and influential *Metropolis* (1927), the silent movie with the live orchestral sound track. These are all shot with cameras and yet we are likely to conclude that they somehow lack realism (such as we are used to), that they look overly staged and artificial.

At the same time, just to complicate matters, we may also regard Picasso's *The Tragedy*, a blue-period painting of 1903 now in the National Gallery of Art, Washington DC, as more realistic than photographic portraits of the time. Why? *The Tragedy* depicts a family, a woman, a man and a boy, standing barefooted on a beach. The woman is slightly isolated from the two males and she and the man have their heads – in profile – bent down They are withdrawn into their own thoughts. There are indications of poverty and the two adults hug their clothes and their arms to themselves as if in deep grief or coldness or both. In terms of verisimilitude, a photograph appears to be more faithful than the quite abstract Picasso painting done almost entirely in the colour blue. And yet, the emotional power of *The Tragedy*, the title itself evocative (especially as we are given no clues whatsoever as to what the tragedy may have been) produces such excessive

and varying responses, way beyond the simple forms of the figures, that we are inevitably caught up in the painting's intensity and, with such a strong emotional response, it can seem 'more real' than a 1903 photograph. Even in a much more restricted time frame, perceptions of realism and verisimilitude shift their ground. A 3D digital movie like *Avatar* (2009), seen in an Imax cinema makes a 2D movie *seem*, for some at least, less realistic.

Realism and verisimilitude are therefore tricky concepts. Nevertheless, the general belief in the truthfulness of film and photography in a visual culture where the recording and the consumption of images is a major and potent way in which we make sense of ourselves and of the different environments we inhabit, has important implications for heritage places, objects and landscapes. We allow the images in our visual culture to inform the way we respond to places and vice versa, for it is always a two-way street. Further, images are persuasive because of their *imaginative* power, their ability to be attention-seeking, their ability to draw the viewer into their own 'reality'. It is almost impossible to look at an image, any image, without beginning to construct a narrative about what it is we are looking at (Abbott 2002). But they are also persuasive because of their ability to manipulate points of view and construct ways of seeing (and ways of not seeing). Images, to use an old cliché, are hypnotic.

How is any of this related to heritage interpretation? Heritage places are given high visibility and are made intelligible by the visual culture they are ensnared within and of which, through the agency of human actions, they are an active component (Waterton and Watson 2010). Through a multitude of observational technologies, heritage places, objects, monuments and landscapes are mapped, drawn, painted, photographed, filmed and scanned. These representations, because they have a life of their own (see Chapter 2), help create a visual experience that in turn both instructs and informs the way visitors 'see' and interpret places. When we look at the Palace of Versailles or Stonehenge, or the archaeological site of Abbey St Maurice in Switzerland or the Milson Sound Fjord in New Zealand or the ancient Egyptian Tomb of Kha in the Egyptian Museum in Turin or the Railway Bridge across the Firth of Forth in Scotland, or the Great Wall of China or the Forbidden City in Beijing, our looking is immediately informed by the visual technologies and the visual representations that surround us and which we constantly utilize. There is a constant traffic between the things visitors select to view and the technologies of observation (convention-bound as they are) and the iconography we share and contribute to regarding visual classifications like 'palaces', 'archaeology', 'fjords', 'old steel railway bridges', 'ancient Egypt', 'ancient China' and so on. This aspect of a heritage visual culture is perhaps the most crucially important to heritage interpretation and is what I want to call 'heritage iconography'. This visually informed meaning of places and sites arises from a repertoire of images that powerfully position objects, monuments and places not only in our imaginations but also within the heritage experience itself.

Rojek's 'files of representation', 'indexing' and 'dragging' and heritage sites/ sights

In an interesting essay, Chris Rojek, building on the earlier work of John Urry (1990 and 1995), and earlier still Dean MacCannell ([1976] 1999), examined the social construction of tourist sights (Rojek 1997). His analysis, *ipso facto*, equally applies to heritage places. Rojek's starting point is that heritage/tourist places are socially constructed as spaces that signify something extra-ordinary, their 'aura' pertaining to a fusion of visual power (including the iconographic and, therefore, the symbolic), discursive power (including descriptions – whether empirical or mythological or fictional – and disciplinary expositions like botany, history and archaeology for example) and imaginative power. Some places are already semiotically dense, that is, they are rich in associations through the intersection of numerous representations via history, myth, archaeology, literature, image, art, music, associated cuisine (and so on). Heritage places are often already imbued with wonder, reverie and speculation, writes Rojek, or they have the potential to be. The imaginative power of heritage places relies on a wellspring of intoxicating and various (and often simultaneous) desires: spiritual, aesthetic, sensual, intellectual, fantasy, power, identity, knowledge, overcoming alienation, nostalgia and even the desire to journey/travel itself (cf. Leed 1991).

Because of the reach and the pervasive nature of visual culture, the 'aura' of heritage is not confined to a particular place or site but is a constant eruption within the everyday. Rojek writes of 'files of representation' which he defines as 'the medium and conventions associated with signifying a sight' (Rojek 1997: 53). In other words, the visual and discursive representations of heritage places produce semiotic density and engender imaginative power. For Rojek, what erupts into the everyday is an 'index of representation', a phenomenon made up of those representations from the file that produce familiarity in the everyday. To the notions of 'file' and 'index' Rojek adds 'dragging', a process whereby a number of players in heritage site visitation (managers, guides, interpretation designers, education officers, curators and the visitors themselves) combine elements from the 'file of representation' and, in so doing, 'create new value'. 'Dragging', therefore, refers to an ongoing process of, firstly, using existing grids of representation and, secondly, creating new representations some of which are by design and some of which are improvised and are performative in nature (cf. Staiff 2010). In Rojek's view, following the ideas of Walter Benjamin, the physical site – its originality, its uniqueness – is mired in endless reproductions (particularly images but also texts) so that, in a sense, the original is always 'corrupted' or, to use less rhetoric, the 'original' is *always* mediated. No heritage site can be seen in some pure pre-epistemic way, the viewing and the view will always be implicated with representations/discursive practices that mark heritage as 'heritage' (cf. Smith 2006). Or, to link it to my earlier discussion, viewing and the view will be 'pictured' and infused with the technologies of vision.

Rojek then proposes that sights rather than being 'attractions' (as in tourist attractions) are in fact 'distractions' as the mobile traveller moves from one stimulation to the next, where 'velocity' is the animating energy rather than the static contemplation of static sites/attractions. Arrive, see, photograph, move on. Therefore, for Rojek, there is something *insubstantial* about visiting a place because of (1) the visitors' 'restless movement'; (2) the heavy and dense mediation of representations of places; (3) the endless and open ended possibility of responses by visitors because controlled linear logic and externally imposed coherency is impossible and because the self-referencing of 'new' meaning making is activated; (4) objects and places within contemporary (Western) culture have become disembedded because the authority of formal and institutionally sanctioned discourses (for example, history or ecology or archaeology) have become relatively weak; and (5) objects and places are often (re-)embedded within hyper-realities and the fantastical (cf. Eco 1987).

While I subscribe to this analysis, I want to extend Rojek's insights beyond the geographic precision of specific locations, specific topographies (necessary in his regard for particular tourist destinations or particular heritage sites) to a more general relationship between heritage and 'files of representation'. I refer here to what I term a visual repertoire, something that is a constitutive part of heritage place construction whether 'real' or imaginative and which is powerfully 'present' in certain types of heritage visitation precisely because the visual repertoire becomes entangled with the place/site/landscape/object in a way that cannot be managed. While my reference to a visual repertoire relates to all the dimensions of contemporary visual culture and the files of representation it spawns, here I'm most particularly interested in just one visual form – the moving image.

Visual repertoires and the moving image

According to the BBC documentary series *How Art Made the World* (2005), in the year 2004 seven billion people, worldwide, went to a cinema to watch a movie, a figure that obviously includes multiple visits by one person. This figure, however, excludes DVD movie rentals and purchases. Cinema has an impressive and unprecedented reach. And the moving image has a unique position in contemporary visual culture for another reason: its considerable and unique ability to captivate the viewer and take hold of our imaginations. The promotional by-line for James Cameron's immensely popular *Avatar* (2009) was 'Enter the World. Avatar'. This experience of suspending disbelief (about the fact that we, the viewers, sit in a room watching a series of moving images produced by a computer and projected by a light source onto a screen) and the sense of being transported, as it were, into another world is the contemporary surrogate experience once related to other fusions of images, sound, music, movement, text – performance, religious rituals and so forth. However, the cinema seems to surpass these other fusion experiences. Movies enchant, captivate and enthral. They are intense sensorial

experiences involving images, sounds, music, narrative, action, emotions and our imaginations (our internal world of images and imaging). Like all technologies of vision, film involves us knowing how they work and we learn how they work not from film-making courses but through the years of endemic exposure to the cinema experience. We understand the fast edit and multiple views and perspectives, simultaneous plot lines, character development, complex manipulations of time, panning, zooming, the use of sound effects and music, the conventions of titles and credits, and so forth. Today, the moving image has become ubiquitous and (almost) universally understood, especially if we also include video and television.

Because of the sheer power of the moving image to not only connect to our imaginations but to produce memorable memory images – in other words, a memory iconography or a memory 'file of representations' – it has, over time, produced and contributed to a repertoire of visual images that has standardized a visual interpretation of history. This is precisely where it potentially produces a visual heritage interpretation that is independent of site-based interpretation. Such a visual interpretation, this visual repertoire we carry around in our heads, is at our constant disposal. When I say 'Ancient Rome' or 'Ancient Egypt' or 'Feudal China' or 'Medieval Europe' what *images* come to mind? And more importantly, what is the *source* of these memory images? These 'worlds' of the imagination, Ancient Rome, Feudal China and so on, exist in a mode that has never been so vivid or as detailed. Earlier generations – for example, the late nineteenth century – relied on the pictures or illustrations in books, supplemented by material culture in museums (and, for the few, travels to the ancient sites) along with their reading of history and classical literature or Shakespeare and so forth. This is not to say that their imaginative understanding of Ancient Rome or Egypt was any less than in the twenty-first century but, I would argue, the repertoire is, today, (1) more vivid, (2) more detailed, (3) has greater conformity and (4) is more widely known. This iconography of places/times like Ancient Rome is fed and fuelled by the representations of ancient Rome in movies, books, video games, travel books and magazines, documentaries, novels, the Internet (Google Images, Wikipedia, virtual tours and/or reconstructions) and so on. And similar (but different) to the late nineteenth century, these visualizations are supplemented with museum visits and increasingly significant tourism to ancient sites or to medieval cities and so forth.

Ancient Rome is a very good example in Western culture. A cursory survey of the available visual material on Ancient Rome reveals a rich ecology of interconnected visualizations. Within cinema, the film *Gladiator* (2000) may be the most recent but it joins a host of others (now all re-released on DVD): *Spartacus* (1960), *Ben Hur* (1959), *Cleopatra* (1963) and the Biblical epics like *The Robe* (1953). Series made for television – now also released as DVD sets – join the big screen epics. The latest is the sumptuous two-series American, Italian and British production *Rome* (2005 and 2007) (notable for its use of computer-generated images) along with the re-release of the BBC series *I Claudius* (1976). Documentaries on Ancient Rome and its rulers are numerous but the BBC's docudrama *Ancient Rome: Rise and Fall of an Empire* (2006) was impressive with its dramatic reconstructions of

conversations and events (based on the accounts of Roman writers and historians) and also visually enhanced with computer-generated images.

What I find extraordinary about this ecology of imagery is the complete dissolution of the borders between fiction and the archaeological, and the dissolution of time itself. The cinematic iconography of Ancient Rome may make important distinctions about the Rome of Sulla compared to the Rome of Augustus Caesar or the Rome of Constantine, but in the mind's eye these distinctions dissolve and in the end, through constant visual reinforcement of certain standard images about the dress and armaments of Roman soldiers and generals, the details of villa interiors (invariably of the rich and powerful Roman elites), the dress and jewellery of Roman patrician women, of senators and slaves, of Roman architecture (especially the Forum, the Colosseum, temples, theatres and aqueducts), chariots, Roman triremes, gladiators, roads and so on, a generalized and somewhat uniform memory iconography of Ancient Rome becomes established. What are important are the ways this visual repertoire is activated and the ways it is connected to heritage places. Can those who vividly remember the chariot race in *Ben Hur* not recall, in a general sense, this cinematic representation of both the place and the event when standing looking at the present-day sad remnants of the Circus Maximus in Rome? Can we look at the Colosseum without being informed by the way it was represented in *Gladiator*? The use of this visual repertoire is not reliant on language-based interpretation, rather it is the fusion of memory images with our direct perception of a heritage site and our imaginative capacities. Of course, language-based knowledge is implicated, but it's not the primary mechanism I am describing (Staiff 2013).

For some time I've been interested in the way Chinese cinema, released in the West, is also producing a dominant iconography, ideology and an aesthetic of Feudal China. Like the Ancient Rome example, the collapse of distinction and time frames creates a general *visual idea* of pre-Modern China that does not respect historical differences. This dominant visual imagery is reinforced over and over (cf. Taylor 1994; Crawshaw and Urry 1997). Beginning with Chen Kaige's *The Emperor and the Assassin* (1998) set in the third century BCE in the Kingdom of Qin, this movie was followed by Ang Lee's popular *Crouching Tiger, Hidden Dragon* (2000) (set in the Quing Dynasty, and the reign of Emperor Qianlong in the late eighteenth century CE). In 2002, came *Hero*, directed by Zhang Yimou that was set in the so-called Era of the Warring States, 476 BCE to 221 BCE. Two years later, Zhang Yimou directed another historical action drama called *House of Flying Daggers*, this time set towards the end of the Tang Dynasty in 859 CE and then, in 2006, yet another with his *Curse of the Golden Flower* set in the tenth century CE. In 2008 and 2009, viewers (especially Asian viewers but also Western viewers) were enthralled with John Woo's exhilarating spectacular *Red Cliffs*, as both a two-part epic of over four hours' duration and a somewhat diminished edited version of two plus hours. These films were based on the Battle of Red Cliffs (Battle of Chibi) at the end of the Han Dynasty during the winter of 208-209 CE. Then 2009/2010 saw the release of Jingle Ma's *Mulan*, the story of a

literary heroine who may have lived between 386 and 534 CE, and Hu Mei's visual epic *Confucius*, set in the Zhou Dynasty of the sixth and fifth BCE. An interesting phenomenon, from a Western viewer's experience, is the consistency with which the same actors kept cropping up in these films: Chow Yun-Fat was in three of them as was Zhang Ziyi, and Tony Leung, Gong Li, Tekeshi Kaneshiro and Chang Chen were in two each. The repetition of actors produces a persuasive, if illusory, familiarity about life in China's pre-Modern past.

Such a brief overview can give no more than a hint about the ways films like these produce an imagined visual representation of Feudal China. Like Ancient Rome, the cinematic imagery and the cinematic imaginary are supplemented by a host of other visual representations. Together, they produce a very rich memory archive but, unlike Ancient Rome (or Ancient Egypt or Medieval Europe), this archive is not, on the whole, supported with extensive language-based knowledge on the part of Western viewers. However, that is the very point. Historical time collapses into this generalized 'file of representations' and the image repertoire takes no account of whether the period is Han, Qin, Tang or Quing. Viewing the Great Wall of China or the Terracotta Army of Qin Shi Huang in Xi'an, consciously or unconsciously activates the visual repertoire, and the link between visual representation and heritage site is forged. The critical question for heritage interpretation is how this visual alliance should be regarded.

The lure of 'complete' worlds

Often what we see are sites that are not in any way complete, like, for example, Pompeii in Italy. Pompeii is relatively easy for the visitor compared with archaeological sites such as Sukhothai in northern Thailand or Machu Picchu in Peru because the site has topographical and historical integrity and does not compete with the remnants of historical developments over the centuries like in Rome. Nevertheless, while the streets can be walked down and villas can be entered and the forum can be sensed as a civic space and we can identify a baker's shop and a wine tavern and marvel at the chariot grooves in the road and the remaining frescos, the town today requires imaginative engagement. To try to imagine a living, vibrant and complete urban landscape is quite difficult. And so, into this space of the imaginative steps visual culture: films, docudramas, pictures and visual reconstructions (by artists and now computer-generated images). What cinema does so well is create total urban environments to give the viewer the illusion of 'being there', as it ostensibly was at some moment before the city's destruction. The BBC production *Pompeii: The Last Day* (2003) directed by Peter Nicholson, and noted for its use of computer-generated images, is the most recent English-language film but also recently released on DVD was the television miniseries from 1984, *The Last Days of Pompeii* starring Lawrence Olivier, a series that had French, German and Spanish versions. These films do what no visit can and that's (re)construct places into lived-in environments peopled with characters

enmeshed with these virtual worlds, where the streetscape of archaeology is transformed into complete urban places as though we can somehow see in the twenty-first century how it 'really' was just before the cataclysm of the eruption. The filmic versions of Pompeii fill the town with action and an iconography of daily life (whether historically accurate or assumed is beside the point). We see markets full of produce, social class and status played out semiotically with different costumes and activities (slaves carry, the patricians are carried), transport of various kinds, we experience the internal calm of a courtyard garden in a villa, we observe a Roman feast with guests lying on couches, we sense the politics of the *imperium* through the different roles played by the different social classes, by the relationships between men and women (and the position of the *pater familias*), by harsh punishments; we are exposed visually to a world that seems obsessed with order, with superstitious beliefs and the randomness of divine favour and we are introduced to a world of licentiousness and exotic past-times, of whores and gladiators (cf. Wyke 1997).

For me, the critical question is this: what is more significant in the way contemporary culture operates, a description in a guidebook or by a guide or an audio-guide of life in a wealthy patrician's villa, or a cinematic reconstruction of the villa like the one described in Chapter 1 as part of the *Day in Pompeii* exhibition at the Melbourne Museum? The way film reconstructs Pompeii effectively (and devastatingly) competes with other didactic forms of interpretation because of the unique power of visual culture and, in particular, of the moving image hitched to a soundtrack of mood-evoking music. Irrespective of the arguments for and against reconstructions, for and against the use of film as an interpretation tool, for and against didactic heritage interpretation, the cinematic plays a critical and ongoing role in the way we imagine worlds past, present and future. We cannot divorce ourselves from the world of images that we inhabit and the visual repertoires we carry in our heads (cf. Crawshaw and Urry 1997). Heritage interpretation in its current formulations, and the ICOMOS *Charter for the Interpretation and Presentation of Cultural Sites* (2008) is a good example, wants to protect, or at the very least demarcate, the 'authentic' aura of 'original' objects, the scholarship of material culture and the communication of significance against the imaginative and the fictional account. It is a battle about truth claims, about the veracity of history over the imaginative, science versus fiction (cf. Clendinnen 2006). This is all well and good and there is undoubtedly a case to be made here, but when visitors are experiencing heritage places, that which cannot be controlled is given free rein. And it is not just the truth claims of science against imaginary reconstructions. A dominant heritage iconography forged within visual culture also strikes deeply into the territory of community linkages to heritage and to alternative heritage narratives, especially those with spiritual and intense local connections. Tim Winter's important work with regard to 'official' interpretations of Angkor compared to the significance placed on Angkor by Cambodian communities (Winter 2003, 2004, 2007) starkly highlights the issue in relation to a film like *Lara Croft: Tomb Raider* (2001). Cinema-informed iconographies of history may also

be having a major impact on complex relationships between local communities and the heritage places in their midst, something sometimes embraced (like the Ned Kelly legend in northern Victoria, Australia)) and sometimes a cause of angst (like in Angkor or the (mis)representations of Indigenous peoples in film over a number of decades). I think this is *one* of the reasons why, in relatively recent times, heritage interpretation has become so fixated on communicating messages and has become quite didactic in nature. It is a response to that which cannot be controlled. This adversarial conceptualization, however, is counterproductive. What is needed is a much richer imagining of heritage interpretation that does not so easily push to the margins the visual repertoire phenomenon I have described nor trivialize the very significant issues raised by Tim Winter and Inga Clendinnen (to mention but two recent commentators in what is an understandable and necessary chorus of dissent and critique about heritage and history and tourism).

Pompeii, however, is just one convenient example. Whole periods of history have now been given visual form and an iconography. We live in a time where it is possible to visually behold Victorian London, mid-nineteenth-century rural England, colonial Australia, the era of the Civil War in the USA, Revolutionary and Napoleonic France, Revolutionary Russia, aristocratic life in Europe in the eighteenth century, and so on. 'Real' history and 'real ' heritage is often fragmented (understandably so because the past is a construction built on the fragmentary nature of what remains for historians or archaeologists to work with) and heritage interpretation expends energy trying to convey to the visitor something more than the ocular experience. Heritage interpretation, traditionally, adds context, it adds narratives, it fills in gaps and it tries to compensate for the partial, for the fragment, for that which is not apparent and it attempts to rectify a (perceived) lack in visitors' knowledge. However, so too does cinema replete with context and narratives and its ability to seemingly 'fill the gaps'. Film powerfully transcends the reality of (historical and heritage) fragments and disparate remnants with its illusion of complete worlds.

Recently, I watched an episode of the BBC series *Warriors* (2008), a docudrama reconstructing episodes in the lives of characters as diverse as Genghis Khan, Spartacus, Richard the Lionheart and Attila the Hun. The Napoleon story focussed on his rise to military fame when, against all odds, he defeated the British in Toulouse. The opening moments of the episode establishes the mood of Revolutionary France with a gruesome guillotining. The town square and its architecture, the crowds, the players in the execution and the sounds associated with such a grisly death establish the physical place and the atmosphere of menace and fear. I was instantly 'transported' into this world and the dramatic sequence occurred as I was visually connected to the semiotics of this historical moment – the costumes, the form of execution, the style of architecture, the modes of transport, the symbols of power and powerlessness, gender differences and poverty are all visually created. It is a textbook lesson in the construction of a history (and heritage) iconography that then deeply resonates because of the connections between this film 'text' and all the others that reinforce this iconography (paintings, descriptions, other movies,

museum objects, the preservation of late eighteenth-century French architecture and townscapes). The veracity of the docudrama lies not in its historical accuracy or otherwise, but in the way it communicates a visual rendition that is increasingly standardized. We recognize the visual signs of Revolutionary France.

'I don't want realism. I want magic!'

Of course, there are significant issues here. There is the paradox within (Western) modernism and postmodernism where the fragment, rather than the whole, is the object of desire (Nochlin 1994). The aesthetic of fragments has a long history in Western culture and erupts discontinuously in time. Ruins in the landscape as a way of looking at the romantic and picturesque landscape is a hallmark of eighteenth- and early nineteenth-century travel. Objects out of context (and deprived of context) were a feature of nineteenth-century antiquarianism, connoisseurship and early museology. In early modernism the fragment was fetishized in the art of Degas and in Cubism, for example, and in postmodernism the fragment was embraced in opposition to (illusory) totalities. When the fragment comes into focus visually, it does so in opposition to the dominant iconography emerging from mainstream cinema and reminds us of the complexity of the visuality within which heritage places and objects exist.

Docudramas often receive a 'bad press' from some parts of the academic community, particularly historians and archaeologists and from documentary film-makers themselves, because of the degree of invention and the emphasis on narrative history – telling a good yarn for television consumption. Series like *Rome* (2005 and 2007) are considered more 'hollywood' than history and are charged with blurring history with fiction in the name of entertainment (cf. Rosenstone 2001 and 2006). Well yes, just like historical novels can and yes, there is little control over the memory visualization process that is engendered by films and made-for-TV series. Important as it is, this is not the place to debate the history versus fiction debate (see Clendinnen 2006; Curthoys and Docker 2006). What is critical is the sheer visual seduction of a series like *Rome* or, to choose other examples, the various cinematic permutations of the Robin Hood legend or the countless cinematic representations of nineteenth-century Britain, everything from the many adaptations of Charles Dickens and Jane Austen to recent movies like *The Young Victoria* (2009).

And it is not only a question of visual seduction. The relationship between these visual repertoires and the imaginary is also crucial but somewhat unaccounted for in heritage interpretation except vaguely as the 'prior knowledge' of the visitor (Black 2005; Falk and Dierking 2000). But, for me, 'prior knowledge' is the least of it. In a way, all visual images *enhance* reality and have always done so. It is almost as though unmediated reality were not enough. As Blanche DuBois so memorably says in Tennessee Williams' *A Streetcar Named Desire* (1949), 'I don't want realism. I want magic!' (Scene 9). In visual culture there is a propensity

to exaggerate and enhance (Spivey 2005). This exaggeration, paradoxically, increases abstraction. This is why a painting like Picasso's *The Tragedy* (1903) can seem more 'real' than a portrait photograph taken the same year. What has been abstracted in the Picasso strikes a chord in the twenty-first-century viewer that may not be reciprocated in the photographic portrait. So the propensity to exaggerate and to increase abstraction (potentially producing hyper-real states) is a culturally inscribed quality. But more than this it gives visual images (static or moving) a comparative edge over the 'real' world of the everyday. The urge to exaggerate in image construction is part of what causes images to demand our attention, to activate our engagement and to enchant us (Spivey 2005). The way heritage places are marked out semiotically (as not the everyday, as significant, as special, as vital and so on) shares something with images and when the two are fused – image and site – a complex interplay is established. The visual imagery of heritage places gives us the magic Blanche DuBois craved.

This leads us to consider heritage, interpretation and visual reconstructions. I will not easily forget a visit to the Roman archaeological excavation site that forms an extensive underground section of the Museo d'Historia de la Ciutat in Barcelona and my first acquaintance with a digital reconstruction presented on a screen. Visitors get to walk on a transparent walkway suspended over the excavations and along the walkway are video screens that, when activated, produce a computer-generated film that begins with what it is we are seeing – the outline of a house, the walls and doorways quite clear but very little remaining. The film, with its attractive sound track, shows the building of the walls beginning with what has been exposed by the excavation and ending with a complete house. We 'enter' the virtual house and see the interiors with their decorations, their furnishings and their occupants. Following a bird we 'fly' out of a window and get to see the exterior of the house from above and then, as the overhead panorama extends, we view the house in the street and then within the context of its neighbourhood, and then, as we 'fly' higher, within the context of the whole of Roman Barcelona. And then the scene begins to visually 'collapse' as we descend and, in reverse, enter the street of the house, enter the interior by way of the window and then leave by the doorway and finally, as the soundtrack comes to an end, the walls begin to crumble away leaving in the final frames of the video the view we see beneath our feet. For the duration, not a word is spoken. The link between site and image produces an affecting and effective visual interpretation of the site. The power of visual culture and especially of the moving image is acknowledged. The difference between knowing/imagining through looking and knowing/imagining via language is made manifest.

The one vital aspect of visual culture and the way heritage places are unavoidably mired within visual cultures that I have only touched upon is the visitor's active participation via the camera. Carol Crawshaw and John Urry, in an important essay on tourism and the photographic eye (1997), explore the complex interrelationship between place, visual representations, the camera as a technology heavily mediated by discursive formations, historically constructed

ways of seeing and the visitor's photography in the Lake District in northern England. What they illustrate is a web of practices and discourses, within which a place is given both visibility and visuality and the processes that produce a dominant iconography, a dominant visual ideology and a dominant aesthetic; and within this web of practices the tourist is both producer and consumer of images. Generally, visitors reproduce/replicate the standardized iconography of a place and ensure the continuous circulation of dominant imagery. But this is not always the case. John Taylor, in his study of landscape, photography and the tourist's imagination, *A Dream of England* (1994), describes why there is an important difference between the gaze, the glimpse and the glance. The former is structured, mediated and infused with power play. The latter is subversive, disruptive and acts as a type of resistance to dominant imagery. In relation to photography, with the glance we enter the realm of irony, parody and unorthodox and experimental individuality. It is another sphere of the unauthorized. The possibility and the reality of heritage site photography by visitors who do not conform to the 'rules' of the dominant iconography and therefore create visual interpretations of places that are highly individualized and/or create havoc through parody and irony cannot be underestimated. Within subversive photography, we meet once more the notion of the heritage experience as heritage conjured *in play*. In the age of the digital revolution the potential and the possibilities of such visual interventions have been magnified many times over. The unauthorized is not only here to stay but is something little considered, if at all, in heritage interpretation. Rather, it is dealt with by implication in the attempt to control the content of interpretation under the aegis of scholarly research, authenticity and science.

On a visit to an art gallery in Auckland New Zealand, there was an exhibition of contemporary landscape art. The exhibition was devoted to, in the main, paintings and prints. But on one wall, mounted like a painting, was a screen. The video that played on this screen was an accelerated rush of landscape images, short sequences of landscapes being travelled through and shot from a moving vehicle. The video alternated between stark black-and-white images and colourful renditions of the landscape, and the switch between the two added to the frenetic pace of the movement and the radical sense of a landscape not as a static object of surveillance and contemplation but as a rather terrifying pastiche of fast-moving perspectives. What struck me most of all, however, was not the video, impressive as it was, but the effect of this one screen in a gallery of static images. The attracting power of the screen was quite phenomenal. No matter how much I tried to concentrate on the paintings and prints my eyes were constantly arrested by the screen. I could not look away for very long. For me this experience was a metaphor for the complex relationship between moving and still images within contemporary visual culture and a metaphor for the dominating effect of the moving image (as both experience and communication) compared to static images in heritage interpretation. Also, there is something immensely powerful about stories told through moving pictures compared with those told through static images. And it is to storytelling, the narrative urge, that we now turn our attention.

Chapter 5
Narratives and narrativity:
the story is the thing

Strange companions – Florence and *To Kill a Mocking Bird* – what is narrative?

Standing on the street below Florence's *Duomo* (or Cathedral), called Basilica di Santa Maria del Fiore, creates, spontaneously, a sense of scale and proportion. The towering and massive architectural monument at the ritual centre of the 'old city' dwarfs both inhabitants and visitors. Santa Maria del Fiore was built in the form of a basilica, a rectangular structure with a wide central nave and a chancel and transepts of identical size in the shape of polygons so that, seen from above, it creates the shape of a Latin cross. The Cathedral is 153 metres long, 38 metres wide in the nave and 90 metres wide in the crossing. The height of the building from the floor to the opening at the top of the vast dome over the crossing is also 90 metres. The dome is octagonal in shape and is made up of two domes – a dome within a dome – an outer lighter skin and an inner heavier structure separated by a gap. The double-dome design reduces the overall weight of the dome and the herringbone pattern used for the laying of the four million bricks helped transfer the weight to the horizontal and concentric octagonal ribs during construction (en.wikipedia.com 'Florence Cathedral').

We are not sure how Filippo Brunelleschi, the fifteenth-century Florentine architect and archetypal figure of the Italian Renaissance, came to the ingenious solution of how to build the dome. Its shape, octagonal rather than the more usual circular, mirrors the octagonal shape of the Baptistry, the earlier building next door to the *Duomo*. The Florence Baptistry was and is dedicated to the patron saint of Florence, St John the Baptist. The Renaissance symbolism of the number eight may have been important as '8' was the symbol of eternity, of the Resurrection of Christ (the eighth day of Creation) and of baptism, the sacrament of Christian membership when, it is believed, the old self of the acolyte dies only to be reborn into everlasting life with Christ.

The deadline for the competition to choose a design for the dome was fast approaching and this we are told, unleashed a fury of creativity in Brunelleschi. Huddled in his small studio-living quarters, he began sketching ideas and executing drawings with increasing desperation. The floor of the studio was strewn with drawings and intricate measurements and calculations. His untidy and shambolic appearance was exacerbated by poor health. His long-suffering assistant was constantly in two minds: to help his master and incur his wrath or keep clear of him and incur his wrath. Brunelleschi had no convincing solution to the problem

of how to construct the dome and time was fast slipping away with the sand that trickled through his hourglass (based on King 2005).

The first two paragraphs about the dome of Florence's Cathedral include descriptions, narrative and exposition. The third paragraph, however, is pure narrative. As readers, we immediately recognize a story being told. In the earlier paragraphs we move from narrative mode ('the towering and massive architectural monument at the ritual centre of the 'old city' dwarfs both inhabitants and visitors') to a descriptive mode ('the Cathedral is 153 metres long, 38 metres wide in the nave and 90 metres wide in the crossing') to exposition ('Its shape, octagonal rather than the more usual circular, mirrors the octagonal shape of the Baptistry, the earlier building next door to the *Duomo*').

What is narrative? This is a complex question that, in Western culture, has been the subject of exacting scrutiny since Greek antiquity. A useful beginning, and companion for our discussion, is H. Porter Abbott's *The Cambridge Introduction to Narrative* (2002). At its most basic, he argues, narrative involves events and time. This is clearly the case in the paragraph about Brunelleschi and the looming competition deadline. And, while the passing of minutes and hours (or what Porter Abbott calls 'clock time') is a central feature, there are other time elements in the story. The state of Brunelleschi's room and his health, the comings and goings of an assistant, the sheets of parchment bearing earlier calculations and drawings, all suggest to us a time before the moment where the story finds him sketching with desperation. Narrative has the capacity to represent multiple time dimensions. As Porter Abbott writes, 'narrative is the principal way in which our species organizes its understanding of time' (Abbott 2002: 3). But time is always related to events in a narrative. In a dozen lines of prose numerous events preceding Brunelleschi's solution to the problem of how to build the dome of Florence's Cathedral are mentioned and linked together causally. His 'fury of creativity', huddling in his studio, sketching, being sick, treating his assistant badly, the sand trickling through the hourglass, these are multiple events and they coalesce as causal links to the main action.

There are other characteristics of narrative that are equally important. Stories are *representations* because they relate to events that precede them (whether real or imagined) – or at least, events that precede the telling – and, at the same time, the story is independent of the events depicted, is its own event (reading or listening or viewing) and, seemingly, has a life of its own (see Chapter 2). By 'having a life of its own' I mean, stories *do* something to us that descriptions do not; we seem to enter into what I want to call 'fictive space'. I align this sensation, this experience, with reading fiction and watching movies and looking at pictures. It relates to the power of the imagination to 'take us somewhere' that is, in some quite profound way, 'beyond' the 'reality' of reading a book or watching a film or looking at photographs. Strikingly, the theorist Louis Marin has written that when we encounter representations, when we look at a map or read a book or watch a film, we go somewhere, we 'travel in our minds' and, for just a few moments or even for a sustained time, seem to have transported ourselves to somewhere else,

'lost' in our memories or in our imaginations (Marin 1993). Film theorists refer to it as 'diegetic reality' where the cinema audience suspends disbelief – they are after all, sitting in a large darkened room with many other people or in their homes looking at a screen – and enter the 'reality' of the film world (film being regarded as a type of diegesis, where the camera acts as a narrator). Consider this passage:

> I gazed down at the swirling waters of the River Arno. It was cold, the air chilled by wintry gusts from the Alps and instinctively I gathered more tightly my woollen cloak. The bustle all around and the traffic on the bridge did not interrupt my thoughts. It must have been noon because the bells of the churches of the city began to rhythmically chime announcing the Angelus. From my vantage point, I could see the top of the forbidding tower of the Palazzo Vecchio and beyond that the newly finished dome of the cathedral. With my father's morning announcement of my impending marriage I should have been happy, but I was miserable. The one I truly loved, whose furtive and forbidden kisses were still vivid in my mind, would be swept aside in a tide of family obligations and contractual agreements decided by my father. My marriage would be a joyful celebration that would unite my family with the family my parents considered the most noble of all. And who would be my spouse? A name. All I had been told was a name. At some distant time I would be introduced to 'the name' but by then it would be too late, as the day of our first meeting would be the day of the ring ceremony.

The consequence of this journey in the mind is always embodied and invariably affective. Stories move us and sometimes the emotional impact is quite pronounced. We feel, we see, we sense, we hear, we smell, we laugh, we cry, we are happy or sad or angry as we enfold ourselves into the story and use our memories of past experiences to activate somatic and emotional responses. Our understanding of what it would have been like to stand in mid fifteenth-century Florence gazing down at the Arno from the Ponte Vecchio is only partial. Indeed, the description is inaccurate because it would be almost impossible to see Brunelleschi's dome from the bridge. More than this, the historical and the material culture of fifteenth-century Florence allows for no more than tantalizing glimpses broadened out with the historians' suppositions, strands of historical representations woven together over time so that a more congealed understanding of the past emerges, precariously, from records and material culture remnants. Nevertheless, whether we know Florence in the fifteenth century or not, the story is not place-dependent for its impact and the way we get 'hooked' into the melodrama. The key is the power of narratives to seemingly suppress our perception of the physical environment we inhabit and, fleetingly, allow us to occupy somewhere else in our imaginations. But, crucially, this process cannot be controlled. The 'fictive spaces' we enter when we are told a story or read one or watch a movie or look at a photograph will be tailored to the individual. So, while the story may be about love and marriage in

Renaissance Florence, the responses of the reader may have nothing to do with the setting and everything to do with individual memories and experiences. As Roland Barthes and others have cheekily but pointedly written, texts 'read' the reader, the reader does not read the text (Barthes 1984). Stories, therefore, do not guarantee a connection to the topographical and physical setting of the narrative. This is a crucial insight often lost in heritage interpretation.

Further, the emotional content of stories and the events they portray can be different in the *same* reader/listener when the circumstances of hearing/reading/ viewing change, even if the words of the story do not change. I first read Harper Lee's *To Kill A Mockingbird* ([1960] 2006) when I was in my mid-teens. By chance I wrote about the book and this fragment from my past has survived. As it so happens, I re-read Lee's novel quite recently to see if it would be useful in a seminar considering the use of fiction in social research. As one would expect, the two responses to the novel were vastly different. The teenager me was particularly taken by the outsiders in the story, 'Boo' Radley and Tom Robinson, an Afro-American falsely accused of rape. The race relations depicted by Lee also made an indelible impression, especially the notion of justice in a world wracked by racism. And I seem to have been fascinated by the narrator, six-year-old Scout Finch. In my recent reading I was absorbed by the account of race relations in Alabama in the 1930s, my historical knowledge now much more informed; by the liberalism and jurisprudence of Scout's father Atticus Finch, who defended Tom Robinson at his trial, and by a sense of seeing events not just through Scout's eyes, despite her role as narrator, but from the perspective of Atticus Finch and his emotional struggles as a single parent, as a type of human rights activist in a distinctly hostile climate, as a man sensitive to all manner of social distinctions and how these operated in a small rural community and the fragility of reason in the face of prejudice and high-running passions.

While we cannot control the responses of individual readers or listeners or viewers, the experience of particular narratives is sufficiently shared to enable a discussion about the story and for there to be enough common ground for meaningful dialogue across different readings and responses. This, commonality, however, tends to be structural in nature – we can agree about who the protagonists are, what the setting is, what the plot is, which characters have which moral virtues and so forth. We can argue about authorial intentions, about the meaning of the story about its aesthetic value. But the all-powerful somatic responses and deep emotional responses will remain intensely personal and individualized. Sometimes we may want to share these, sometimes not.

It is obvious from the Brunelleschi story, the story set on the Ponte Vecchio in Florence and my consideration of *To Kill A Mockingbird*, that narrative and meaning-making are intimately connected. Indeed the etymology of the word 'narrative', from the Latin *gnarus* meaning 'knowing' and *narro* meaning 'telling', makes the relationship between story and understanding quite explicit. As Porter Abbott explains, there is a strong sense that we don't understand unless we know the story and if the story is somehow incomplete or doesn't make sense then we feel

robbed of understanding. Further, Abbott and writers like Roland Barthes believe this is universal like narrative itself. The story-understanding relationship is a tool employed across cultures, across languages, across historical time and across geographical boundaries. Barthes' renowned essay on the structural analysis of narrative was first published in 1966. Abbott quotes Barthes' opening description of narrative in its entirety and it is worth reproducing here too:

> The narratives of the world are numberless. Narrative is first and foremost a prodigious variety of genres, themselves distributed amongst different substances – as though any material were fit to receive man's [*sic*] stories. Able to be carried by articulated language, spoken or written, fixed or moving images, gestures, and the ordered mixture of all these substances; narrative is present in myth, legend, fable, tale, novella, epic, history, tragedy, drama, comedy, mime, painting … stained-glass windows, cinema, comics, news items, conversation. Moreover, under this most infinite diversity of forms, narrative is present in every age, in every place, in every society; it begins with the very history of [human]kind and there nowhere is nor has been a people without narrative. All classes, all human groups, have their narratives, enjoyment of which is very often shared by [people] with different, even opposing, backgrounds. Caring nothing for the division between good and bad literature, narrative is international, transhistorical, transcultural: it is simply there, like life itself. (Barthes 1984: 79)

In heritage interpretation the power of narrative has always been recognized. What is less understood is the way stories work, the different contexts of narrative, the debates about narrative and history (and by implication the debates about history and fiction), and the debates about narrative and heritage places. The rest of the chapter will concern itself with these important dimensions of narrative as it pertains to heritage, both tangible and intangible.

The work of narrative

Brian De Palma, the film director, has said that: 'People don't see the world before their eyes until it is put in a narrative mode' (quoted in Abbott 2002: 6). The British theatre director Peter Brook has written that: 'Our very definition of human beings is very much bound up with the stories we tell about our own lives and the world in which we live. We cannot, in our dreams, our daydreams, our ambitious fantasies, avoid the imaginative imposition of form on life' (quoted in Abbott 2002: 3). Such ideas are easy to comprehend.

Let us assume a group of visitors who have made their way to the archaeological remains of the fortress-city of Mycenae in southern Greece, have arrived there by dint of the itinerary of their package tour rather than arriving as 'pilgrims' to a citadel made famous in the epics of Homer. Setting aside for one moment the desire for an explanatory narrative, the visitor walks between the huge outer

walls towards the entrance, a stubby opening dominated by its massive lintel upon which is a carved tympanum with two lions facing each other and separated by a decorative column. Inside, quite near the entrance, is a series of concentric stone walls containing deep rectangular pits. And beyond the circle of pits there is a maze of low stone walls and pathways that form an irregular pattern and look haphazard to the eye. Let us further assume the visitors are equipped with an MP3 player (or a podcast on an iPhone) and as they walk about the chaotic site are told the following story:

> In 1874, when the archaeologist Heinrich Schliemann began to excavate this site, he was obsessed with a childhood dream of finding the truth about the epic tales of gods, heroes and warfare found in Homer's great epic poems *The Iliad* and *The Odyssey*. Mycenae, in Greek mythology, was the home of the powerful king Agamemnon. When his brother Menelaus, king of Sparta, asked him to assist rescuing his wife Helen who had been kidnapped by Prince Paris of Troy (or, as some would have it, she eloped with him), Agamemnon left behind his wife Clytemnestra and his children Iphigenia and Orestes and led a force of a thousand ships and 10,000 men in a war against Troy that lasted ten long years. Eventually, after the Trojans were tricked by the deception of the wooden horse they brought into their city, believing it to be a gift from the Greeks, Troy was sacked and burned. Agamemnon returned home to Mycenae only to find that Clytemnestra, his wife, had taken a lover, Aegisthus. Clytemnestra and Aegisthus murdered Agamemnon and then suffered the same fate at the hands of the children Iphigenia and Orestes. But was there any truth to the myth? Schliemann, after digging at Mycenae for two years, discovered the circular precinct with its royal graves and inside the graves he discovered skeletons and amazing golden treasures, goblets, jewellery and funerary gold facemasks. He believed he had found the burial place of Agamemnon and that he was looking at a golden portrait of the king of the legend of the Trojan War.

The story does many things. It immediately gives a form or a structure to the ruins of Mycenae by placing the archaeology within a historical framework. That which appears to be hard to fathom – a site strewn with rocks and criss-crossed with low stone walls – is transformed into something imaginable, a walled ancient city connected to a foundational myth of Greek antiquity. Further, it peoples the place with both mythological characters and historical characters by infusing the archaeological remains with 'life'. What seemed like remnants, fragments and rubble for our hypothetical visitors is given order, coherency, a place in time and a bridge to the twenty-first century by the narrative they listen to on their MP3 players.

However, in linking narrative's power to produce form, structure, coherency and meaning to the ruins of Mycenae, we run into a number of major problematics in the heritage-narrative relationship. One to which I'll return is the tendency of

narrative to give form and structure to phenomena, but this is an imposed and even artificial structuring of heritage places. What then of the possibility that places may be best understood, appreciated and experienced in ways outside of the effects of narrativity? Allied to this is the way a heritage place becomes sutured into the demands of narrative structure in order that the place can carry a story. Is the way a narrative organizes time and events (into causal relationships) the most appropriate way to communicate with visitors about a particular site? In other words, what are the implications of a heritage place being ordered by time and events linked into causation sequences? Causation is a vexed historiographical issue (see below).

Another problem is that, for a number of reasons, stories in themselves, and despite their promise, do not guarantee understanding. At the opening of this chapter, focussing on Florence's *Duomo*, I included technical descriptions and exposition as well as narrative. We therefore have to acknowledge that, despite the power of narrative in making sense of the world, there are other modes of knowing. If we want to understand why a structure like Hagia Sophia, the 1,500-year-old building that dominates the historical centre of Istanbul, remains standing and why the dome over such a vast internal space does not collapse, we need to turn to mathematics, physics and engineering techniques for an answer. To be sure, scientific knowledge can be subsumed into a narrative like the way it is in the National Geographic television documentary *Ancient Megastructures* (2007) and in the episode on the building of Hagia Sophia, but the physics and mathematics of building design and construction is independent of narrative understanding.

Another reason why narrative does not guarantee understanding is because of the frame of the story. By 'frame' I mean something akin to a picture frame (cf. Abbott's usage, Abbott 2002: 25ff.). A story is a contained entity (see below) but the way a story produces meaning is, to a large degree, dependent on what is happening outside the frame: in other words, on the context of the story's creation, the context of the story's subject matter and the context of the telling/hearing/reading of the story (how does the narrating happen, where does it happen, to whom is the story being told?) (cf. MacLachlan and Reid 1994). The story of Mycenae is a good example. There is a great deal of assumed knowledge in the audio-narrative I invented. Homer's epics are mentioned without any explanation. A basic familiarity with the Trojan War is assumed and it is assumed the listener will understand the reference to the wooden horse. In fact, the more the reader/listener knows about the epics of Homer, the plays of the Athenian dramatists, Virgil's *Aeneid* and the history and culture of the period, the more layered and complex will be the understanding of the podcast commentary. However, interestingly, and this points to the capacity of narrative to engage, the contextual details will not prevent understanding, limit it maybe, but not prevent it. Rescuing a kidnapped woman, a war and the destruction of a city by deception, the murder of a husband, the murder revenge of a mother and her lover by the children, a child obsessed by a legend and the discovery of hidden golden treasures assures access into the imaginary and even enjoyment of the story. The

'frame' of a story may indicate the inhibiting of particular understandings when the listener is a visitor from another culture and may not have the appropriate cultural knowledge to understand the story at the level of it being a culturally coded text, but even when this happens the listener/reader/viewer will still be 'read by the text' and their own cultural references will be used to make sense of the story (see Chapter 7). This is another reason why meaning-making cannot be controlled (see Chapter 2).

The Mycenae narrative also reveals something else about stories and understanding. Every narrative is linked to other narratives. Stories are intertextual (Allen 2000). I use the term 'intertextuality' in two senses: the importance of other texts to make meaning within a text and the way an individual text is linked to other texts in a network where texts are interdependent. This is more than authors referring to other texts in their writing. The Mycenae story can never be told as though it were entirely independent of the original stories of the Trojan War and the earliest of these are Homer's two epic poems *The Iliad* and *The Odyssey*. But there are other Greek sources that contribute (usually unconsciously) to the form and content of the narrative as the tale is retold in the twenty-first century – the Athenian playwrights Aeschylus, Sophocles and Euripides, and the Roman poet Virgil in his epic *The Aeneid*. Since the writing of the Greek and Roman sources (particularly those that have survived), the story of the Trojan War has been retold over and over throughout Western history and in a number of genres – literature, history, painting, sculpture, cinema, opera, ballet and popular culture. It has become archetypal. From a visitor's perspective, these numerous retellings of the story – including the Wolfgang Petersen film *Troy* (2004) – provide a cultural milieu for the comprehension of any Trojan War narrative encountered while visiting Mycenae as a tourist. The individual text (like the one I wrote above) has a complex symbiotic relationship with the many texts that precede it and exist along side it. Both the author of the narrative and the reader/listener/viewer of the story activate this intertextuality or this community of related texts. It is, I would argue, an important part of understanding the efficacy of narrative as it is used in heritage interpretation and in appreciating how and why stories work.

There is yet another. If we go back to the stories used thus far in this discussion (all of them pertaining to World Heritage sites) – the building of the dome of Florence's cathedral, the story of the fifteenth-century CE announcement of a betrothal in Florence and the story of Mycenae – there is an additional and central feature of these narratives other than events and the organization of time. It is the characters. There are people in the stories: Brunelleschi, his servant, the unknown narrator standing on the Ponte Vecchio looking down at the waters of the river Arno, Schliemann, Agamemnon, Clytemnestra and quite a few others. In Western culture the centrality of character in stories has been recognized since Greek antiquity. In narrative theory there is a debate about whether action can exist without characters and whether or not characters or action have precedence in stories (Abbott 2002). For me, the crucial thing, in relation to heritage interpretation, is the way stories demand that places be peopled. In cultural

heritage this is relatively straightforward as no material culture is devoid of human activity or, in some cases, the activities of supernatural beings like the deities and spirits. It matters little if the people are anonymous and their identities lost to us, material culture is, in our imaginations, inextricably associated with people who once lived and breathed on Planet Earth and built or made or lived in or used things we have designated as 'heritage'. Even in places of natural heritage, there are peopled stories and, perhaps more controversially, stories that anthropomorphize animals and plants or animate the flora and fauna with spiritual beings that have names and personalities.

The action/character relationship in narrative is one of the most powerful ways we engage with stories because, in the characters, we engage not only with other humans but also with ourselves. As social beings, we narrate stories to each other every day and we cast ourselves as a character in the stories we tell. Think of the news media and how often the stories and the pictures put characters at the centre of the action. In storytelling character is, to a lesser or greater degree, subservient to place. Hollywood has made its fortune on the back of the action-hero movie (as has Chinese action cinema) – I'm thinking of Lara Croft and James Bond. The places in the movie *Lara Croft: Tomb Raider*, Lara Croft's ancestral home, and her exploits in and around Angkor in Cambodia, are stunning and extremely memorable evocations of particular settings and landscapes, but it is the action-hero's exploits that drive the story and deeply exploit film's ability to absorb us. For all the magnificence, detailed rendering and eccentricities of the places and landscapes depicted in *The Lord of the Rings* movie trilogy, it is the characters that hook us into the action/time structure of the narrative.

I think this urge to animate the inanimate in Western society is very interesting in the context of heritage interpretation because it raises some important issues about material culture in the post-Enlightenment West that, in turn, can be contrasted with various non-Western cultures where the animate/inanimate division is nowhere near as distinct (for example, see Sutton 1988; Holt 2009). Because of the stories of the ancient Olympic games that we associate with the ruins of Olympia in southern Greece, the remnants of buildings and arenas and running tracks become more than their materiality. It does not much matter whether the stories are about the gods of the sacred grove or the athletes and the various sports undertaken to honour their deities and their cities every four years, or the story of Phidias, the famous Athenian sculptor who worked on the temple of Zeus (Perrottet 2004). Stories re-unite the tangible and the intangible. I say 're-unite' because, since the eighteenth century CE, Western culture has increasingly desacralized material culture, but never completely. The remnants of the sacred have been recast as aesthetics or notions of 'sense of place' or into symbolic ideologies. In other cultures the physical is alive with the spiritual and with the stories of spiritual beings. For the Anangu people of central Australia, Uluru the much photographed red sandstone monolith that soars above the flat landscape is not a geological wonder, but one inseparable from the stories of *Tjukuritja*, the creation ancestors (Parks Australia 2012). For the Laotians of Luang Prabang, the

former royal capital of Laos, the Mekong River and its tributaries are indivisible from the *Naga* spirits and the associated legends of the many headed serpent protector (Ngaosrivathana and Ngaosrivathana 2009).

As Porter Abbott explains, there are profound issues related to the stories we tell and the characters that people our narratives. Who are these people in our minds? Juliet of William Shakespeare's play *Romeo and Juliet* is a fictional character but whenever I hear about Juliet I always recall Olivia Hussey from Franco Zeffirelli's 1968 cinematic adaptation of the play. She is, in my mind's eye, Juliet. But what of a historical character like Brunelleschi? For some reason, and maybe because I've read Ross King's books about Brunelleschi and Michelangelo, when I think about Brunelleschi I think about Raphael's portrait of Michelangelo posing as Heraclitus in his epic fresco *The School of Athens* (1510-1511) in the Vatican. This is a complete fiction on my part but I can't seem to eradicate this image. When someone mentions the ruler Jayavarmin VII, who initiated the building of the temple complex known as Angkor Thom at Angkor in Cambodia, I think immediately of the giant portraits carved into the walls of the temple. But these are what narrative theorists call 'flat characters' (Abbott 2002). The image is not the person. For me, Brunelleschi and Jayavarmin VII, but not Juliet, are fairly two-dimensional as people, much like the images I recall. And this is often a real problem when narratives are used in heritage interpretation. At Angkor the guides will reel off the names of the rulers associated with various temples. As characters in the story, however, they remain elusive and virtually invisible. This is the case for many historical figures recalled in stories associated with heritage places. What therefore tends to happen is that the listener or reader will invent something to go in the gap; we will give the character of the story as much depth as we need for the story to do its work for us. Whether this conjuring is accurate or not is irrelevant because of the way we suture ourselves into narratives and because of what we learn about people from the continuous interaction we have with others in the 'real' world. There is, however, a constant dark side to all this because of our capacity and tendency to stereotype characters in narrative when there is an absence of detail and psychological depth, when we can't get beyond the image and when our imaginations fail us.

In heritage interpretation, I'm not sure there is an easy answer to this. Historical fiction, historical biographies and film can often present characters in narrative that are 'well rounded' and come across as 'real' people. Earlier, I mentioned Harper Lee's *To Kill a Mockingbird*. In both novel and film, Atticus Finch seems to live and breathe as someone I may know, and in one sense, I do know him. However, if I wander about the central business district of the city of Sydney and hear a tale about Governor Lachlan Macquarie, the fifth governor appointed by King George III to the colony of New South Wales, while I'm looking at the beautifully restored Hyde Park Barracks (a building he commissioned), I do not have anything like an experience that equates with my 'meeting' with Atticus Finch. Macquarie as a person is elusive. Herein, I believe, lies a challenge for characterization in heritage narratives.

Narrative as a determining construction of time/events/people/places

Thus far the discussion has *implied* the structure of narrative. We have noted that stories organize time and organize events in a causal relationship. We have explored some of the aspects of the ways stories and understanding are intertwined and the idea of the 'frame' as a way of thinking about this. We have considered the centrality of character in narrative. However, there are other elements of narrative that need to be recognized because of their importance in fathoming out to what degree narrative is a determining structure when it is used to convey information and meanings in heritage interpretation. Does narrative change the substance of what we communicate to visitors? On one level, the answer is 'of course' as do all representations (see Chapters 2 and 3). On another level, we have no choice because communication always involves a medium of some kind and the media in its own way will alter the communication process. Hearing a story orally is radically different to reading a story or seeing a documentary or movie or reading a comic book, both at the experiential or performative level and in the ways the different media are used to communicate stories and become inextricably part of the narrative. I will return to the issue of media types.

On the whole, narratives are linear, or perhaps more precisely, they have direction. Because time is involved and because our experience of time is in a forward direction (we can't reverse time in the physical cosmos) and European languages all employ tenses (past, present, future) then narratives bear the imprints of both the physical experience of time (the passing of the seasons, from childhood to old age, from morning to night) and the representations of time built into the grammatical structure of spoken and written language. That is why we are constantly told that stories have a beginning, middle and end. However, as Porter Abbott explains, narratives are not simply creatures of clock time. Stories can also manipulate time in ways that we cannot physically experience and therefore do things with time that we are forced to imagine. A story can go back and forth in time and can leap into the future; it can, through the use of sub-plots, offer parallel time sequences; it can bend time into unusual shapes (it can make time circular or it can make the past co-exist with the present, like in time travel, or it can compress time like historical narratives sometimes do and so on).

Despite these manipulations, however, stories follow a trajectory of sequenced events where time is an intricate player. This trajectory is the plot. If we avoid, for argument's sake, significant exceptions to this convention and experimentation with the narrative form itself, there is a general expectation that stories will begin somewhere and end somewhere else. Immediately we can comprehend that this may be problematic when applied to interpreting heritage places: it subsumes heritage into an event-structuring sequence and above all it brings into play the concept of closure. As Porter Abbott explains, audiences and readers generally presume a story will include satisfying resolutions to questions and expectations raised along the way. The resolutions of the plot and the satisfaction that we are not somehow 'left in the dark' at the end of a story, is the function of closure.

However, it is all a bit tricky. Readers and audiences will debate about whether an end to a story is good or bad (so some endings are obviously more satisfying than other endings) and many writers or film directors will argue that having everything resolved in a story makes for poor writing or film-making as it leaves the audience with nothing to ponder. Closure can be too absolute. For me, all of this raises very interesting questions about how we use and do not use narrative in heritage places. If we think closure is not necessarily the way we want a visitor to experience a heritage place, what then the role of stories and storytelling? I'll leave these as open questions for the moment.

Consider the following two sentences. The great pyramid of Cheops is the oldest of the three pyramids of Giza in Egypt, is about 4,570 years old and is the only remaining intact member of a group of monuments known as the Seven Wonders of the Ancient World. During his reign the Pharaoh Cheops ordered the building of his grand necropolis, probably appointing his Vizier Hemon to supervise and perhaps even design the structure. The first sentence is description because nothing happens. The second is a narrative because it contains action: Cheops orders and appoints. In the first sentence causation is weak. There is a link between the pyramid and the list of ancient wonders but the precise nature of the link is only inferred. In the second sentence the causation is strong. The pharaoh's command and appointment of Hemon produced the act of building the imposing tomb. As I have noted elsewhere, action and causation are two fundamental characteristics of narrative. However, we need to examine this more carefully. It is true that some theorists (Porter Abbott is one) argue that cause and effect is not necessary to make a text or picture a narrative but the *perception* of causation in narrative is almost unavoidable and is quite seductive. Porter Abbott writes of the gratification that comes from the desire for order and that narratives not only order time and events, but do so either explicitly or by suggesting cause and effect in the action sequences being represented. The desire and the gratification arise because of the human quest to understand the cause of things, for explanations of why things are why they are. The 'inevitable linearity' (Abbott's term, Abbott 2002: 37) of narrative helps because the composed sequence of events we find in narratives either makes cause and effect a conscious technique of plot construction or gives the illusion of cause and effect. We can observe the power of this in this passage about the birth and naming of the tempestuous but brilliant sixteenth-century Italian painter Michelangelo Caravaggio, taken from Andrew Graham-Dixon's recent biography:

> Michelangelo was a fitting Christian name for any child within the sphere of the Colonna family, defenders of the faith and warriors against heresy – but all the more so in the case of a child born not just on the saint's name day, but on the eve of the great battle between Christian and Muslim [the naval battle in 1571 between the Holy League and the Otterman Turks in the Gulf of Corinth in Greece and in which the Otterman navy was destroyed and] in which the head of the Colonna family himself would take a leading role. When victory

at the Battle of Lepanto followed within just a week of his birth, the hopes and prayers attendant on his baptism were answered. Perhaps he was thought of as a child who had brought good luck. Perhaps that was another reason why, despite his difficult personality and despite lapses into criminal behaviour, Constanza Colonna would always stand by him. (Graham-Dixon 2010: 15)

Cause and effect is writ large here and it works because we are so wedded to the *idea* of explanation as much as to explanation itself. However, there is a danger in all this (Porter Abbott calls it a treacherous experience) and from my perspective, with regards to heritage interpretation, it is a worrying danger. Because we are so enamoured and satisfied with understanding the cause of things, and because this is an in-built feature of narrative, then we can easily fall victim to the fallacy that because something follows something else it is causally connected. As Porter Abbott explains, this can, obviously, be the case and countless experiences bear this out, along with numerous theories, like the Newtonian laws of gravity, all illustrating cause and effect. I fall off my bike. I hurt myself. The danger arises when this appealing and deeply satisfying logic is applied to narrative contrivances. To a degree Graham-Dixon's story of the circumstances of the naming of Caravaggio works in this way. He wants to suggest cause and effect when there may be none at all. Of course he is a writer well aware of his craft and the demands of historical explanations and so he adds qualifications to his story, but the overall perception works brilliantly because of the reader's easy familiarity with the technique and the satisfaction causal connections bring. As readers of the story, we simply overlook the caveats.

In heritage interpretation the desire for explanation is often paramount in both those creating narratives and those listening, reading or seeing them. The following extract is from a popular guidebook to London. 'After the Romans beat a retreat in the 5th century, London entered a dark and confused period … By the beginning of the 9th century, calm and order returned to the troubled country under the rule of the man often called the first English monarch, King Egbert' (Berlitz 1977). Putting aside the fact that these are sweeping historical generalizations, the logic of cause and effect suggests that London's 'dark and confused' time was caused by the departure of the Romans and the 'calm and order' came about because Egbert was the king. It's neat and it offers an ordered explanation and, above all, it is intellectually satisfying. (It is also a contrivance that can be easily contested.)

Another characteristic of narrative that warrants attention is the voice of the narrator, the one who tells the story. While there are conflicting views about the identity and role of the narrator of a story (see Abbott 2002), it is fair to say that the position of the narrator is a powerful one. It can be an actual character in the story, like Nick Carraway in F. Scott Fitzgerald's famous novel *The Great Gatsby*, or it can be assumed the author and the narrator are the same person. In either case, there is always a narrator's presence in narrative and even in narratives written in the third person there is an assumption of the narrator's presence. In first-person narrative the character quite obviously occupies a commanding position because

they appear to be telling the story after the events and so are retrospectively representing them. From the reader/listener's perspective it is assumed the narrator knows all about the events they are telling us. Of course this is not always the case and the first-person device can be used to good effect when the narrator is not fully informed. For example, in crime fiction the narrator often tells the story as it unfolds so the reader is making discoveries at the same time as the narrator. With third-person narrative the author has the most scope. The narrator occupies a position of almost complete knowledge of all the characters in the story and the events that are staged, although the degree to which this is the case can be varied along a continuum that runs from a position of presumed – but illusory – objectivity (or detachment) through to complete identification with characters and events and complete knowledge of all that is and will happen and all there is to know about the characters. What does this mean for the reader/listener? With first-person narration, and because the narrator is a constant mediator, a sense of distancing (rather than immediacy) can be created, but obviously this is not an option often used by writers. With third-person narration the reader/listener mostly feels much closer to both the characters in the story and the events of the story. Consequently, decisions writers make about the narrator's voice have implications. Such implications flow through to the use of storytelling in heritage interpretation because of the way they position the visitor and the power relationship inherent in narrative with regards to the narrator vis-à-vis the reader/listener/viewer.

Types of narrative: is listening to a story the same as watching a movie?

We turn now to narrative types. Is there a difference between narrative that uses language (spoken or written) and narrative in the visual arts (sculpture, paintings and photography) or when images and language are combined (as in the cinema)? On one level there is little difference because the characteristics of narrative explored thus far, hold for all types. However, there are differences that are worth examining, especially given the increasing prominence of cinematic narratives in heritage interpretation and visual storytelling that involve no spoken or written words but are accompanied by evocative soundtracks. Computer-generated moving images that narrate archaeological reconstructions come to mind.

Let us begin with painting and photography. Narrative art has a long history in the West. It distinguishes itself from other genres of the visual arts because it is concerned with the representation of action and events. Generally, in portraits, in landscapes, in a still life and in religious images, especially icons, nothing happens as such and the image is therefore regarded as not being a narrative. Or, if the image or sculpture is not part of a well-known story, it too is considered as not having a narrative dimension. However, there are two-dimensional images that are narrative pictures.

One of my favourite action paintings is by the Japanese woodblock artist Katsushika Hokusai who printed his *Tsunami off Kanagawa* in about 1831.

The great wave picture is the first in a famous series of woodblock prints called *Thirty-Six Views of Mt Fuji*. The image was not made from one woodblock but a series so that Hokusai could produce coloured scenes. The image shows three wooden longboats facing tumultuous seas. A towering wave rises dramatically and menacingly over the boats, dwarfing them at the moment just as it appears to be breaking. The tiny rowers in the boats seem to bow or cower face-down beneath the immense power of the wave, awaiting their fate as the foam of the angry ocean appears to reach out to them like hundreds of grasping tentacles. Unlike language-based narratives, stories in a single picture compress the action and freeze time. The viewer fills in the gaps as we anticipate the next sequence of events. The wave will come crashing down on the boats with immense energy. Maybe the boats will somehow survive, but such is the predicament of the situation it is more likely that they will be smashed up and the occupants thrown into the churning sea. They are in peril. Unlike most stories, closure is withheld and this is partly the source of the image's hypnotic power: we are left in suspense about what actually happens next. And this is the point. The image engages because we are so familiar with the conventions of narrative. By compacting the action and stopping clock time, action and time are, paradoxically, enhanced in the viewing. While the characters of the story are 'flat' they are nevertheless central. If the boats had been without crew, then the implications of the breaking giant wave would have been emotionally very different. It is the threat to the lives of some twenty men that triggers our response. Beyond the frame of the picture we as viewers can conjure potent memories, perhaps of the devastating tsunami off Aceh in Indonesia on 26 December 2004 or the sensational Japanese earthquake and tsunami on 11 March 2011, or perhaps something much more personal.

At many heritage places, photographs are an integral part of the presentation of the site but in my experience the dominant mode of representation is of static views of material culture, often historical pictures, that try to evoke a mood and an impression of some past moment in time or are used didactically to compare an earlier time in the monument's history with a contemporary view. Rarely are these narrative images. Mostly they do not show any action; there's simply nothing happening in the image. This need not be the case. Narrative photography is far more evocative than still photography. A search of Google images under the headings 'action photography' and 'architecture photography' is instructive. The pictures of architecture, perhaps surprisingly, are full of movement and are charged with aesthetic cues designed to trigger a 'wow' response. But, despite the sense of movement, they do not tell a story. The action photos, however, narrate in the same way as Hokusai's *Tsunami off Kanagawa*. Such a comparison is not a plea for heritage interpretation to privilege action photography. Rather, I'm simply pointing out that, while both are forms of representation, only one tells a story and, crucially, the medium is part of the story because of its in-built capacities. To read the story of Hokusai's *Tsunami off Kanagawa*, as I have written it, is a very different experience of narrative to looking at the image on my laptop.

Cinema is the ultimate form of visual narrative and can stand alongside prose fiction in its powerful capacity to entrance the viewer in a complex choreography of characters, action, time, place, aesthetics and sound. Nevertheless, reading a narrative is not anything like watching a cinematic narrative. Film has long passed the point where it draws heavily, as it once did, on nineteenth-century serial novels like those of Charles Dickens, and stage plays as a way of representing action, character and time. While all the structural elements of narrative associated with written stories remain in films, the way they are configured is profoundly different. I was reminded of this during a viewing of John Woo's epic movie *Red Cliffs* (2008), the four-hour battle saga set in third century CE China during the time of the Han Dynasty. The juggling of multiple viewpoints during the narrative's action is typical of film's adeptness in enhancing and extending the structural characteristics of a story. The fast edits allow us as viewers to shift perspectives among the various players in the drama in rapid succession as we are thrown, in the battle scenes, between the vantage point of the various commanders on both sides and from that of the fighters embroiled in the chaos and carnage of the fighting. We switch from intense close-up shots of the faces of the protagonists, to ground-up scenes of intense one-on-one fighting by soldiers laden with armour and weapons, locked in deathly combat where the screen is full of thrusting and heaving bodies, and then suddenly to a magisterial view of the battle, looking down from afar giving the viewer a glimpse of the military strategies in play. And it's not just what we see; it's also what we hear, the action intensified and magnified by the sound effects of the battle and the orchestral soundtrack.

And, of course, it is also about the way film manipulates time. The Woo film has a strong narrative arc or plot that drives the story from beginning to end, from a time before the battle for the south to the end where the southern warlords defeat the ambitions of the Han Prime Minister Cao Cao's attempt to conquer them. However, within this structure time has amazing elasticity. In the battle scenes slow motion is used to enhance the gruesome nature of the violence. In some scenes the past is revealed in a series of shots interspersed with the present. In other parts of the film the illusion of simultaneity is created by a series of edits that show events ostensibly occurring at the same time in different places. Sometimes time is achingly elongated as in the scene where the bodies of those killed by an epidemic of typhoid are set loose on a boat to drift through the sea mists into the waters of the camp of the southern warlords. At other times hours of battle are compressed into just a few minutes. It seems that every trick of narrative time is employed by Woo.

Character is evinced just as much through action as by dialogue. The turmoil of indecision in the mind of the young lord of the Wu Kingdom, Sun Quan, is revealed in a solitary moment when he slowly unsheathes a sword of great symbolic value and in his almost fatal hesitancy during a tiger hunt. The viceroy Zhou Yu, we discover, is not just a clever military strategist but also a man who can be seduced by the lyrical pipe-playing of a young shepherd boy and who enjoys calligraphy with his wife before their sensuous lovemaking.

What *Red Cliffs* exhibits is quintessential narrative in general and cinematic narrative in particular. The telling of the famous historical story of the battle of the Red Cliffs in 208-209 CE is a creature of the cinema in the same way that the telling of the story of the Tsunami near Kanagawa is a creature of the woodblock print and the telling of the story of Atticus Finch and his children in *To Kill a Mockingbird* is a creature of literature. What must now be clear from all these examples, and the ones earlier in the chapter, is that the notion of narrative is not just the story but also the structure of the story, and the two are utterly inseparable. One cannot exist without the other. But also, as we have seen, the structure of narrative is quite determining and this has implications. The rest of the chapter, therefore, will devote itself to the complex question of history, heritage and narrative and to the issues that arise when narrative structure is applied to the past/present.

Stories: truth, fiction, history and heritage

Our lives are not narratives or stories. However, within our life experiences there are elements that are the building blocks of a story: the passing of time, the events of the day and the people we interact with. Consequently, with little effort, we can turn the events and people in our lives into a story; we can use narrative to communicate aspects of our experiences. And we do, every day and often. Nonetheless, when we tell our stories we are imposing a narrative structure onto our lives in retrospect, after the event. This does not, for most people, detract from the veracity of the stories we tell because as narrators we are characters in our own stories, thus the notion of the 'true story'. Does this common-sense understanding of the relationship between our daily lives, stories and truthfulness hold when narrative is applied to history or heritage? It is, perhaps, not surprising that this is a sophisticated and complex philosophical question.

In recent decades there has been a debate about whether narrative history is closer to fiction than reality because of the way historians use the techniques of narrative to reconstruct the events of the past and that the dictates of narrative therefore alter the past and, in consequence, our understanding and knowledge of the past (Roberts 2001). The same argument could be mounted about stories that pertain to heritage places. I think it is an important debate but from my perspective I feel confident about the use of narrative in both history and heritage and this is my reason.

History and cultural heritage are human constructions of the present. In the case of history, we can never return to the past as it was lived. What historians do is construct plausible explanations and interpretations about the past based on the materials that have survived from yesteryear (material culture, written records and oral stories) and based, where they exist, on earlier interpretations by preceding historians and archaeologists. History, like all explanations, is a representation (see Chapter 2) and therefore it is open to contestation and multiple understandings by different readers. And history is an ongoing process as each generation interprets

the past anew, based on the unearthing of previously unknown material or because different explanatory frameworks like feminist theory or postcolonial theory are applied to the archive of material the historian is working with or the archive itself is rearranged in such a way that new insights emerge. Historians can only ever represent the past. It is always an incomplete project because we cannot go back to the past to check our understandings, and the closer we get to the present, the more information is available to historians who must carefully select from an over-abundance of data. So the question is *how* to represent the past in the present. Because history is about time, events and people and because historians have always been tempted to explore causation (why did something happen) then narrative is a strong contender for the mode of representing the past. Some would argue it is the natural contender because it accords with the relationship between people as story generators and story perceivers; humans use narrative to know, understand and explain and this is what the enterprise of history is all about (Roberts 2001).

Narrative history has also been extremely successful despite the profound and important critiques mounted by scholars like Hayden White (2010). Putting aside my critical hat, I know I'm very easily seduced by narrative history in all its forms: a narrative account of the fall of the city of Delhi, the last Mughal capital, as in William Dalrymple's colourful and complex masterpiece (2006); a documentary account like the History Channel's *Rome: Rise and Fall of an Empire* (2008); a historical novel like Geraldine's Brooks' *Caleb's Crossing* (2011); a historical movie like *Red Cliffs* (2008). What is important here is that it is through narrative that I get my own unique sense of the past fashioned by the way time, action, character and causation are employed by the historian in a manner that matches my own experiences of how narrative works and my appreciation of how important it is to human knowledge and understanding. Of course a furious debate can arise over the fact I could put, side by side, on my list of narrative histories both fiction as well as scholarly history, William Dalrymple with Geraldine Brooks (Clendinnen 2006; Curthoys and Docker 2006). I don't discount this debate. It's an important one about the distinctions between fiction and history and about causation. However, I also know that many fine historical novels and filmed versions of the past can be as 'true' to the records of the past as any scholarly attempt and that some scholarly attempts can be as deceptive and untrue as any fictional account (cf. Rosenstone 2006 and his study of history and the cinema).

Narrating heritage places, monuments and landscapes is no different. All the issues pertaining to narrative history apply to narrating heritage. Indeed, as is often the case, narrative is the link between places marked out as 'heritage' and the scholarly pursuits of history, archaeology, art history and ecology. However, as we have already seen, narrative is also a contemporary mode of expression that, in Western heritage, brings into spatial and ontological proximity material culture, ecology and intangible culture (and doubly so when the intangible culture of a place is its stories). Thus heritage interpretation is often a meta-narrative like the one I scripted for a hypothetical podcast about Mycenae. My story sits over

and draws upon other stories connected to the ruins of the city: one is intangible heritage, the story of the Trojan War from ancient Greek mythology, and the other is the archaeological story of the city. And, while I'm aware of all the critical issues that arise from such a construction (the issue of the affinity with fiction, the issue of a determining structure, the issue of inbuilt causation), I still see the value of storytelling as both a function of and an expression of heritage places. Ultimately, the desire to tell and hear stories about the places we are visiting is a deeply satisfying experience that emotionally and intellectually connects us to our perceptions of the past, to our understandings of our identities, to our cultural affiliations, to our fellow travellers and for me, above all else, to our imaginations and our desires; to the ineffable.

Narratives and heritage interpretation: some implications

The urge to narrate is overwhelmingly powerful in all people and in all cultures, and like language is an inescapable part of being human. We are not just listeners and watchers of stories; we are all story-makers and storytellers. And so, in summary, what are the implications for heritage interpretation? I want to reprise four.

Firstly, because stories are representations of heritage places and because heritage sites can be apprehended and comprehended through narrative, then on one level the story really is the thing. Story and the physical world of heritage places become co-joined in a way that defines both. Of course, as we saw in Chapters 2 and 4, narrative is not the only way heritage places are represented but narrative is a very potent form of giving material things meaning and making material things the touchstone of our deepest desires, feelings, imaginations and emotions. As so many writers argue, heritage in the twenty-first century is related to all manner of uses and now seems ubiquitous (Lowenthal 1998; Smith 2006; Waterton and Watson 2010; Anheier and Isar 2011). The role of narrative in heritage interpretation reinforces the fact that what's often at stake is not things, objects and landscapes, but us. The use of stories to interpret underscores the social nature of all heritage(s).

Secondly, there are many stories associated with any single heritage place and there are a variety of ways we may want to think about this multitude of stories: for instance, as ethnography, as performance, as ideology, as semiotics, as embodied (cf. Eco 1987; Edensor 1998; Bruner 2005; Crouch 2010). However, in terms of heritage interpretation I think one of the ways to consider the profusion of narratives is to think about officially sanctioned narratives and unofficial narratives. By sanctioned narratives I mean those stories that have the imprimatur of institutions. It can be the narratives of scholarship (of historians, archaeologists, art historians, architectural historians, ecologists and so forth) and the narratives of custodians of heritage places (those who work for conservation agencies, heritage agencies or are traditional owners of a site) and usually a combination of the two. Unofficial stories about heritage places are those created by everyone else.

Uluru-Kata Tjuta World Heritage site in central Australia is a good example of the way the official, the semi-official and the unofficial all jostle together in a very rich narrative environment. As I've already mentioned, the official stories of Uluru, the massive red sandstone monolith, are those told by the traditional owners of the site, the Anangu people, who focus on the stories of *Tjukuritja*, the creation ancestors. However, there is a semi-official story. Many non-Indigenous Australian visitors are often aware that Uluru was where Azaria Chamberlain, the baby daughter of Lindy and Michael Chamberlain, disappeared one night on a camping trip in August 1980. Lindy was charged and convicted with the murder of her daughter despite her claims that the baby was taken by a dingo, a wild dog. After the discovery of the child's jacket in an area full of dingo lairs, she was exonerated. The case was a media sensation in Australia and in 1987 the episode was made into a film, directed by Fred Schepisi and starring Meryl Streep as Lindy Chamberlain. For many complex reasons the Anangu people never mention this story in the interpretation of Uluru. Many tour operators and non-Indigenous guides do. Interestingly, the Wikipedia site devoted to Uluru, presumably authored by the Australian Government, makes no mention of this case. At the same time, a popular narrative of Uluru is the story told by visitors who, controversially, climb the rock. This action is against the wishes of the Anangu people and the National Parks service. When it is mentioned in the official material of the site it is not as a narrative but as a warning about the risks and as a request not to climb. However, many visitors do climb and it is a very common story of people's experience of Uluru.

Thirdly, narrative sutures heritage places into a particular form of representation; it absorbs the physical entity into chronological time, and it provides action, character, causation, closure and a narrator. Heritage interpretation that employs narrative furthers this structuring but mostly uncritically. I do not think I have ever heard a story told or written for visitors about a heritage place that questions the narrative/heritage relationship. At the level of delivery to visitors there may be good reasons for this, but in the heritage interpretation manuals (see, for example, Pier 21 2007; Lancaster and York County Heritage (PA) 2007; Pastorelli 2003) there is less excuse for such a lack of critical awareness about the effects of narrative on heritage. Chronology is particularly pernicious in the way that it organizes cultural heritage into a linear sequence (of styles, of functions, of patrons, of political regimes and all manner of classifications) (cf. Bennett 1995). Applied to heritage sites the effect of chronological time is peculiar. Certain buildings, like Florence's Cathedral, for example, become divided up into a chronological jigsaw puzzle: the walls of the nave built in the thirteenth century CE, the apse and side chapels in the fourteenth, the dome in the fifteenth and the facade in the nineteenth. Within urban landscapes of historic towns the chronological narrative teeters on the chaotic as different eras of building are delineated. Different notions of time, free of chronological progression, can create very different narratives. I'd prefer the use of ritual as a narrative subject in the case of Florence's Cathedral because time, action and character in ritual do not depend on strict linearity and

the story of ritual encompasses, indivisibly, both the tangible and the intangible. And as a bonus, the materiality of the building is not then privileged in the story.

Fourthly, because stories are such a powerful and seductive way of connecting people to places, monuments, landscapes or ecosystems, are there responsibilities involved? Is there an ethics of storytelling at heritage places (cf. MacCannell 2011)? Certainly there are cultural issues about who can and cannot tell heritage stories (see Chapter 7) but I'm thinking more about the claims that the stories should contain didactic messages, that an aim of heritage storytelling is to change attitudes and even behaviour by instilling a conservation awareness. I'll return to this in the final chapter but suffice it to say that Chapter 2 exploring heritage interpretation as representation and this chapter about stories indicate why I think such aims cannot be easily realized, if at all (cf. Harris 2010).

A crucial dimension of any discussion of contemporary narrative is digital media. I have been completely silent about digital storytelling, and about narrative and social media. It is to cyberspace, unsurprisingly, that we now turn our attention.

Chapter 6
Digital media and social networking

Contours of a phenomenon

The Sirindhorn Dinosaur Museum is in the small town of Sahat Sakhan in north-east Thailand, or Isan as the Lao-speaking region is often known. Each day the museum is subjected to a minor invasion of schoolchildren bussed in, and in some cases quite long distances. On a recent visit, I was quite taken by something utterly striking: the mediation of the screen. Throughout the Dinosaur Museum there is the widespread use of digital screens as part of the presentation of their impressive fossil collection, Sahat Sakhan being the Thai site of the most extensive palaeontology finds from the Jurassic period. But much more intriguing was the way these student visitors – in their hundreds and ranging in ages from, I guess, 10 years of age to 15 years – used their digital cameras and phones to photograph everything that took their fancy, from photos of exhibits, photos of the signs and dioramas, of each other, of each other in front of towering dinosaur skeletons. Every significant moment was digitalized. It was such a spectacle that I was captivated by the phenomenon of this screen-mediated looking and began recording the event on my own digital camera. I could imagine the next series of actions. The students swapping photos via email or Facebook. Their own photos pasted into assignments. Creating an illustrated story available to friends on social media. Digitally 'playing' with their photos and videos to create entirely new images that bear little resemblance to the original or to its originating context and then this too being 'launched' into cyberspace to be circulated, perhaps globally, and enjoyed by countless others via Google Images or YouTube.

The seemingly obligatory digital media interaction of the students at the Sirindhorn Dinosaur Museum contributes to and is a characteristic of what Henry Jenkins describes as 'participatory convergent culture' (Jenkins 2008). Convergence, he argues in his book *Convergence Culture*, is not just about, nor primarily about, the technological processes that have brought multiple media functions within the same device whether laptops, 'smart' phones, iPads or tablets and globally connected via the World Wide Web network. The crucial characteristic of a participatory convergence culture is that production of content and the consumption of content is co-joined, where the digital media user seeks out and makes new connections between globally distributed disparate media content. Participation in digital media is as much a state of mind, a way of being in the world, as it is a series of technology-enabled actions. Susan Maushart, in her book *The Winter of Our Disconnect* (2010), expresses this more elegantly when she suggests the generation that has grown up with digital technology and

the World Wide Web don't merely use digital media but 'inhabit it, exactly as fish inhabits a pond. Gracefully. Unblinkingly.'

On one level, it is quite difficult to write about digital media and social networking because we are totally immersed in a change event that is marked by ongoing technological innovation, by ongoing massive investment in infrastructure and by user/consumer creativity. All I can hope to do is point to some of the emerging characteristics that, even as I write, are already of the past/present, such is the rate of change, but nevertheless seem to be significantly re-configuring the lineation of heritage interpretation (for useful and acute descriptions of digital media, see Jenkins 2008; Hillis 2009; Lister et al. 2009). After all, heritage interpretation and the various ways people interact with heritage sites puts communication as one of the *a priori* fundamental dimensions, and digital media, or 'new media' as its is sometimes termed, has increasingly become an integral mode of that interaction with heritage places whereby this interaction has become inseparable from the communication of a digitally mediated experience to others and to the visitors themselves.

Digital media provides its own fascinating 'snapshot' of the extent of the distribution and penetration of various digital media platforms and it is worth summarizing some of the salient features of global connectivity and the modalities by which the so-called 'convergent culture' is created by its participants. In September 2012, the number of Facebook users reached 1 billion. In the same year in a country like Australia, Facebook reached a penetration of 54.6 per cent of the total population and nearly 50 per cent of these users were aged between 18 and 34 years. According to socialbakers.com, the penetration of the Internet in Australia stood at 70 per cent of the population in 2012. In January 2012, worldwide, YouTube users watched 4 billion videos a day and 60 hours of videos were added every minute. The source for this astounding statistic was mashable.com, itself a social media website with 20 million visitors and 6 million social media followers.

As of November 2012, Wikipedia, often considered one of the archetypal examples of digital media, had 23 million articles online in 285 languages. The English edition had 4,106,899 articles. The site is visited monthly, on average, by 12.5 per cent of all Internet-users and hovers around the top 6 most popular sites. The English version of Wikipedia receives 7 million global page views per day. Google, in comparison, in May 2011 received 1 billion unique visitors per month. In contrast to Wikipedia and YouTube; but, as an indicator of the extent of the video-sharing phenomenon with a global reach, XTube, a Netherlands-based pornographic video-hosting service that allows the sharing of adult video content with producers/users had, in November 2012, nearly 10 million registered users and an Internet global traffic ranking of 491 (en.wikipedia.org). The online virtual world *Second Life* in November 2010 had 21.3 million registered accounts and in May 2010 the concurrent use was averaging at 54,000 (en.wikipedia.org). In the virtual world of online role-playing video games, in February 2012 *World of Warcraft* had more than 10 million subscribers. The number of players of the online game using handheld devices like smart phones was 55 per cent. The average age

of a multiplayer online role-playing gamer was 30 years and these 30-year-old players had played, on average, for 12 years. Women accounted for 42 per cent of gamers and 29 per cent were over 50 years of age. Most interesting of all is that 65 per cent of gamers play games with other gamers in person (en.wikipedia.org).

While these figures are quite impressive they do not tell the whole story. There has been an ongoing discussion about the geographic distribution of the Internet and smart phones and concerns have been expressed about the so-called information technology divide based on the numbers of devices and users within and between nations and the availability of infrastructure like broadband Internet and 3G wireless connectivity (Jenkins 2008; Lister et al. 2009). But the most recent figures available on the Web suggest a very fascinating emerging global scenario (see table below).

World internet users

	Percentage of global total in June 2012	Penetration as percentage of population	Percentage growth 2000-2012
Asia	44.8	27.5	841.9
Europe	21.5	63.2	393.4
North America	11.4	78.6	153.3
South America	10.4	42.9	1310.8
Africa	7.0	15.6	3606.7
Middle East	3.7	40.2	2639.9
Oceania	1.0	67.6	218.7
World		34.3	566.4

Source: internetworldstats.com

Even more interesting perhaps, is the rate at which smart phones have been adopted. Googleblog.com reported in May 2012 that over 50 per cent of the population in Australia, UK, Sweden, Saudi Arabia and the United Arab Emirates used smart phones and it was already greater than 40 per cent in the USA, New Zealand, Denmark, Ireland, Netherlands, Spain and Switzerland. Techcrunch.com in June 2012 reported that by the end of 2015, based on the current rates of uptake, smart phone penetration in Africa will be 40 per cent and 80 per cent of these users would have Internet connection on their phones. In the same report, it was estimated that in July 2011, across 159 countries, a 3G mobile network covered 45 per cent of the world's population. Connection to a 3G wireless network is the basic requirement for a mobile handheld device to have access to the Internet. Mobithinking.com reported that in Japan, in March 2012, 95 per cent of the

population had mobile smart phone subscriptions and 84 per cent could access the Web on their phones. In contrast, in April 2012, it was estimated that 'only' 431 million mobile phone users in China could access the Web but this was a 49.7 per cent increase from the end of 2010. It was also pointed out that this access to the Web, via mobile devices, would rapidly increase with the spread of the 3G wireless network. As of April 2012 only 159.3 million people in China used 3G on their mobile devices but this situation was likely to change relatively quickly. An important parallel geographic trend has been access to the Web on mobile phones compared to access on desktop computers. In December 2010, according to Mobithinking.com, in Egypt 70 per cent of Internet-users accessed the Internet on their mobile phones (compared to 30 per cent on desktop computers), 59 per cent in India, 57 per cent in South Africa, 54 per cent in Kenya, 44 per cent in Indonesia, 30 per cent in China, 25 per cent in the USA and 22 per cent in the UK.

So what does all this mean? The most significant aspect of these trends for heritage interpretation is the way mobile devices are increasingly being used to access the Internet and that this type of access is the preferred form of Internet access in developing countries. In the developing world inhabitants have virtually skipped the desktop computer phase of connecting to the Web. The growth of 3G and now 4G wireless mobile networks and the increasing ownership of smart phones, or other handheld mobile devices, suggests, in populations across the world, both rich and poor, a closing of the technological gap with regards to Internet access and it points to the fact that globally the Internet will increasingly be, literally, in people's pockets.

For heritage site visitors, the implications of these trends are quite obvious. In the not too distant future, a majority of visitors to any heritage place will arrive with a mobile device connected to the Internet. In May 2012 Googleblog.com reported a survey of mobile phone users indicating that 80 per cent of smart phone users in the USA would not leave home without their phones and that a third of these would give up their televisions before their mobile devices. Irrespective of the accuracy of these figures or the veracity of the survey methodology, the sentiment is what is important. New digital media, with a focus on handheld devices with Internet capabilities is, increasingly, the preferred means of access, consumption and production of content. The arrival of tablets, such as the iPad, underscores this preference and points to a future that in some places (like Japan and Korea) is already here: people, wherever they are geographically, have the capacity to be connected to the Internet all day and every day on handheld mobile devices. The Web as a global network, in essence, is permanently connected to and an extension of the body. The fusion of flesh and bones with technology has long escaped the domain of science fiction and has become the everyday, but never has this been starker than with digital technologies. The imaginings of William Gibson in his novel *Neuromancer* (1993), and that of the Wachowski brothers in their 1999 film *The Matrix*, have edged closer or, as Donna Haraway wrote in a somewhat different context, we are all cyborgs (Haraway 1991).

A new conceptual architecture

It would be reductive and a misconception to see these quite radical changes as simply about a more effective communication of information at heritage sites. On one level, this is undoubtedly true, but the changes I've described are also emblematic of other capacities. The ability to create and send content wherever and whenever; the ability to be in constant communication with a global network of contacts or friends; the ability to access whatever the Web offers, whether words, images or sounds, at any time and in any place; the ability to contribute to conversations via a huge number of sites offering blogging facilities; and the ability to project one's ideas, desires, identity, personality and feelings via social networking in numerous ways. The latter can include memories, family history, interacting with heritage (however conceived) especially visually (photography and videos), making heritage political (like campaigning to save something from imminent destruction), recording family recipes for posterity or recording family celebrations and so forth. The making of heritage at the local level therefore becomes a complex mixture of individual actions, like those I've just described, along with numerous opportunities for and the numerous dimensions of interacting with heritage places that have been marked out as such. But more than this, crucially, in the realm of social media the personal rapidly escalates into the communal, a shared experience that is sometimes confined to family and designated friends, or to lists of the like-minded, or at other times is launched more widely, even globally, via platforms like YouTube.

We have perhaps only just begun to realize the effect of a networked world where multiple sites of creation/production – that themselves draw on whatever is already available on the Web (in turn an immense and constantly evolving searchable resource for data of many kinds) – become both sites of consumption and a new data source that, together, form a kind of endless process of hermeneutical looping and intersecting. Heritage sites per se are not at the centre of this ecology; it is the individual creator/consumer and her networks that form a node within a dense constellation of nodes and pathways. Heritage, in this scenario, is just one relatively small element of personal creativity, identity-making, memory-recording, social communication, cognitive processes and emotional engagement (cf. Cameron 2008).

This was the process I was witnessing at the Sirindhorn Dinosaur Museum and in the anecdote I related in Chapter 1 about my nephew's visit to the Art Gallery of New South Wales in Sydney. And in my mind this is the big shift that requires a very different conceptual understanding of what is going on (see Cameron and Kenderdine 2007). Heritage sites are, of course, intensely engaging with the digital (see below) and the amount of online material being produced by both museums and heritage places is quite staggering in scale, scope and sophistication as all sorts of techniques of construction and presentation are employed (see Kalay, Kvan and Affleck 2008). Another type of convergence is quite easy to identify as archaeological reconstructions, object records, virtual tours, specific apps for smart phones and so

on use ideas that are drawn from, for example, digital cinema, computer-generated imagery, video games, virtual immersive worlds, Google maps and geographic information systems. However, to consider this as just a new way of effectively communicating with visitors in a one-dimensional way (as though in the same order of things as a guide talking to visitors or a clever audio-visual presentation in a theatre or installation within a heritage place, or reading a guidebook on site) misses the main game altogether. It is the active participation of the user/visitor that is critical and this participation is not just active looking, or considered and thoughtful listening or reading, or the meshing of new information with the already known, or a sense of informal learning in situ. Such a paradigm of understanding digital media is defective and far too limiting (Cameron and Kenderdine 2007).

Siena as a 'mashup'

Let me illustrate what I'm talking about. In recent years I have been asking my students in Australia and Thailand to consider digital media and heritage interpretation in the form of a project that is quite self-directed, and that charts their own digital and social media behaviours (as consumers and producers), on a heritage site of their choice. The following is the work of a number of students over several years but I've merged these together to form a composite example from a hypothetical student I will call Gabriel. Gabriel chose Siena in northern Italy as a World Heritage city for the investigation. The choice was not accidental because Gabriel's maternal grandparents grew up in Siena before migrating to Australia after World War II. The first task s/he chose was to construct a digital inventory of all the information s/he could find on the Web about Siena past and present and these s/he documented on an iPad as a series of hyperlinks. This was extremely extensive. It included not only the materials available on sites like Wikipedia and YouTube (official and unofficial), but official city sites and official heritage sites, tourism sites, personal blogs by tourists and residents. There were Web sites related to the Palio, the bareback horserace that has been run twice yearly in July and August for over 800 years in honour of the Virgin Mary, and is a singular spectacle that has made Siena justly famous. There were also image archives on Google Image and Flickr. There were virtual tour sites that offered 360-degree panoramas in the horizontal plane and 180-degree views, from floor to ceiling, in the vertical plane. Google Earth offered maps and panoramas of the city and there were audio-tours to be downloaded to iPods. There were interactive maps to explore. YouTube offered a feast of visual material, everything from lengthy videos of the Palio, and the trials and tribulations of the Siena football club, to Sienese food, heritage tours of the city and personal reflections and tributes to the city, plus an array of idiosyncratic videos of people 'doing stuff' in Siena and using pictures of Siena as the basis of a music video. The archive, therefore, produced a wide assemblage of disparate representations of the city and its life, all of them interpretations in their own right (see Chapter 2).

So what did Gabriel do with this material? Before I answer this question I want to highlight what I would focus on when I look at what is available on the Internet. Because of my academic background and professional interests, it is not surprising that what stands out for me about the Siena material has little correspondence with the personal reflections of tourists or locals (most of which is in Italian). I would gravitate towards the city's turbulent and colourful history, the art and architecture of Siena, the Palio, the food and wine of the region and the summer music festival. My Siena is a distinctly late medieval one seen and enjoyed through the prism of contemporary Siena. I do have personal stories about Siena and it is a city redolent with significant memories for me, but these always seem to exist in a parallel universe, especially when I consider the way I would represent the city to others, whether tourists or my students. Not only am I caught within the confines of linear and eschatological time, my interests create an imagined Siena that highlights the tangible and the intangible in a distinctive pattern that would be recognizable to many Westerners working in the fields of history or heritage (cf. Harrison 2013).

Gabriel's response was significantly different. The personal Siena was not a parallel universe but the ground of the digital interventions. What emerged was a 'mashup', an interactive website that was strongly linked to a Facebook page and to YouTube and other Web applications (en.wikipedia.org). It was not a static or 'completed' project/site, but one that was dynamic, open-ended and creatively evolving thanks to the numerous inputs by those who were contributing to it. In fact, Gabriel wasn't the only author. Certainly s/he designed the digital interface, something that was a work of art in itself – inviting, colourful, engaging, personal and idiosyncratic. But beyond this what emerged was a ceaseless interaction between fellow classmates, his/her family and friends.

It is impossible to describe in words the way this digital creation worked or what it included because what stood out changed, at any point in time, as did the conversations and the contributions (that, from the beginning, were in both English and Italian). Siena the city and its rituals was always a presence but one that seemed to float in and out of view. What follows is a representative list of things that caught my eye and my attention:

- contributor's links to interesting images and videos of the Palio (a constant reference point on the site);
- a grandmother's reflection about growing up in the *contrade* (neighbourhood) of the snail;
- a serious discussion about the ethics of government prompted by Lorenzetti's famous fourteenth-century fresco *Good and Bad Government* in the Palazzo Pubblico;
- a recipe for *panforte*, the well-known sweet and spicy concoction sold all over Siena;
- a photographic series on gargoyles and other fantastical sculptural figures on Sienese buildings;
- a YouTube video about the flags of the *contrade*;

- a blog interaction about falling in love in Siena and a discussion about Sienese men and their sense of the masculine;
- a poem about the death of a beloved aunt who lived in Siena;
- a link to a 'virtual tour' of the *Duomo* or the Cathedral;
- a family history of the Sienese grandfather with a scrapbook of family portraits;
- a cousin's lament about being torn between his love of Sydney, where he was born, and his love of Siena;
- a friend's university essay on Ducio's *Maesta*, the masterpiece that once adorned the high alter of the Duomo and now dwells in its own special room in the Opera del Duomo;
- a funny video about the cats of Siena;
- a somewhat grotesquely 'gothic' description of the bodily remains of St Catherine of Siena with pictures, followed by a touching devotional piece about the saint;
- a link to a university's student's design project, a 3D reconstruction of the tower of the Palazzo Pubblico;
- a link to a video game *Assassin's Creed*, two of the series set in fifteenth- and sixteenth-century Renaissance Italy (but not Siena); and
- numerous links to recipe sites and music videos and other sites that were of mutual interest to the online contributors, but had little to do with Siena as such.

The site was live for about twelve months and has now become an invitation only site, and is a special place/space in Gabriel's family with contributions from both the Sienese side of the family and the Sydney side of the family. It continues to host blogs, pictures, videos and links to other Internet sites. It continues to evolve and change in shape and function as the contributors change or drop in and out of the site. It has become what Elisa Giaccardi (2012) calls 'spontaneous and continuous' heritage-making where heritage, however conceptualized and via social media, is knitted into the everyday.

Laurajane Smith, in her extremely important book *Uses of Heritage* (2006), makes the point that heritage is something we do rather than being a material object/monument/landscape. She and others, including myself, have suggested that heritage is best understood as a verb rather than a noun. Rodney Harrison puts it this way:

> Heritage is not a passive process of simply preserving things from the past that remain, but an active process of assembling a series of objects, places and practices that we choose to hold up as a mirror to the present, associated with a particular set of values that we wish to take with us into the future. Thinking of heritage as a creative engagement with the past in the present focuses our attention on our ability to take an active and informed role in the production of our own 'tomorrow'. (Harrison 2013: 4)

Gabriel's digital engagement with Siena past and present, with her/his family and friends in an ongoing creative process and engagement was, as Laurajane Smith might say, 'doing the business of heritage'. But note how the emphasis is on production and doing rather than purely on consumption; note how consumption is part of production that, in turn, becomes consumable; note how the process is not linear but a complex interactivity that is dynamic and evolving and not governed by teleology; note the promiscuous use of whatever is available on the Web, some of it 'official', 'authoritative' and scholarly, but much of it serendipitous and unofficial. And, most significantly, note how this is qualitatively different from reading a sign or guidebook, listening to a guide, or taking an audio-tour or even using an iPhone app that provides alternative ways of negotiating a particular monument (for example, experience the Palazzo Pubblico in the words of the Sienese; or experience it with a soundscape; or listen to a historical narrative; or view a computer-generated image reconstruction; or listen to the room-by-room guide). No looking or listening is, of course, entirely passive as the visitor has to make sense of what is being communicated, but the 'traditional' communication techniques used at heritage sites are not, it seems to me, in the same order of things as Gabriel's 'mashup'.

But how consequential is this difference? Heritage visitors may be part of 'mashups' but do they affect the physical experience of heritage sites in real time and space? Isn't the Sienese project considerably different to the digital interventions that are now characterizing heritage place experiences, like a downloaded podcast tour onto an iPhone or a GIS-activated commentary on a smart phone as a visitor navigates the officially marked heritage of streets in a historical city like New York or London? The first two questions remain important issues that I will address later. There are two ways of answering the third question. One can persist with the idea that podcast audio-tours and GIS-activated commentaries are just extensions of 'old' ways of interpreting material culture but simply using digital techniques, or one can regard such applications as being part of a much deeper digital transformation of culture. My view is that Web 2.0, and all it emblematically stands for, is indeed as much a rupture with the past as anything contiguous. Web 2.0, and, more generally, the Internet and other digital technologies like G3 wireless, has markedly changed the quotidian in quite radical ways (see Cameron and Kenderdine 2007; Kalay, Kvan and Affleck 2008).

Web 2.0: the game changer

How, then, do we understand the difference between analogue media, and the communication that flowed from its use, and digital media and what is now commonplace in communication? Just how different are text panel signs, guides, interpretation centres and guidebooks when compared to 'mashups'?

I would argue that since 2004, the launch date of Web 2.0, this innovation within the Internet's architecture has created something unprecedented and has

overturned many of our accepted notions about data, information flows, learning, producers and consumers, and the interface between technology and identity. Wikipedia is often cited as one of the major manifestations of Web 2.0 and so it seems appropriate to consult it in order to define the characteristics of this Internet development. The term Web 2.0 simply denotes the transition from websites that were static and individual information silos controlled by webmasters and website designers, to a social phenomenon where web content is both generated and distributed via an Internet platform that is characterized by open communication, decentralized authority, the freedom to share and reuse material, and a phenomenon that supports collaboration and sharing. Web 2.0 consists of user-owned sites and user-controlled data. It is, as Wikipedia describes it, an 'architecture of participation' that is user-friendly, allows material to be both uploaded and downloaded and facilitates social networking. Web 2.0 users, as we have seen in the case of Gabriel and his/her family, are famously described as 'producers and consumers' that generate their own content through discussion boards, blogs and social networking sites like Facebook, MySpace, Flikr, YouTube, Wikipedia and hyper-linking across a number of disparate and individually selected Web sites (the details about Web 2.0 can be found at en.wikipedia.org).

Elaine Gurian, the indefatigable and highly influential museum professional and writer (see Gurian 2006), described the implications of Web 2.0 for heritage sites in her keynote address to the International Council Of Museums (ICOM) General Assembly and Conference in Vienna in August 2007. While she was specifically addressing the impact of the new digital technologies on museums, her thoughts resonate powerfully for all of us working in heritage more generally. The following points are my own, but I've expressed them through the prism of Gurian's presentations and the work of Fiona Cameron and Sarah Kenderdine (Cameron and Kenderdine 2007; and especially Cameron 2008) and the significant publication *New Heritage: New Media and Cultural Heritage* (Kalay, Kvan and Affleck 2008).

Digital media and its various applications and technological architectures have resulted in heritage places being prompted by these developments to go beyond the instructive authoritative voice of professional management and of academic scholarship and more fully recognize how the new media brings a democratization that focuses less on the objects and places over which they have stewardship and much more on the communities they serve. Publications like *Letting Go? Sharing Historical Authority in a User-Generated World* (Adair, Filene and Koloski 2011) are a testament to this prompting and to the increasingly widespread idea of regarding heritage places and museums as sites of facilitation and not sites of instruction. This process pre-dates the advent of Web 2.0 and has been underway for some time in many Anglophone countries and in the West more generally. Digital media, and Web 2.0 in particular, has increased the tempo and the breadth and depth of the shift in emphasis.

Web 2.0 and the generation of users who inhabit this experience, like Maushart's analogy of fish in a pond, are not interested in pre-packaged information that is

passively received; rather they want open access to databases so that they, as visitors, can share the content and be co-authors of the interpretation. The digital savvy visitor wants to be a creator of meaning as well as a consumer of meaning. This indicates that the old authoritarian structures will not work because visitors of the Web 2.0 generation are already part of a series of interlocking networks of information flows where they are both producers and consumers, and often both simultaneously. The Siena 'mashup' by Gabriel is a pungent illustration. Further, the Web 2.0 visitor not only wants immediate access to information – in the way the Internet now provides it through its browsing functions – they will want to personalize the content. Again, vividly seen in Gabriel's website. As the platforms that bring together the Web, MP3 player functions and audio-visual communications further evolve, like the iPad, it is now commonplace to imagine visitors carrying wireless mobile devices that will allow access to the Web as they traverse heritage places. The 'new' generation of visitors will not be satisfied with what is provided on signs because the information on the signs may not relate to the visitor's question or context or experience and it will increasingly become easier, as the new technology becomes an indispensable personal accessory, to use Google to find the answer while walking around the site.

Many of the long-term effects of this 'democratization' of heritage interpretation are probably unknown to us. Certainly there are many anxieties about these developments. Will it empower the powerless or does it marginalize professional expertise? Does it rupture the continuum between the knowledge generated by archaeologists, historians, art historians, ecologists and conservators, on the one hand, and the interpretation/experience of visitors on the other hand? Who 'owns' the content of interpretation? How will we deal with 'authoritative' narratives and the unauthorized narratives that Web-shrewd visitors like Gabriel and his/her generation may generate and that may or may not have veracity? How do we open up heritage interpretation to allow for the personal quest and the personal questions of the visitor? Maybe these questions are only asked by professionals concerned about not 'letting go', who perhaps inhabit a way of thinking that is passé and are more interested in protecting their professional practices.

Ironically, from my perspective, these anxieties have little to do with the Web 2.0 phenomenon per se. Research has shown that visitors have always 'personalized' their heritage experience; they have always 'subverted' authoritative accounts as their own 'lived experience' becomes the template for their on-site meaning-making (see Morkham and Staiff 2002; Saipradist and Staiff 2007). Recent research has investigated how visitors create meaning through associations linked to memories. Objects at the museums or heritage sites serve as triggers for the creation of highly individualized narratives that then jostle with the authorized interpretation provided by site managers or these personalized narratives by-pass altogether the formally provided interpretation. The research also indicates that visitors who view sites together share their ideas about what they are looking at irrespective of how informed these ideas are, they 'teach' each other (Harris 2010). Sometimes, like the Siena 'mashup', the stories

they tell each other are remote to the context of the viewing but significant to the tellers and listeners at the time. In other words, shared memories, prior knowledge and emotions are critical to the heritage visitor experience (cf. Kavanagh 2000; Hooper-Greenhill 2000), not to mention the corporeal and embodied somatic experience of place and the associated aesthetic affects that can be so powerful (see Chapter 3). Heritage sites have never, therefore, 'controlled' either the on-site learning or the way a site will be experienced. At best, sites have only ever, in reality, facilitated these things. What *is* different about the Web 2.0 development is the way the personal/individualized meaning-making is shared and reproduced for mass consumption on the Web. It is the intensity of the personal (in the context of a seemingly limitless horizon of access to an immense diversity of resources, continuously expanding information sources, opinion, multifarious cultural productions and knowledge productions) and the means to express it that has created a discernable shift.

Trustworthiness, authority and truth in a digital world

The issues of authority, of trustworthy sources of information, of what counts as truthful, are important issues. The very phenomenon of 'climate change sceptics' is a testimony to a more widespread culture of distrust, a time when questions are legitimately asked about the truthfulness of science, an environment where the power and authority of knowledge-formation is challenged and a time where conspiracy theories, religious beliefs, and mythologies, secular and sacred, exert their Dionysian vigour and energy against rationality thereby exposing the limits to rational thought. So the concerns expressed about authority and truth around participatory culture, in the context of heritage sites and museums, is both understandable and important.

Partly the issue is that we have grown so accustomed to what Peter Walsh (2010) calls the 'unassailable voice'. This is the voice of authority that we have come to associate with the institutional context of heritage places and museums whether it is the 'voice' of wall texts, exhibition catalogues, 'official' guides, audio-visual tours and the like. Walsh suggests the 'unassailable voice' is virtually everywhere despite its different tones, languages and forms; it is instantly recognizable – confident, eloquent, fluent, uncorrupted, knowledgeable and steeped in gravitas; and it is either the reassuring measured words of authority, disembodied like that of the Wizard of Oz (he writes), or it is reviled as an impediment to enjoyment and subversive thoughts, as something visitors must endure. Walsh suggests the Web undoes the unassailable voice. Far from being authoritative and reassuring, the Web offers frisson and anxiety; we are not quite sure about who is speaking nor whether those that speak, or post, do so from a position we could trust nor whether they are communicating fiction or erudite scholarship. The Web is full of stories of mischievous misinformation being unleashed on users, every day an April Fool's Day!

The point about this is that the Web is a chaotic and uncontrollable place completely lacking anything like an 'unassailable voice', or, as Walsh opines, is hostile to such a voice. Rather, it is a cacophony of voices. Personally, I do not find this cacophony a threat; a challenge yes, but not something to abhor. We are invited by the advances in digital technology to acknowledge the strengths of the 'new' media – provisional and ongoing conversations that are not fixed or informed by what Paul Arthur calls 'the dream of rendering the world fully knowable' (Arthur 2008: 34); the interactivity of the Web 2.0 age; and the ability of the Web to provide many layers of information and genuine choices for users about what content they want, how they want it and at what level of complexity. Trustworthiness of material on the Web is a learnt skill. One can find the equivalent of the 'unassailable voice' if that is desired; one can develop heightened scepticism about sources (surely a good thing in itself) and one can learn how to trust in cyberspace. The critical issue for me is that these are the responsibilities of the users themselves, that this is part of the democratization of heritage and a trade-off for the quite amazing access and participation the Web environment offers its users. The reality of the Web is such that we are empowered to control scenarios and authorize sources of data, not because of a passive acceptance of what is provided institutionally by heritage places and museums but because of what we have discovered for ourselves. The institutional forms of knowledge-production, such as heritage sites and museums, will continue to be a source of trustworthiness and a standard by which other sources can be measured, but they are not the only providers of relevant content on the Web. Trustworthiness and truth are indeed important, but for me the onus should be, and is, on individual digital media users to discern how to recognize these qualities and how to negotiate them in a noisy, complex and dynamic data-sphere. This is a different kind of dream: dizzying choice, personalized content, visitors in control of their meaning-making and the ability to be creatively engaged in 'heritage business' (see Adair, Filene and Koloski 2011).

Cyberspace: an embarrassment of riches

Because it is impossible to canvass all that is now available online for the visitor when it comes to engaging with heritage places and because anyone can search the Web for the multitude of heritage interaction options – whether they be reconstructions of monuments, podcast tours, hyperlinks like those found at the Google Earth Ancient Rome portal with its links to Wikipedia, GIS-underpinned city-wide heritage repositories and interactive sites like theglasgowstory.com, dictionaryofsydney.org, and cityofmemory.org, virtual reality initiatives like iCinema – it is rather pointless to try and isolate innovations and, increasingly, commonplace digital practices. Instead, I want to examine a very selective folio of writings by cyberspace commentators, some of whom have tackled the heritage/digital-media interface.

Graham Fairclough (2012) points to the way the Web environment has produced another layer to what he calls 'unofficial' heritage, where heritage creation has become part of 'everyday heritage'. Like Rodney Harrison (2013), he regards digital platforms as furthering and even accelerating trends that have been discernible in heritage for some time, especially its democratization and the linking of heritage to many other social, cultural and political actions and productions. And like Harrison, and many others (for example, Smith 2006), he regards heritage as a complex noun/verb interaction, the merging of things and processes and the broadening out of this interaction to a much wider field of social and cultural signification. This is not new and precedes the digital. Indeed, it has been happening at the global level for some time and, to take but one example, UNESCO has broadened its conception of World Heritage to include cultural landscapes and has adopted of the Convention for Intangible Heritage. More importantly, and as Fairclough expresses it so eloquently, if we regard heritage as essentially dialogic, a conversation between the past and the future, then digital media and social networking reconfigures heritage to this extent: it asks 'everyone to participate in its construction, encouraging openness, not closure of interpretation and valuation, making flux, uncertainty and doubt critical' (Fairclough 2012: xvii). Not only does social media broaden heritage, democratize it, make it more inclusive and ubiquitous, as Fairclough explains, but 'merges or re-unites heritage with the everyday' (Fairclough 2012: xvii). As we have seen, this directly challenges the authorized voices of heritage specialists and the highly regulated and controlled canons of masterworks subject to protection regimes. Fairclough suggests that, for those who are permanently connected to cyberspace, heritage is no longer about discrete entities marked by place and time (and existing under previously determined and institutionally authorized descriptions) but is a dialogue with the past that is truly of the present and with an eye on the future. The Siena 'mashup' embodies Fairclough's description of this dialogic relationship (also see Chapter 3).

Paul Arthur (2008), in an examination of the digital future of exhibiting history, described the great advantage of the digital media environment because of the way it 'spatializes knowledge' by linking and connecting disparate information and the modes by which that information is presented; bringing into the 'real time' of the visitor, via their mobile wireless devices, maps, GIS, digital 3D reconstructions, text-based resources (whether primary documents or historical commentaries or participant/user observations or poetry or fiction set in heritage places), sound (including oral accounts, storytelling, music), video, cinema and photography. As Arthur makes clear, digitalization has reunited physical sources that have been hitherto kept separate by the silos of government bureaucracy and by the different missions and professional practices of geographically separate institutions like libraries, museums (private and public), archives (private and public) and universities. Now all digital users have the capacity to do what twentieth-century historians and archaeologists had to do professionally: that is, re-unite sources artificially separated in the collecting/preserving process whether print, visual or

material in order to make coherent analyses and narratives. This democratization of knowledge practices gives the visitor an unprecedented opportunity to make their own heritage, to participate in the processes once confined to specialists. Or, as Kos (2008) writes, it allows the user/visitor to bring together for themselves an explanation that draws upon the patchwork of fragments, snippets and layers of information available on the Web; to create (provisional) meaning in the manner of doing a jigsaw puzzle, a temporary assemblage of parts that is a product of, but which contributes to, the constantly evolving digital environment. As Arthur rightly claims, this interactive participation means plural engagements, a multiplicity of forms, expressions and points of view and, for me, the exciting possibilities of cross-cultural dialogue (see Chapter 7). The participatory environment has been helped by the fact that history, art history, archaeology and heritage knowledge-formations have been increasingly regarded as open-ended, works in progress, contested, un-fixed and incomplete (see Harrison 2013). In the academic disciplines that inform cultural heritage praxis, the post-structural perspectives of recent decades neatly map onto the characteristics of the digital media environment.

Recently, I was with a group of students in The Rocks in Sydney Harbour, at the site of the first British settlement on the continent of Australia. In 1788, a motley group of soldiers, sailors, convicts and free settlers arrived in ships from Britain and began to create a European town on the homelands of the Cadigal people, the Indigenous Australians who had been part of the 'Sydney Harbour landscape' – to use the colonialist designation – for perhaps 40,000 years. It was an act of colonial dispossession of the original peoples. Enough of the nineteenth-century and early twentieth-century architecture of the colonists has survived for the (eventual) creation of a coherent heritage precinct that is protected, highly managed and constructed as a tourist/leisure space within the shadow of the Sydney Harbour Bridge and across the water form the Sydney Opera House. I regard The Rocks as a 'teaching laboratory' because so many of the issues related to contemporary heritage can be found there. On this particular occasion, the exercise was to navigate through The Rocks as a 'heritage tourist' using only the resources available on a smart phone. The only pre-visit preparation for this exercise was familiarization with what was available online. The precise nature of the exercise wasn't revealed until the students were on-site.

A list of websites is hardly scintillating reading but I want to illustrate the range of online material available on smart phones to a visitor who is exploring just one well-known Australian heritage site. It is worth noting that online material is quite extraneous to any traditional heritage interpretation offered on-site (guided tours, signage, guidebooks, street-art and so forth). Google was the search engine of choice and offers its own portal to maps and images, including historical and contemporary photographs of the site. Wikipedia has sites devoted to The Rocks and to the Cadigal people. The Rocks has an official website that combines heritage and history, videos via YouTube and activities for visitors including a list of vantage points for photography. Australian Screen, an online government

agency devoted to visual and audio heritage, has video materials, There are three museums in The Rocks: the Discovery Museum, Suzannah Place Museum and the Museum of Contemporary Art. Between them they host material culture online, a guidebook, podcasts, videos, blogs, and links to Facebook and Twitter. The City of Sydney, the website of the local government authority, has self-guided tours of The Rocks, and pages devoted to the Cadigal people with links to a tribute song. Sydney Architecture hosts a Rocks walking tour, monument by monument, each place of historical significance has a webpage with external and internal photographs, and descriptions including the style of the architecture and the date. The Dictionary of Sydney is an online city encyclopaedia with a permanent historical digital repository that offers photographs, historical paintings, thematic essays, blogs, projects, oral history, sound and moving images and oral history. The Big Dig Archaeology Education Centre offers information and pictorials about the archaeology of The Rocks. The Mitchell Library Collection within the State Library of New South Wales hosts an online collection of manuscripts, oral history, a picture collection of 2,205 images of The Rocks, maps, videos and podcasts. There were also media stories including video-clips, newspaper articles and radio podcasts.

This 'embarrassment of riches' is all very well, but could it be of use to someone walking around The Rocks with a smart phone? What surprised me was the array of uses to which the students put the online material and the highly individual ways they, as mobile subjects, negotiated both the fragmented nature of the material, its diversity and the heritage precinct represented. Here are some: replicating historical photos of streetscapes with their digital cameras; creating itineraries with different themes; making a video inspired by the YouTube videos they found online; undertaking, and at the same time, creating a tour of the historic hotels in The Rocks; attempting to locate exactly where bubonic plague broke out in The Rocks in 1900; undertaking a tour of buildings that no longer exist; seeking out any references that may still be extant in the landscape, to the dispossessed Cadigal people including a visit to the Discovery Museum to watch video interviews with descendants still living in Sydney; searching out places of ill-repute, crimes and criminals especially the haunts of the notorious nineteenth-century gang the Rocks Push; from paintings, trying to locate long-gone places like the first European hospital, windmills and hotels; reconstructing the lives of women and children in The Rocks but anchored to specific locations; attempting to locate Sydney's first China Town; documenting a retail transformation within the The Rocks by seeking out buildings with a historical retail association and then documenting with their digital phone cameras current retail use – and so on and so forth.

As with the Siena 'mashup', what was impressive about this hetcrogencity of activities was the magnitude of individualization and the creativity the student/tourists exhibited. Of course this was, to a degree, a response to the particular interests of the group. But, for me, perhaps of greater significance was the level of authorship involved in the meaning-making that occurred. None of these activities

were pre-determined by either the custodians of The Rocks or engineered by professionals designing heritage interpretation for the site. The online material was no more than a stimulus and a resource for individually crafted engagements. The visitors were co-authors of their own distinct interpretations of The Rocks. The debrief was instructive: they liked the open-ended choice of how to negotiate both the physical environment and the Web-based materials; they liked the access they had to blogs, Facebook and Twitter; they were able to learn about The Rocks in ways that dovetailed with their own interests; they were not 'forced' to consume pre-digested material officially sanctioned by the custodians of the site; it was experimental rather than scripted; it was fun and interesting and they incidentally learnt more than they thought possible; and they were motivated to go back online and follow up all sorts of leads they had discovered.

What this simulation revealed is that digital media enables something that has always been a characteristic of heritage visitation. Ross Parry (2008) puts it this way. Building new pathways through sites is not new but digital media facilitates this more acutely and encourages it; handheld devices with multimedia content, with the apparition of limitless choice and aided by convergence technologies and convergence culture, is new although the concept of bringing together a variety of sources within the viewing space is not new (exhibitions, signage and guided tours have been doing it for decades); the degree of cross-referencing executed by the visitor when on-site is new; interactivity per se is, quite obviously not new because interactivity is at the heart of the heritage/people relationship, but the digital/screen mediation and associated creativity and co-authorship of meaning is new. What Parry emphasizes is the way heritage sites are 'reconfigured, rewired, re-located, reconnected', and in doing so, are 'decentred and de-aggregated' (Parry 2008: 183). The physical site is a node in a network of routes; nodes that include digital pathways and digital loci: the physical heritage site, therefore, is both expanded and, equally, is elsewhere (in cyberspace). As Arthur (2008) reminds us, physical sites and the digital world are not binary opposites; material culture and the digital environment are fused entities.

Conclusion: utopias and dystopias

In September 2006, the ICOMOS International Scientific Committee on Interpretation and Presentation (ICIP) had a round table discussion with the UNESCO World Heritage Centre in Paris about emerging interpretive technologies. The concerns expressed during this discussion starkly reveal two things: the failure of those present to understand the impact of Web 2.0 compared to those who live their lives enmeshed within this digital world; and the anxiety about who controls the authoritative knowledge associated with heritage places. The discussions moved inexorably towards the need for standards and guidelines to govern the authenticity of data and the uses of technology in visitor interpretation. In this discussion we can discern an ongoing attempt to control knowledge and

the communication process by those empowered to be custodians and to govern officially sanctioned heritage places. The digital media eruption, and the way it has manifested itself in recent years, illustrates that neither is possible. What is needed is a complete rethink and reconceptualization of the role of heritage places in the digital age and to see the technological devices used by visitors, not as 'things' separate from the carrier, but as 'organic' and constitutive parts of the embodied spatial, social and aesthetic experience (see Hillis 1999, 2009). Technology is no longer a purely functional 'thing'; rather, it has become something that is part of us, and part of how we define who we are (Burgess and Green 2009). The knitted technology/self relationship is increasingly a norm across cultural and national boundaries in a globalized world.

Nevertheless, for many partisan observers, there are unresolved concerns. The relationship between authorized and unauthorized narratives and analyses continues to be a 'ghost in the machine'. While blog sites have separated the authorized from the online blogging community, this is an institutional response on the websites controlled by heritage places and museums. However, the Internet is obviously far bigger and far denser in its inter-connectivity than the heritage-museum network. 'Heritage business' is happening outside the formal heritage networks and the Siena 'mashup' is a prime example. Parry (2008) wonders about what role visitor-generated content has in the wider scheme of things. He wonders what type of history and what type of narrative is being negotiated in the institutional/cyberspace interstice. On the one hand, cyberspace is encyclopaedic but, on the other, heritage places are precise sites that have precise geographies and histories, and particular social, cultural and political contexts. How does the specific sit within the encyclopaedic? Perhaps from the user/visitor's point of view, this is not very important. And if it's not important, what are the implications?

My concerns are different and echo ones I expressed a decade ago with two of my colleagues when writing about heritage interpretation in national parks (Staiff, Bushell and Kennedy 2002). They are also the concerns that Jean Burgess and Joshua Green (2009) have more recently articulated with regards to YouTube and participatory culture. In the digital world, who is participating, who gets to speak, are all speaking positions valid in relation to cultural places, objects and practices (see Chapter 7), who is listening/viewing, who is responding and why, what are the power relations involved here, do marginal voices continue to be sidelined, what about offensive and politically unpalatable commentary (see Chapter 7)? On the one hand, the statistics suggest wide global participation that is increasing in numbers and social penetration across political, cultural and economic boundaries. More people, more voices, more discursive interventions. We know 'old' cultural boundaries are breaking down in cyberspace as cultural taxonomies of form (high, low, popular, folkloric and so on) intermingle and become equally accessible (see, for example, Burgess and Green 2009). But exactly how this will play out in a future where all the actors and entities (heritage itself, digital media, mobile subjects) are dynamic and ever-changing is unknown. And as we wait to see where all this might go, we are ever more enmeshed in cyberspace as participants;

participants defined by 'increasingly complex relations among producers and consumers in the creation of meaning, value and agency … [in] the co-evolution and uneasy co-existence of "old" and "new" media industries, forms and practices' (Burgess and Green 2009: 14).

Chapter 7
Conversing across cultures

Outwardly, a book by an award-winning writer set in contemporary Mumbai, travelling to Bali in the early 1970s and a Chinese epic movie about the life of Confucius, have nothing in common. However, they do describe various aspects of the terrain that is the substance of this chapter: encounters with heritage places that are, on many deeper levels, not constitutive of the primary cultural affiliation of the visitor. Whether it is Chinese- and Japanese-born visitors at Chartres Cathedral, outside of Paris, or in the National Archaeological Museum in Athens, or French- and British-born tourists in the Forbidden Palace in Beijing or at the historic monuments of ancient Nara in Japan, or anyone from anywhere encountering Aboriginal Australian culture, one of the supreme challenges of heritage interpretation is communicating across cultural difference. I want to begin with three examples because, in quite different ways, they begin to sketch some of the various dimensions of this 'supreme challenge' within heritage interpretation praxis in a time of unprecedented global travel.

Mumbai

Behind the Beautiful Forevers (2012), told through the stories of its inhabitants, is an acclaimed account of life in the Mumbai slum named Annawadi. Katherine Boo, has written a powerful and evocative narrative woven around the lives of characters who dominate her account. What I find particularly striking about this book, other than the richly textured exposé of precarious lives amidst fast-moving contemporary India's deep economic inequalities, social injustices and corruption, is the way the account of the slum *sees through cultural difference*. Boo is a Pulitzer Prize-winning reporter who has worked variously for publications like *The Washington Post* and *The New Yorker*. She could be regarded as an outsider who has, in ethnographic fashion, immersed herself into an Indian slum to observe, analyse and report. However, for non-Indian readers of *Behind the Beautiful Forevers*, the cultural differences are erased or, at the very least, muted; her writing translates the complexities of Mumbai into something understandable by turning the domain of Annawadi into an imagined reality accessible to Anglophone readers living elsewhere. Annawadi breathes more the air of the reader's world than the air breathed by the inhabitants of India's marginalized underclass.

Boo's writing, that sees through cultural difference, is at once both appealing and disturbing. It's appealing because it achieves, seemingly effortlessly, what cross-cultural translation hopes for: making cultural differences intelligible to a

target reader; making a Mumbai slum legible for a white, educated, middleclass reader living in Sydney or New York or London. It's disturbing because, to accomplish this feat, much of the cultural complexity of those living in Annawadi is emptied out, leaving behind a few semiotic markers to do the work of *indicating* cultural difference and, at the same time, building on the assumption of similitude, a shared humanity across cultural divides: Abdul the Muslim teenager in the largely Hindu shanty town; Asha, the kindergarten teacher, who exploits political corruption so that she and her family may perhaps escape the oppressive poverty of their situation. 'Hindu', 'Muslim', Mumbai', 'Annawadi', 'Abdul', 'Asha', 'Kalu' – these are the words that produce, for English readers largely living outside of India, the apparition of cultural difference in contemporary Mumbai/India. If one were to strip away these words, the story of poverty, of slum communities and their hopes, dreams and crushing realities becomes geographically detached. It could be anywhere. It could be fiction. This is not a criticism of Boo's outstanding achievement but a symptom of the challenge of effective cross-cultural translation: difference is dampened and similitude is heightened when communicating with audiences that are not Indian by birth or ancestry. And indeed, as we will see later, this offers important possibilities for cross-cultural conversations at heritage sites.

Bali

When I was in my early twenties, I had an encounter with something I could only hope to understand. It was my first trip to an Asian country (other than a two-day stopover in Singapore on the way to Europe two years before). Being in the early 1970s, the international airport on Bali had only recently opened and, at the time, it was still possible to experience Kuta beach not as shopping malls and globally branded hotels and resorts, but as a coconut palm-fringed beach dotted with small villages and family-run guesthouses connected by unmade roads through the tropical forest. One late afternoon, as the sun drifted low on the horizon, my travelling companions and I went to a local temple and there we sat, truly mesmerized by a performance of the Barong accompanied by a gamelan orchestra. I now know Barong, a lion-like creature, is the mythological king of the good spirits who confronts Rangda, the queen of the demons, in the perpetual battle between good and evil. At the time, I didn't even know this much about the performance (it was just before the arrival of Lonely Planet guidebooks*)*. I could isolate different 'characters' in the frenzied narrative (because of their costumes and face-masks), but they were nameless and had no substance as characters, and the story itself remained completely unintelligible. Nonetheless, it was indelibly memorable, especially the attempt by the dancers to stab themselves with daggers (*kris*). In the music, intense rhythmic patterns of slow and fast percussion sequences – made with xylophones, metallophones, gongs and drums – seemed to dominate the harmonies made with flutes and stringed instruments. To a Western ear, the sounds were not unpleasant and in fact were aurally exciting, although

cacophony is a word that, at the time, probably came to mind. Certainly, for those accustomed to the Western harmonic scale, it was not as alien as, say, traditional Chinese opera.

For me, the performance of the Barong, at the level of cultural understanding, was a complete narrative and symbolic failure; I was confronted by the limits to my comprehension. However, at the same time, this deficiency did not prevent this elaborate dance-ritual being a powerful, memorable and profound spectacle-experience. The lack of understanding offered a challenge to my comfortable (European) cultural-centric space (physical, cognitive and emotional). Bali and the Barong opened up radical possibilities that had previously only been dimly perceptible; it provoked a number of questions; it brought to the fore experiences of culture and places, people and customs that were, until the travel encounter, largely peripheral, imagined, locked in representation and lacking real-time-real-space embodied 'presence'. And the challenges wrought by the experience were quite confronting because of what was posed by something I didn't really understand; and what confronted me was not just epistemic difficulties but things to do with behaviour, attitudes, values, emotions, sensualities and something I could not name at the time, but with which I'm now very familiar, my 'orientalism' (to use Edward Said's potent term), my Eurocentric fantasies about 'the East'. For me, this dimly understood and not entirely comfortable cultural and social experience was deeply affecting and began a cultural and emotional odyssey that has yet to be fully 'played out'. The 'cultural other' (always recognized as a Eurocentric conception of South East Asia) has become a profoundly significant personal space/place full of intimacies, friendships, relationships and work that, on one level, offers a type of transcendence of my own cultural familiarity, a familiarity that some might regard as the 'prison' of the culture into which we are born and into which we grow up. But, simultaneously, the 'cultural other' has become, for me, a mode of thinking and being that enables me to more acutely understand my own culture, historical imaginaries, epistemology, identity, gender, desires and fascinations.

Interestingly, and importantly, this response to Bali and the Barong was not shared by one of my travel companions whose experience of Indonesia produced a very different response. In this case there was no sense of wonder or liberation but an intense feeling of disquiet and insecurity that had the effect of affirming an Anglophonic culture; that strengthened the veracity of held beliefs and attitudes; and that validated Western values. For my fellow traveller, the 'other' was, I assumed, a threat, a contagion, something to be wary about, perhaps even feared.

In terms of heritage interpretation these varying responses are obviously significant if we are thinking about visiting heritage sites in places that are not of the visitor's culture. We cannot assume, therefore, empathy and the sense of a shared humanity or any of the other ideals often associated with communication across cultures at heritage places, ideals like an increase in tolerance and a greater understanding of other places, peoples and cultures. This belief is explicit in the way UNESCO rationalizes the World Heritage system beyond the obvious primary

concern for conservation; indeed, it is a central belief underpinning UNESCO's mission and much of its work (www.unesco.org).

On returning home from Indonesia I recognized three things: a desire to further cross the borders of what seemed to me to be my own constricting cultural inheritance; I acknowledged there were limits to my understanding of 'other' cultures; and that I had inherited an earnest belief in the value of 'knowing everything' and this was a type of 'colonialist' disposition.

The movie *Confucius*

Filmed in Hebei Province in China, *Confucius*, directed by Hu Mei and starring Chow Yun-Fat as the philosopher, was released for distribution in 2010. The score for the film was written by Zhao Jiping, the renowned composer most often associated with the films of Zhang Yimou (*Red Sorghum*, *Raise the Red Lantern*, *To Live* and *The Story of Qiu Ju*). Set in the fifth century BCE, *Confucius* was made to help mark the sixtieth anniversary of the founding of the People's Republic of China and to celebrate the 2,560th birthday of the sage. *Confucius* is, therefore, mainstream Chinese cinema with eyes focussed on a local Mandarin-speaking audience. My DVD copy has English sub-titles. As an example of cross-cultural communication, the film stands somewhere between the experience of the Barong in Bali and Katherine Boo's book about Annawadi. Naturally, the film makes no concession to a non-Chinese viewer but it didn't have any of the incomprehension I associated with my experience of the Balinese Barong. The reasons are instructive. Film is now a global medium and its conventions are extremely well known, and almost universally so, such is the global reach of cinema. Films set in Feudal China are, for Asian cinema aficionados, relatively commonplace and so viewing *Confucius* with its feudal iconography meant that visually, the *mise en scène* of the film was quite familiar. Having English sub-titles made, to some degree, the narrative arc of the film accessible. The dramatization of scenes including the communication of emotions had few if any barriers: a wife's love for her husband, a tearful farewell of a man leaving behind his wife and children, the care and concern shown for a teacher by his students and companions, the compassion for a child in dire circumstances, the horror of a child entombed alive, the anguish of difficult decision-making by political leaders and the lust for power. And so while the markers of cultural difference are visually and linguistically dominant in the movie – the *mise-en-scène* plus Mandarin – the shared humanity the film assumes simply overrides difference for a non-Chinese audience. Finally, there is the musical score of the movie. This is not the music of the Beijing Opera. It is not the music of the plucked Chinese zithers or the bowed Chinese two-stringed fiddle, the *jinghu*. Zhao Jiping's music is like most of his movie compositions: achingly beautiful and lush orchestral scores with an emphasis on mood-inducing string parts using Western instruments and Western compositional devices. It is why his movie scores are so beloved in the West. Of course, there are Chinese

elements to his music, but the overall sound is aesthetically Western. While watching *Confucius*, we are swathed in a ceaseless rising and falling of rich orchestral sounds that are, at once, familiar.

What are the lessons here? The translation of cultural difference is not dependant on language or upon cultural particularities. Cultural difference, in its visual form, including material culture, can be understood, on certain levels, even when the deeper symbolism, the ideological renderings, the social conventions (with their gestures, body language, hair-styles and costumes) and historical significance of the (material) culture is not accessible. In the cinema, and in other visual images (paintings, photography) Western viewers are able to access China's feudal past via similitude and not difference. In *Confucius* we effortlessly read the iconography: cities, city walls, city gate-houses, armies and battle scenes, pre-modern transport, class status and political hierarchies, courtly ritual, tribalism, familial love, education and teaching, the importance of writing, childhood innocence, betrayal, banishment, a plaintive song played on a zither, the pain of the loss of a dear friend. All of this without any knowledge of dates, periods of Chinese history and Chinese historiography, the particularity of the politics of the warring factions, the name of the Emperor, the biographies of the warlords, the geography of Feudal China, the morphology of feudal Chinese cities, the meaning of the symbols on banners or the meaning of decorative features of the architecture or even a knowledge of the historical figure that the West calls Confucius. And here is the critical point: I think visiting heritage sites is somewhat like the cinematic experience I have described here; that it is, on many levels, akin to watching a film like *Confucius*.

In the example of the Barong, cultural difference was the dominant experience and particularities were one source of that lack of understanding. Who were the characters in the dance? Why was there conflict? What did the conflict mean? Why did the characters have animal features? Why did the 'good guy' have such a ferocious looking face-mask? Why did the male dancers try to stab themselves? What was the point of the dance? Why was it held in a temple precinct? Was this actually dance or a religious ritual, or both? How did it link to the Hinduism of the Balinese? By focussing on cultural difference, the task of communicating across cultures is made exceptionally difficult because it requires cultural expertise and competencies in both the culture of the original and the culture of the audience (and here I'm assuming a non-Balinese audience). What *Behind the Beautiful Forevers* does is the very opposite. Boo finds those aspects of her story that can be shared and translated with ease across the cultural divide by seeing through it, almost as though it weren't there. *Confucius* achieves the same effect but without even trying to primarily address a non-Chinese audience. Nevertheless, as I have indicated, even without the particularities that would have made the Barong (partially) intelligible, it was still an irresistible and resonantly memorable experience that was to have me questioning a great many things that I had, previously, so comfortably assumed. The complete lack of understanding was not a barrier to the profound affect/effect of the performance; such is, perhaps, the nature of spectacle and religious ritual/drama.

Lost in translation

The phrase 'lost in translation' is an expression commonly used to indicate that several aspects of cross-cultural communication involve insurmountable hurdles. It assumes that some things are not translatable at all. It assumes that significant cultural understandings are somehow 'lost' when they are translated from one cultural context to another. It assumes there are limits to cultural translation and communicating across cultural differences. Some highly regarded scholars, such as David Bellos, are not taken with the term believing that it ignores the very idea of what translation is about (Bellos 2011). And, while I understand and agree with his arguments, I wish to explore this idea further as I do think it is a valuable notion when considering cross-cultural communication in heritage places, even if it is a misconception in the realm of language translation.

Let us begin with language translation. When I visit Angkor in Cambodia and as I walk around Angkor Thom, the 'great city' built by the ruler Jayavarman VII in the twelfth century CE, I'm always very conscious of the numerous Cambodian guides. This is especially so in one particular, and always crowded, place where the guides slowly process, with their tour groups, along the bas-relief sculptured murals in the Bayon, the temple at the centre of Jayavarman's city. The two-dimensional murals are rich in narrative detail, documenting the life of the city. I hear Cambodian guides speaking English, German, Mandarin, Italian, French and Thai. We assume that what each tour group is getting is an account that is basically the same but in a different language. It is true the Cambodian guides have all done a course in the history of the monument and can refer back to their course notes that are written in Khmer, the Cambodian language. But the course notes are not translated into the languages the guides use when they are with tour groups. Setting aside, for the moment, the individual differences between guides and their own predilections and ideas about what they will tell their tour group, and setting aside the fact that all expert tour-guiding is a type of performance that will adjust itself to suit its particular audience, can I assume that what the tourists from different countries hear, as they stand looking at the intricate picture stories of the sculptured wall mural, is roughly the same thing?

I will answer that question using David Bellos as my informant. His book, intriguingly entitled *Is that a Fish in Your Ear? Translation and the Meaning of Everything* (2011), argues that it is not possible either to produce literal translations of the original Khmer notes or for the various languages being employed at Angkor to produce anything other than approximations of each other with regards to what is spoken. The six languages I can hear being spoken will be approximations of the original Khmer text and what the six languages, spoken side-by-side in the same place, communicate, will be approximations of each other. It's not so much that things get 'lost in translation' but that the complexities of language translation are such it is an unrealistic expectation to believe that what is communicated in the six languages will be anything like the same. The reasons are quite obvious. As we discovered in Chapter 2, the meanings of representations are always changing,

and language is a type of representational system. But it's not just the idea of multiple meanings it is also about context. Where the language is uttered is critical because, as Bellos points out, in translation 'meaning is context' (Bellos 2011: 71). Change the context and the meaning changes. The example Bellos uses is 'I smell coffee'. How different is the meaning of this sentence if you have been lost in a jungle for three days compared to a Chinese traveller arriving in Italy and uttering these words or a student who has been cooped up with a laptop for perhaps two hours of intensive study. In each case the context of the utterance is a crucial part of its meaning, not the words by themselves. So, what is said to visitors viewing the Bayon sculptures at Angkor is not as important as the context of what is being communicated. Herein lies amazing flexibility because there are always many ways of saying the same thing, so the six languages heard at Angkor may, in fact, be communicating quite different things but the context becomes the overriding element of the guides' declamations. It is yet another example of where meaning-making at heritage places cannot be controlled and where meaning is being continuously negotiated.

One of the critical elements of translating across cultural difference involves understanding what happens when the original language is communicated to the language of the target audience. This process invariably requires that the translation is more in keeping with the cultural ambience of the target audience than the original would suggest, so translations from Hindi or Japanese into English, for example, makes the subject of the translation more English than either Hindi or Japanese. The English-speaking audience is accommodated in such a way that there are often major divergences from the so-called original. In other words, as we saw with Katherine Boo's book, similitude is given prominence over difference, and cultural difference is thus dampened so that what the reader/ listener receives is something that appears to breathe the air of the cultural world of the English speaker (the audience) than the air of the cultural world of Japan or India (the original text). Does this matter?

In order to answer the question let us examine a number of examples employed in heritage interpretation. Western visitors to heritage places in Thailand will be introduced to two dating systems. Dates of monuments, buildings and objects will be given as a number (like 2443 BE) or an appellation (for example, 'in the reign of Rama V' or 'in the Fifth Reign'). For most Western tourists, especially first-time visitors, this is a meaningless system of dating. The BE after 2443 refers to the years since the birth of the Buddha and so using the international dating system, 2444 BE is 1901 CE, the beginning of the twentieth century. 'In the reign of Rama V' refers to the reign of the fifth monarch of the Chakra dynasty, King Chulalongkorn, who ruled from 1868 to 1910 CE.

Translating the dates at heritage sites in Thailand from Buddhist Era (or the name of the reign of Thai monarchs) to CE has several effects. Thai history is, to some degree, appropriated into a Western/European historical framework. This means that, for some Western visitors, buildings in Bangkok built during the reign of Rama V or King Chulalonghorn, like the Chakri Maha Prasat Throne

Hall in the Grand Palace, are perceived as being contemporaneous with the Eiffel Tower in Paris, the monumental railway stations like the Gare d'Orsay in Paris, St Pancras in London and Grand Central in New York, or museums like the Natural History Museum in London and The Metropolitan Museum of Art in New York. Comparative history of this type is, obviously, a powerful and useful form of interpretation and indicates an important process whereby visitors absorb and accommodate the unknown into something familiar. The assimilation of the new, or the never before experienced, into what is known, occurs via a complex cognitive process where our previous life experiences act as a template for processing experiences that are either unfamiliar or outside the realm of anything previously encountered (see Morkham and Staiff 2002). We need cues, like dates or physical entities that resemble something we are intimate with, so that this virtually automatic response can be triggered.

Whether this is a benign process or not, is debatable. Postcolonial theorists like Edward Said have shown that such perceptual assimilations can fuel representations of cultural difference that maintain the centrality of Western political and cultural power, and domination, as places like Thailand are incorporated into a European fantasy of 'the East' (Said 1985; see also Hallam and Street 2000). Therein lurks a constant peril with cross-cultural translation when the power relationship between the various players is unequal or where considerable historical residue inflects the transaction. Similarly, substituting a Thai date – with its overt references to the Thai monarchy or to the Buddha – with a date that sits so easily in Western thinking and experience (whether AD or the more inclusive CE) masks the centrality of Buddhism and the monarchy in Thai society, culture, politics and religion (Peleggi 2007).

And so we reach the critical issue. In cross-cultural encounters at heritage sites what sort of translation should we be attempting in heritage interpretation? Should we be attempting what Katherine Boo does in *Behind the Beautiful Forevers* or should we be attempting what is unintentionally achieved in a film like *Confucius*? Or should we attempt to translate the performance of the Barong in a Hindu temple in Bali? Or should we avoid translation altogether and allow cultural difference to be experienced without mediation? These are not easy questions and, before I mull over possible answers, I want to describe two situations where cross-cultural communication is attempted at heritage places via translation and where there is a highly articulated attempt at communicating cultural difference. Both examples are World Heritage sites: Sukhothai Historical Park in northern Thailand and Uluru-Kata Tjuta in central Australia.

Sukhothai: a failure in communicating difference?

In the officially sanctioned nationalist historiography of Thailand, Sukhothai is proclaimed as the first royal capital of the Thai-speaking peoples in a progression of kingdoms from Sukhothai through to Ayutthaya, Thonburi and finally Bangkok

(Peleggi 2007). By 1238 CE the Sukhothai kingdom had absorbed neighbouring fiefdoms and asserted itself against the suzerainty of the Khmer kingdom at Angkor. The Sukhothai kingdom barely lasted two hundred years as tributary cities fell away and the increasingly powerful Ayutthaya kingdom in central Thailand successfully invaded Sukhothai and eventually eclipsed its power. For Thai nationalists, Sukhothai is the crucible of Therevada Buddhism, the Thai language, the Thai system of monarchy and distinct styles of Thai art and architecture. Today, it includes remnants of the city walls and gates, the moat, a royal palace and some forty temples (inside and outside the walls) set in a mountain-rimmed landscape that includes a complex system of canals, some still visible as small lakes festooned with lotus flowers (Rooney 2008).

Unsurprisingly, therefore, Western visitors to Sukhothai are presented with a narrative of the place that wants to emphasize its distinctiveness. After all, it is this very distinctiveness that enabled UNESCO to inscribe it onto the World Heritage list in 1991 CE. Throughout the historical park there are a series of large text panels that are complemented with an official guidebook. The text panels are in Thai and English. The visitor is, therefore, presented with a translation of the cultural significance of Sukhothai from a Thai perspective – that is, from the perspective of the heritage custodians (the Fine Arts Department of Thailand) and the specialist archaeologists and historians that advise the custodians and the managers, and from a perspective that fulfills the nationalist ideology writ large across the site (Peleggi 2002).

Outside Wat Mahathat, the principal temple in the city, the English sign reads, in part, as follows:

> Wat Mahathat is situated within the Sukhothai city center. It is a grand and very important temple of Sukhothai. It consists of more than 200 chedis. The lotus-bud shaped chedi is the main one of this temple and is surrounded with 8 minor chedis, one at each of the four sides. The characteristics of this chedi demonstrate the influence of Khmer art that existed before the diffusion of Ceylonese art to this region. Although the structure of the main chedi is in the Khmer style, the decoration shows other influences. For instance the style of the decoration of the dragon with its tail pointing shows the Ceylonese style of art, while the decoration of the chedis in the corners represents the influence of Pukham-Lanna art. The impressive style of chedi with its lotus-bud top section is unique to the architectural style of the Sukhothai period. This style integrates together Khmer and Ceylonese styles. The chedi is used to house the sacred relics of the Lord Buddha in accordance with the beliefs of Ceylonese Buddhism. Sukhothai accepted this belief in order to show that the Khmer no longer had control over Sukhothai.

The sign gives quite useful information and is accompanied by a new sign that illustrates pictorially a reconstruction of the temple. Note, however, the way the description emphasizes difference. Quite a depth of cultural and historical knowledge is assumed. It is assumed a visitor will know what a *wat* is and perhaps

that the word 'Mahathat' signifies the major or main or principal temple in the city. It assumes the visitor understands the hierarchy of Buddhist temples in urban places and within the system of royal patronage. It assumes that the reader understands the religious symbolism of the lotus plant. It assumes some knowledge about Khmer culture, Ceylonese culture (and why Sri Lanka is important to a thirteenth-century CE Thai city) and Lanna culture. It assumes some understanding of the ongoing nationalist debates and armed conflicts with Cambodia over Ankorian history and Khmer culture (Silverman 2011). It assumes a visitor could identify stylistic qualities in the Sukhothai architectural decoration and their meanings and significance.

None of this is impossible. There are a number of English-language guidebooks, scholarly studies and websites that will provide sufficient material to decode the cultural references in the text panel. Whether this works for a tourist with limited time, and probably on holiday, is another matter altogether. My main interest here is the cultural literacy that is required to understand cultural difference and whether the sign works as cross-cultural communication.

During 2004-2005, a Thai doctoral student from Silpakorn University in Bangkok was determined to find out whether the signs did enhance cross-cultural communication and in unpublished research that involved a visitor survey of 224 foreign visitors to Sukhothai, something quite interesting emerged. Of the internationals in the survey, 84 per cent were Westerners from Europe, North America and Australia/New Zealand; 64 per cent had tertiary qualifications; 36 per cent were staying in Thailand for a period of 2-6 weeks; and, although 70 per cent claimed their visit to Sukhothai was motivated by a desire to learn about Thai history and culture, 86 per cent of those surveyed were spending only one day or less in the historical park and, of these, 54 per cent for less than half a day. Only 48 per cent of foreign visitors read any of the signs outside the monuments scattered throughout the site. These statistics give us a general idea about one cohort of visitors in one twelve-month period. The last question on the survey, an open-ended one, asked visitors to describe, in their own words, their visit to Sukhothai Historical Park: 75 per cent of the respondents mentioned 'the beauty of the landscape', 58 per cent the architecture and 54 per cent the history and culture of the site (Lormahaomongkol 2005).

The high number of responses referring to architecture, history and culture were to be expected, as it is difficult to escape the architectural focus of the site and the way it is represented in guidebooks and signage. The high aesthetic response, however, is compelling. One can speculate why this is the case. Partly, it is to do with the site itself. The architectural remains are not clustered together but are separated by bare grassy areas with well-established trees, flower beds and the remnants of the canal system, lakes with their floating lotus flowers. The Park has high scenic values that encourage an aesthetic response and it is strongly amenable to Western pictorial conventions and photography. In other words, it is a highly picturesque setting and encourages a picturesque response. Maurizio Peleggi suggests something else. Western visitors are confronted with a landscape

of architectural remnants that are overtly presented in a way that, firstly, defines what is exceptional about Sukhothai and, secondly, rhetorically binds the place to Thai nationalist history-making. This discourse (particularlism and nationalism) is built on locally accumulated cultural capital and is not easily accessible to non-Thai visitors from Western countries. The Western tourists tend to bicycle around the park and imaginatively revert to what is familiar to them: the aesthetics of the 'ruin in the landscape', a strong European cultural trope that has a long history of invention and re-invention and is soaked in nostalgia (Peleggi 2002). The number of visitors who confessed to not reading the text panels (52 per cent) perhaps underscores Peleggi's observation.

This falling back onto familiarity when faced with a cultural landscape that is full of things not necessarily understood is to be expected (Morkham and Staiff 2002). However, what I think is far more critical, in the context of conversing across cultural difference, is the difficulties of having that conversation when difference is enhanced at the expense of similitude. I would suggest many Western visitors, on a short trip to Sukhothai, experience, to some degree, something akin to my viewing of the Barong in Bali (see above).

Uluṟu-Kata Tjuṯa: cultural difference as incommensurability?

The Aṉangu people (the Pitjantatjara and Yankunyjtatjara Indigenous Aboriginal Australians) own Uluṟu-Kata Tjuṯa National Park because they have lived in these lands for 40,000 years (although it took until 1985 CE for the Australian Government to recognize this). In 1994 CE, Uluṟu-Kata Tjuṯa gained World Heritage listing as a Cultural Landscape and is now co-managed by the Aṉangu people and the Australian Government.

At Uluṟu-Kata Tjuṯa several narratives are entwined with the experience of the place. For the Piṟanpa (white or non-Aṉangu), there is an interplay between the sciences of geology and biology and the mythology of the 'red heart' or 'centre' of Australia, somewhat saturated in national symbolism that resonates quite profoundly in the non-Indigenous Australian psyche (Haynes 1998). For many white Australians, a 'pilgrimage' to the 'heart of Australia' has become a rite of passage overlaid with Australian patriotism and identity (Haynes 1998). For many international visitors to Australia, Uluṟu-Kata Tjuṯa is a 'must see' attraction and consequently frequently features in Australian tourism promotion campaigns.

Despite this, non-Aṉangu visitors to Uluṟu-Kata Tjuṯa, are confronted with a very different 'reality', especially non-Aboriginal Australians arriving with their keen sense of national identity: at Uluṟu-Kata Tjuṯa what is recognized in the World Heritage inscription is not geology or the mythology of the 'red heart of the nation' but something else entirely. The World Heritage nomination document speaks of *Tjukurpa* as a spiritual philosophy linking Aṉangu to their environment; of Aṉangu culture as an integral part of the landscape; and of the Aṉangu perspective and interaction with the landscape.

What does this mean? The *Uluru-Kata Tjuta National Park Media Information Folio* issued by the board of management (Parks Australia 1996) takes the Piranpa or non-Anangu reader into a construction of the natural world that is dependent on Anangu cultural formations. These cultural processes bring the physical environment and the Anangu people together into a space/place that is undifferentiated. This is in stark contrast to Western ways of thinking and knowing. Western thinking is built on discrete differences: 'the physical', 'the spiritual', 'the law', 'history', 'science', 'art' and so forth. There is no equivalent set of discrete entities in Anangu cosmology (Sutton 1988).

Because the media package represents the official interpretation of the site by the Anangu people, I want to quote it extensively to illustrate the degree of complexity involved in the cross-cultural translation being undertaken at this World Heritage site:

> When we look at our land with all its features and wildlife, we see evidence of Tjukurpa events and our ancestral beings. To us our land is full of deep spiritual meaning which guides our daily lives. Tjukurpa is the Pitjantjatjara word for our collective history, knowledge, religion, morality and Law which has always dictated the way in which we look after each other and country. It is a complex concept which can be roughly described as 'Law", but there is no accurate translation into English.
>
> …
>
> **Tjukurpa.** 'This Law was given to us by our grandfathers and grandmothers, our fathers and mothers, to hold onto in our heads and in our hearts'.
>
> Tjukurpa refers to the creation but also to the present and the future. In the creation ancestral beings, Tjukaritja, created the world as we know it. Tjukurpa is also our religion, Law and moral system. It shapes the structure of our society. Anangu life revolves round Tjukurpa.
>
> The Creation. The world was once a featureless place. None of the places we know existed until our ancestors, in the forms of people, plants and animals, travelled widely across the land. Then in a process of creation and destruction, they formed the world we know today.
>
> Our land is inhabited by dozens of ancestral beings. Their journeys and activities are recorded at sites linked by iwara (paths or tracks). These iwara link places that are sometimes hundreds of kilometres outside the Park and beyond Pitjantjatjara country.
>
> Our land, 'mapped' through the events of the Tjukurpa is, therefore, full of meaning. Tjukurpa is the basis of our knowledge. We identify ourselves

through Tjukurpa. Our birthplace, where we live and where we die, are of great significance to us. When we travel across the land we do so with the knowledge of the exploits of the ancestral beings. Our knowledge of the land, the behaviour and distribution of plants and animals is based on our knowledge of Tjukurpa. We recount, maintain and pass on this knowledge through ceremony, song, dance and art.

…

Our Society. We refer to sites as being 'my grandmother' or 'my grandfather' because we are part of the land. Our identity with land and Tjukurpa shapes our relationships with people. Our kinship system, based on Tjukurpa, prescribes a range of proper behaviour within our immediate family and with other relations. It gives us rules about marriage, and other relationships between men and women, young and old. Our family obligations extend to our entire language group.

Tjukurpa provides us with a system of beliefs and morality. Tjukurpa guides our daily life through its series of symbolic stories and metaphors. The stories are not simple stories but are technically complex explanations of the origins and structure of the universe, and the place and behaviour of all elements within it.

...

Tjukurpa establishes the rules we use to govern society and manage the land. It dictates correct procedures for dealing with problems and penalties for breaking the Law. The proper way of doing things is the way things are done in Tjukurpa.

Passing on Tjukurpa. Tjukurpa is not written down, but memorised. It is our cultural obligation to pass on this huge volume of knowledge to the right people. Ceremonies play an important role in the passing on of knowledge. Specific people or groups in our kinship system have responsibility to maintain different sections or 'chapters' of Tjukurpa. These chapters may relate to a specific site, or section of an iwara (ancestral path). This knowledge is carefully passed in to people who have inherited the right to that knowledge through, for example, their birthplace, or earned that right, for example, by progressive attendance at ceremonies.

There are many interrelated devices for remembering Tjukurpa, such as specific verses of inma (songs), site-related stories, ritual dances or rock art. The iwara (ancestral paths) are recalled in long sequential lists of sites, sometimes including sites beyond country which has been visited, and including sites belonging to other people.

Tjukurpa may also be recorded in physical forms such as ritual objects. Some objects are created for specific ritual and then destroyed, others are very old and passed on from one generation to the next. These objects are extremely important, and knowledge of their form and existence is highly restricted. They are not discussed in front of children, and may be specifically restricted to men or women.

Tjukurpa may be recorded in various designs and paintings such as the 'dot' paintings of the Western Desert and are often sacred. Use and creation of these designs is restricted to specific groups or individuals who have inherited or earned the rights to them.

Tjukurpa is extremely important to us. We can share some of the information with non-Aboriginal people, but the secret sacred information must stay only with Anangu.

(*Uluru-Kata Tjuta National Park Media Information Folio*, c.1996).

For non-Indigenous visitors to this World Heritage site, the translation of Anangu culture into the language and conceptual framework of the English-speaking visitor is an amazing challenge. The attempt to bridge the cultural gap between Anangu and English involves dealing with ideas, concepts and ways of knowing that verge on the untranslatable. The translation of Anangu culture into English brings it, unavoidably, into the epistemological sphere of the Western visitor and so transforms extreme cultural difference (that is, beyond the epistemological reach of Westerners) into something meaningful to English-speakers. Anangu culture, therefore, is not being seen *as it is* but is observed via a *Western representation* of Anangu culture (Hall 1997). Consequently, the spiritual foundations of the explanations offered to visitors can only be *appreciated*, almost as an aesthetic object is appreciated, rather than *understood or lived* as an Anangu-speaker would do so. We can *appreciate Tjukurpa*. We cannot ever *know* it as an Anangu-speaker knows it. There is, therefore, a level of incommensurability at the heart of the cross-cultural translation undertaken by the Anangu people at Uluru-Kata Tjuta. And this is the case, to varying degrees, for all cultural translations.

Does this really matter? What is the alternative? Having no communication across cultural difference at heritage sites does not seem to be an option. In some form or other, visitors are always in a dialogic relationship with heritage places (Staiff, Bushell and Watson 2013). The very marking out of places as 'heritage' initiates a communicative act; 'heritage' is a form of enunciation. The media kit and the visitor guide (Parks Australia 2012) at Uluru-Kata Tjuta are not failures, in fact quite the opposite, but they illustrate distinct limits when heritage sites, not of their own culture, provide a challenge to visitors intellectually and emotionally. As to the question of whether it matters, let me put it this way – and David Bellos (2011) articulates the issues much more eloquently and in more depth: is it better

to have the literature of Russia, France, Germany and Japan available to me in translation or not at all? I have seen the plays of Molière, Anton Chekov and Bertolt Brecht in English, I have read the novels of Herman Hesse and Thomas Mann, not in German, but in English. The same for the works of Emile Zola, Albert Camus and Jean Genet, not in French but as English translations, and I have read the novels of Yukio Mishima, not in Japanese but in English. And this is just the beginning of what would be a very long list indeed, especially if I included all the non-English scholars I have read in translation. The answer is, therefore, obvious: it is far better to have translations. And, as Bellos makes clear, when we are reading translations we are not aware of it being a translation (unless, of course, it is written in very poor English) and we certainly do not know if it is a good translation unless we can read and compare it with the original and, for many of us, that is not possible (Bellos 2011).

A translation of A̱nangu oral culture into English while visiting Ulu̱ru-Kata Tju̱ta may be imperfect but it is all that is possible. The translations in the official visitors' guide and the official websites are supplemented with the material culture displays and extensive explanations in the evocatively designed and multiple award-winning Cultural Centre. This ensemble – aesthetically potent architecture in a visually arresting landscape with numerous translations from A̱nangu into English – becomes a portal into a 'world' that would otherwise remain completely inaccessible. And while the dangers of exoticism will never be entirely overcome, the sheer density of the interpretation available at the Ulu̱ru-Kata Tju̱ta Cultural Centre goes some way to circuit-break the reductionism that accompanies exoticism of the cultural 'other' (cf. Hallam and Street 2000).

Whether the post/neo-colonial politics of this place is interrupted in these translations is a moot point. Like all translations, the referent becomes that of the target audience and, at Ulu̱ru-Kata Tju̱ta, it is the language of the former colonizers. In translation, A̱nangu culture becomes more 'English' than A̱nangu. Some translation theorists argue that this is an example of the 'violence' that translation does to the texts of the primary culture, a violence that tends to assimilate differences and thus homogenize the foreign text in order to be intelligible to the target language reader or, in this case, visitor (Venuti, 1993). Such arguments alert us to an important point. Translation is a negotiation of cultural difference. Either, it can enhance an appreciation of, and knowledge about, difference, or it can obliterate/assimilate difference (Venuti, 2000). Translation, therefore, is always a social, cultural and political intervention. I like to think that A̱nangu translations into English are a political intervention by the traditional owners, the A̱nangu people, in spite of the post/neo-colonial context; that in this act of cultural translation, there are overtones of the once colonized answering back to their former colonial masters.

But the question of whether or not it matters that I learn about A̱nangu culture in translation has another dimension and so we return to issues I raised in the first part of this chapter. The liberal humanist assumptions and beliefs that underpin the idea of conversing across cultural difference at heritage sites,

especially UNESCO-sponsored heritage sites, insist on the value of inter-cultural understanding because it ostensibly leads to tolerance and an ability for different cultures to co-exist peaceably. I'm not certain exposure to cultural difference does ensure the attainment of this lofty ideal and I here recall the reaction of my travelling companion in Bali. I think it is much more complicated than the rhetoric suggests. But certainly the opposite of cultural understanding and tolerance is abhorrent to me: xenophobia, racism, colonialist behaviours, cultural intolerance, cultural imperialism, apartheid regimes, destroying the heritage of the 'other', sectarianism and so forth. Yes, this is a strong ideological position, but when we are dealing with cross-cultural conversations in a globalized world of multiple cultural differences and contestations about heritage, ethics cannot be avoided.

The ethics of negotiating cultural sensibilities/sensitivities

One of the more intriguing aspects of visiting Uluru-Kata Tjuta, as the extracts from the media information folio make clear, is that there are many things about Anangu culture that will not be, under any circumstances, communicated to visitors. There are things a non-Anangu person cannot know; there are things that Anangu women cannot know; there are things that Anangu men cannot know; there are things that Anangu young adults cannot know. 'Silences' have an especially significant role to play in Anangu society; certain knowledge is extremely culturally sensitive and is the preserve of those who are the custodians of that knowledge. This may come as a mild surprise to a Western tourist who is in the habit of believing in 'freedom of information'. Also, there is another aspect of the Uluru-Kata Tjuta experience that produces an unresolved dilemma in the realm of interpretation: Western science and Anangu law. Visitors learn about *Tjukurpa*, the law/spirituality that both creates and at the same time permeates all aspects of Anangu society and culture, past, present and future. Part of *Tjukurpa* refers to the creation of the landscape by the ancestral beings into an interconnected whole where living and non-living dimensions exist without distinction (Parks Australia 2012). The Anangu conception of Uluru-Kata Tjuta is then placed alongside the Western geological and ecological history of the landscape, including the caveat that this is a 'western point of view and not the beliefs of the Anangu' (Parks Australia 2012). The non-judgemental equivalence that is performed here is left as an open-ended question. In reality, a type of limit to interpretation is exposed and then left unexplained because the sensitivities involved are deemed to outweigh the desire, and possibly the right, to know.

A quite different form of silence and silencing around cultural sensibilities comes from Thailand. As I have already discussed, Sukhothai World Heritage site is presented as, pre-eminently, the first capital city of the Thai-speaking people and the first of a succession of capitals that trace a royal and Buddhist/Brahmanism lineage from Sukhothai to Ayutthaya, to Thonburi and, finally, to Krung Thep (Bangkok). This history is, as all histories are, a contested history

but the contestations (Peleggi 2007; Winichakul 1995) are nowhere evident in the interpretation of the site. In the National Museum at Sukhothai there is a replica of the Ram Khamhaeng Inscription, a stone tablet bearing Thai text. (The tablet was discovered in 1833 CE at Sukhothai and the original is now in the National Museum in Bangkok.)

The museum information about the Ram Khamhaeng Inscription claims it is the earliest extant example of the Thai written script. The inscription, we are told, describes life in Sukhothai in a manner that illustrates how a regime of benevolent kingship produced a land of harmony and plenty. The stone has become a major primary source in Thai history. What the visitor is not told is that the Ram Khamhaeng Inscription is highly controversial and scholars are divided over whether or not it is a nineteenth-century forgery, and a forgery that may have been orchestrated by the discoverer, King Mongkut, Rama IV (Wongthes 2003). For those government officials working at Sukhothai Historical Park, the controversy is taboo. The very idea that a historical icon of the nation is a fabrication, perhaps executed by a member of the Chakri dynasty, should be explained to visitors is a step too far because such an explanation of the stone tablet would, it has been assumed, cast a certain light on the institution of the monarchy. For non-Thai visitors, especially Western visitors, this, like the 'silences' of Anangu culture, can look like a type of censorship. For Thais, it is a matter of significant cultural and social sensitivities where obligations and loyalty to the monarchy, especially to the much admired and deeply revered long reigning current King Bhumibol, Rama IX, far outweigh the scholarly dispute about the stone's origins.

Nevertheless, the treatment of the Ram Khamhaeng Inscription is symptomatic of a much wider issue. The interpretation of Sukhothai for visitors is a highly choreographed performance of Thai nationalist history that celebrates Sukhothai as a royal city in opposition to competing centres of power and culture, especially the Khmer kingdom to the west (Cambodia) and the Lanna kingdom to the north (Chiang Mai). Sukhothai has become, ideologically, the site of a founding narrative of national identity (Wongthes 2003; Peleggi 2002). It is about asserting cultural difference in the heritage arena. King Bhumibol, Rama IX, has declared that, without Sukhothai, Ayutthaya and Bangkok, there is no Thailand (Winichakul 1995). As Peleggi has shown, Sukhothai has become the 'physical locus' of a national narrative that is not only largely mythological but is highly political (Poleggi 2002). Alternative narratives in heritage interpretation for visitors are, therefore, almost impossible, as is a critique of the national mythology that surrounds and informs the visitor experience.

Let me summarize the issues raised in this chapter thus far. Firstly, similitude enables communication across cultural differences (as we saw with the book *Behind the Beautiful Forever* and, in a different register, the film *Confucius*) but at the expense of particularism and what cultural immersion and literacy offers to the 'native' speaker. Secondly, there is probably value in not translating/ mediating cultural difference in a number of heritage/visitor circumstances, as indicated by my initial experience of the Barong in Bali. Thirdly, translation

invariably empowers the cultural position of the target reader/viewer/visitor. Sometimes this can result in the stereotyping or the essentializing of the 'foreign' or originating culture. But sometimes this can be used by the originating culture to defend and protect its culture and its heritage. Fourthly, communicating across cultural divides, that consciously assert distinctions and difference, is not easy to achieve because it inevitably assumes contextual cultural knowledge that the target audience/visitor is unlikely to possess. Fifthly, at a number of heritage places there are limits, silences, sensitivities, boundaries and taboos associated with conversing across cultural differences. Visitors, in these situations do not have an automatic right to know or a privileged access to cultural knowledge; one cannot assume the view of esteemed Australian historian and essayist, Inga Clendinnen, that the 'past of a particular people should be available to everyone' (Clendinnen 2006). Once again, we arrive in a place where the ethics of cross-cultural heritage interpretation can't be avoided. And so, to navigate the ethical dimension of cross-cultural communication at heritage places, my guide is a book by Kwame Anthony Appiah, a well-known philosopher at Princeton University.

Reading Kwame Anthony Appiah

Appiah's book *Cosmopolitanism: Ethics in a World of Strangers* was published in 2006. Born in Ghana to an African father and an English mother, Appiah has written extensively about the ethics of identity. The significance of *Cosmopolitanism* is not in its reception within academe, where it divided commentators, but in its widespread influence in cultural institutions like museums and heritage organizations and within UN circles where it was widely read and debated. At the 2007 International Council of Museums conference in Vienna it was often quoted.

In *Cosmopolitanism*, Appiah seeks to find a way that can accommodate both universal values that apply to all (irrespective of culture and custom) and cultural relativism with its insistence on the tolerance of cultural difference and respecting many knowledge practices and world views. Appiah, through an engaging amalgam of philosophy, history, autobiography and literature, illustrates why 'conversations' with strangers are critical in a globalized world because the intimacy of the village, on the whole, is long past. He argues for a cosmopolitanism that entwines two strands: (1) 'we have obligations to others ... that stretch beyond those to whom we are related by ties of kith and kind, or even the more formal ties of a shared citizenship' (Appiah 2006: xv); and (2) 'we take seriously the value not just of human life but of particular human lives, which means taking an interest in the practices and beliefs that lend them significance' (Appiah 2006: xv). The subtlety of Appiah's exposition defies easy summary but it is rooted in what he calls the 'primacy of practice'. This places an emphasis on widely shared values that arise not from first principles and universal rights but from what he terms 'cultural overlap' that he identifies in the local lived experience of all humans. These shared values include kindness, generosity, compassion, cruelty,

stinginess and inconsiderateness (Appiah 2006: 56). This overlap produces a space for 'conversation'. Appiah suggests 'we can live together without agreeing on what values are that make it good to live together; we can agree about what to do in most cases, without agreeing about why it is right' (Appiah 2006: 71). The significance of 'conversations' across cultural boundaries, Appiah contends, lies in 'an imaginative engagement' with difference and not in a quest to find (impossible) agreement about values or principles:

> we go wrong if we think the point of conversation is to persuade, and imagine it proceeding as a debate, in which points are scored ... Often enough, as Faust said, in the beginning is the deed: practices and principles are what enable us to live together in peace. Conversations across boundaries of identity – whether national, religious, or something else – begin with the sort of imaginative engagement you get when you read a novel or watch a movie or attend to a work of art that speaks from some place other than your own. So I'm using the word 'conversation' not only for literal talk but also as a metaphor for engagement with the experience and the ideas of others. And I stress the role of the imagination here because the encounters, properly conducted, are invaluable in themselves. Conversation doesn't have to lead to consensus about anything, especially not values; it's enough that people get used to one another. (Appiah 2006: 85)

It is not hard to discern that Appiah's philosophical exhortation draws breath from a post-9/11 world and he is not shy in tackling issues like honour-killing, female genital cutting, footbinding or homosexuality, Muslim militancy and cultural taboos. With regards to heritage interpretation for visitors there are many ideas that emerge from Appiah's exposition that sit comfortably with current thinking about interpretation across cultural divides and within multi-cultural societies, thus the discussion of Appiah's book in museum and heritage circles.

The implications of Appiah's call for a cosmopolitanism that is not universalism, that deals with values and cultural relativism, that is about 'conversations' and not persuasion, that puts tolerance and understanding at the level of shared values across human cultures, offer something unexpected in terms of the various issues raised in this chapter about cross-cultural translation and conversing across cultural difference. Appiah provides a discursive space where it is possible to think, from a Western liberal position, the (almost) impossible: an argument *for* limits, reasons why we should accept/tolerate limits to interpretation. In other words, accepting and respecting silences, secret (gendered) knowledge, mythology *and* science, superstition, cultural taboos, the reductionism and stereotyping tendencies inherent in translations, visitor meaning-making, even when it is contrary to scientific meanings of heritage, the right to know in an open society and contrary to the spirit of the democratization of heritage places.

Here we find ourselves in the territory of the multi-cultural, postcolonial and humanist notion of the museum and heritage place as arenas of dialogue and cultural exchange (Karp and Lavine 1991; Witcomb 2003; Carbonell 2004;

Karp et al. 2006; Anheier and Isar 2011). However, via Appiah, it is possible to discern a mode of negotiation that is not simply a restatement of Western liberal democratic ideals. Rather the acceptance of 'limits' in interpretation is related to a range of assumptions that are more ethically inclined and are nourished by the need to negotiate cultural difference and moral disagreement, escape positivism and grow from local practices. An argument for 'limits' has contours that wonder at the imperfection of human beings and the fallibility of knowledge. An argument for 'limits' recognizes that knowledge is incomplete, partial, conditional and provisional. An argument for 'limits' acknowledges that the cosmopolitanism, as described by Appiah, has, in heritage interpretation, more weight than an individual's liberty and freedom to access all knowledge and be privy to all 'cultural information'. An argument for 'limits' recognizes that the 'limits' themselves are an important invitation to engage, especially where the 'limits' are explicit like they are at Uluru-Kata Tjuta but even when they are not, as at Sukhothai. Yes, it is true the tensions between ideology and archaeology are not represented at Sukhothai. Yes, there will be an uncontrollable explosion of meaning-making in the context of the digital revolution and, yes, many 'unacceptable' interpretations will jostle with authorized meanings about significance. The negotiation of the zone occupied by heritage and its visitors, where things can be said, where things cannot be said and where things remain unspoken, is not an issue to be resolved or a problem to be solved but a place to 'converse'.

Not only does Appiah provide a way of thinking about such negotiations, his discussion of values is equally practical in its implications. Currently, the interpretation of Sukhothai for English-speakers is presented in a manner that requires an understanding of Buddhism, Thai history, art and architecture, and knowledge of the influence of the art and architecture of Lanna, Khmer and Sri Lankan societies. For most international visitors the task verges on the impossible and Sukhothai remains partially illegible from the perspective of the visitor and partially illegible, for very different reasons, to the custodian (Sapraidist and Staiff 2007). Rather, Appiah points to the importance of what is common within the cultures of those engaged in conversation across difference. To apply this insight to the interpretation of Sukhothai requires abandoning the current approach to content and focussing on the things that are common across cultures: the sense of the sacred, religious buildings, kingship and kingdoms, monasteries and monks, city-states, defence and security, commerce and trade, marriage, gender and sexuality, social class, work and so on. Commonalities permit 'conversation' whereas providing Western tourists with an analysis/description of Thai history and culture merely reinforces exoticism and 'orientalizes' the site so that the strangers remain strangers/strange (cf. Staiff and Bushell 2003b).

As I mentioned earlier, World Heritage sites under the aegis of UNESCO are committed to peace, tolerance and understanding among the world's peoples. They embody Appiah's notion of cosmopolitanism: places characterized by 'kindness to strangers' through 'conversation'. The 'limits' to interpretation will rightly continue to worry heritage and museum scholars of many hues and colours

but conversations across boundaries/'limits', as Appiah says, are inevitable as the world gets 'smaller' and more crowded. Negotiating the borders/'limits' of heritage interpretation at heritage sites should be part of the 'conversation'. It is an enormous but worthwhile challenge, but one with no guarantees.

To end where we began with the three scenarios I described at the beginning of this chapter. These examples really do give us some options especially when tinctured with Appiah's perspective. At heritage places where cross-cultural conversations are increasingly likely – whether as results of international travel or because of their location in multi-cultural societies – similitude is the efficacious enabler. Boo's *Behind the Beautiful Forevers* is an interesting template of the effectiveness of similitude. However, emphasizing sameness over difference is pregnant with dangers (stereotyping, dis-empowerment, neo-colonialism, assimilation) and these must be taken into account. The translation of cultural difference, however, is not wholly dependent on an intermediary translator. In the film *Confucius*, the viewer themselves translated a great deal through visual similitude via a process of comparison where things in the film were equated with things known about in the viewer's cultural and social world. (Admittedly this meaning-making was enhanced by the sound track and the sub-titles.) What I learn from this is the point Appiah makes: emphasizing the things we share, as opposed to the things we do not, allows for a conversation across cultural difference. The Bali example suggests that, under certain circumstances, the complete lack of translation or explanation will not necessarily reduce the powerful affect/effect of visiting a heritage site. How we negotiate and facilitate these somewhat contrary options is no easy task. All of them entertain considerable risk because of the power relationships involved in all encounters with the cultural 'other'; because of the various ways cultural difference is continually manufactured in systems of representation (the media, popular culture, cinema and within the tourism industry); the fact that 'culture' is not some stable entity and itself is a dynamic process of change (Hallam and Street 2000).

What we can conclude is this: simply translating signs and brochures into various languages that match the profile of the visitors barely touches the surface of what is at the heart of cross-cultural communication at heritage places. And whatever we do, no matter how noble the intention, there is always the possibility that the experience of cultural difference in a heritage setting may lead, not to greater tolerance and understanding, but to its opposite. In the heritage interpretation 'business' we can never control the outcomes of complex social and cultural processes.

Chapter 8
Enchantment, wonder and other raptures: imaginings outside didacticism

There is a scene in Laurent Tirard's 2007 film *Molière* that depicts a theatrical performance presented by Molière's troupe during which a mythical creature flies above the crowd. The theatre patrons look up and, as the creature soars above them, they forget themselves in wonder and awe. I saw the same rapturous transfixion on the faces of a crowded iMax theatre in Bangkok in the first week that the movie *Avatar* was released. More glimpsed than 'saw'; I too was busily being seduced and enchanted as I was enfolded into James Cameron's visual and aural world of Pandora. In Chapter 1, I recounted an anecdote about sitting on a mountain in northern Thailand lost in a reverie listening to a Beethoven piano concerto. What intrigues me about each of these episodes is the way they partly, but not completely, fall outside of the way heritage interpretation is often considered. In most conceptions of heritage interpretation the primacy of informal learning means that 'enchantment', 'rapture' and 'wonder' are granted a supporting role in the communication between people and heritage places. As I wrote in Chapter 1, such somatic engagements are invariably perceived as a powerful means to an end, but not an end in themselves. After all, it is not so easy to explain, from a didactic perspective, how to go from enchantment to action, how to capitalize on rapture to do what is often considered important to the heritage enterprise – extending heritage's constituency so that the protection of vulnerable places deemed significant has a viable and informed electorate now and into the future. Even storytelling, when done well, does something we often call 'capturing the imagination', but it too, in the calculus of heritage interpretation as informal learning, often serves as a mode of engagement that is a vehicle for presenting information and inculcating what some have called 'take-home messages'.

This chapter, the final meditation in the book, is not an attack on visitor learning at heritage sites. How could it be? Making meaning – or 'world making' as some commentators have termed it so as to include the somatic (Hollinshead, Ateljevic and Ali 2009; Hollinshead 2009) – is a fundamental human trait and I'm as much motivated by questions of what, why and how as anybody else. But I am rather bothered by a concern about where a focus on learning leads us theoretically and, therefore, in the way we imagine visitor/heritage dialogic relationships. I want to return to the notion of heritage interpretation being about both representations and what lies beyond representation (indeed something captured by the term 'world making'), in order to consider how this may reconfigure the way we may think about the various communications between visitors and heritage places, especially in the digital age.

I think the mimetic capacity of heritage places is more than about understanding and explaining such places (cf. Taussig 1993). I'm obviously interested in the 'more than' and therefore I will begin with a clutch of terms like 'enchantment', 'wonder" and 'rapture' because of the work they do. This leads quite seamlessly to an interesting debate that has opened up in the museum literature about materiality and one that has particular resonances for heritage sites. And finally, rather than providing yet another manifesto about heritage interpretation, the very antithesis of my thinking, a series of observations and questions will be aired to hopefully keep the interpretation 'community' in animated conversation as we enter a time when visitors have almost limitless digital choices for engaging with places and sites and can co-author their own experiences of heritage (as we observed in Chapter 6).

To be enchanted

Like a bowerbird I'm a collector, but not of things blue. Instead I seem to collect random quotations. My notebooks are full of them although, oddly, this is not an intentional pursuit, but as I go through my jottings I note how many have been recorded. Here are three. The Australian public intellectual Donald Horne, in his book about the intelligent tourist, wrote that 'words are only one of the ways in which we do our thinking' (Horne 1992: 101) and 'we can learn to experience (places, things, people) by looking rather than speaking. We can give up sightseeing for sight experiencing' (Horne 1992: 375). Ang Lee, the celebrated director of the film *Life of Pi* (2012), said in a press interview about the film: 'Imagination. Rationality only goes so far. There's a limit. Beyond that limitation, how do you take the leap of faith of embracing the unknown? One way we deal with that is telling stories.' The equally celebrated writer, Jeanette Winterson, in her introduction to her 2009 anthology of opera-inspired stories wrote this:

> The stories in this collection have the music in them. The rhythm, breath, movement of language, like music,creates emotional situations not dependent on meaning. The meaning is there, but the working of the language itself, separate from its message, allows the brain to make connections that bypass sense. This makes for an experience where there is the satisfaction of meaning but also something deeper, stranger. This deeper stranger place is an antidote to so much of life that is lived on the surface alone. When we read, when we listen to music, when we immerse ourselves in the flow of an opera, we go underneath the surface of life. Like going underwater the noise stops, and we concentrate differently. (Winterson 2009: 1-2)

All three gesture to something interesting: mimesis is implicated in a powerful phenomenon that is central, indeed fundamental to human experience, but hard to define because it belongs to a vitality that is both of representation and beyond it, a creature of representation but not contained by representation.

Throughout the previous chapters I have been articulating the idea that heritage interpretation as praxis is better served by being thought of as pertaining to representation rather than to education/learning. It is the ineffable qualities of mimesis that I'm drawn to: the capacity for looking, reading, listening, acting, touching to enchant. And, equally, I'm intrigued by the processes of the materiality of things that produce within the visitor a sense we may call 'wonder' or 'rapture' or 'enchantment'. What I'm trying to explain is much better described – if that is the right word – in a photograph. The cover illustration of a book edited by Sandra Dudley, *Museum Materialities: Objects, Engagements, Interpretations* (2010), a book to which I will return, is quite mesmerizing. The photograph shows part of the skeleton of the jaw of a *Tyrannosaurus rex*, the mouth ajar and offering rows of deadly teeth. Before the gaping mouth stands a small girl bathed in yellow-orange light. Her small head could easily fit inside the dinosaur's mouth. She is only centimetres from the powerful set of jaws and she looks up into the mouth cavity, her own mouth open and a look of wonder and perhaps awe on her face as she reaches out her left hand to delicately touch one of the teeth with her forefinger. The picture produces so many responses: I'm astounded by it, I'm slightly unsettled by it, I'm amused by it, I'm riveted by it and I'm deeply impressed by the photographer's skill. In that little girl's face is an expression that describes, without words, the very quality I'm attempting to trace out.

But from where does this wonderment arrive? It's quite a complicated question. Partly, it is probably knitted into our DNA and our evolutionary past to be frightened by big things that threateningly tower over us; partly, it is because we have learnt from stories, from school and perhaps the experience of the 1993 movie *Jurassic Park* or the BBC documentary *Walking with Dinosaurs* (1999) that *Tyrannosaurus rex* is scary; partly, it is to do with the way the reptile world is both represented and experienced, whether in zoos or the back yard, plus a host of other likely factors that shape our responses. For me, the critical thing is that the dinosaur in the picture is, for the little girl, both a thing and its representation in and of itself. We cannot divorce the physical from the represented and, equally, that fusion produces an effect/affect that is much harder to predict and to describe and yet is no lesser a reaction/response to the materiality of the bones of the dinosaur. This whole ensemble of interactions and responses produces embodied emotional states that we sometimes language with words like 'wonder', 'rapture', 'awe' and 'enchantment'.

To further illustrate what I'm thinking about, let me narrate three scenarios:

Scenario 1

A book sits by itself. Unopened, but carefully placed on a bare unadorned table. As you approach the book you see it has no lettering on the cover or the spine. It looks to be old but somehow treasured. From the outside you could not say what this book might be: a textbook of mathematics, a memoir, a history, a scientific treatise? You open it. It is none of these. It is the Holy Qur'an. In that split second

of discovery the object ceases to be just any old book and yet the physical object on the table has not in itself changed but, by opening it, everything has changed. The material object has been charged by the representations of itself.

Scenario 2

Imagine watching a highly skilled artist painting a picture. You can see the artist has drawn a young girl seated by a window and through the window you can see the outline, yet to be completed, of a landscape with hills, a lake and a town in the distance. The seated girl holds on her knee a young child and the child looks up at the girl. Now the artist begins to add some further details. A yellowish gold-coloured oval shape is drawn above the head of the girl and above the head of the child and in so doing, with two quick actions of the artist's practised hand, the two figures are transformed into the Virgin Mary and the Christ Child. Two oval marks completely metamorphose the picture, but the effect/affect of the symbolic recasting is more than what is represented by the addition of the haloes.

Scenario 3

You are watching a video on YouTube of a young handsome man sitting cross-legged in quiet contemplation in a verdant forest, his hands loose in his lap, his head slightly bowed down and his eyes shut. It begins to rain but the young man seems to be undisturbed by the rain even as it becomes heavier and he is obviously getting very wet. Suddenly, there is a movement behind the seated man and rising up behind him comes a slithering giant serpent with seven quite terrifying heads. It rises above the seated man, its multiple heads forming an umbrella to protect him from the rain. Instantly, it is no longer *any* seated young man but the Lord Buddha protected in his meditations by the Naga, the guardian water serpent spirit.

Partly, these changes obviously have to do with perception, but it is much more than this because of all the other emotional and cognitive responses the changed perceptions initiate and these responses will, of course, vary greatly between, for example, believers and non-believers, between those who can read the signs and those who cannot. However, for those with particular cultural knowledge there is little immunity from what is revealed. But what is revealed is more than knowing something; it's not just about what the observer in each case has learnt: that the book is the Qur'an or the figures are of Jesus and his Mother or that the man in the rain is Buddha. Something else is going on here in that moment of metamorphosis.

 These scenarios were also chosen because, to a degree, they mimic the processes by which an object or place becomes 'heritage'. Much of cultural heritage, at the physical level, is just bricks, mortar, cement, steel, paint (and so on) or a series of dance steps or chopped vegetables and meat sitting on a plate with an array of coloured spices waiting to be cooked or a song cycle waiting to be sung or music made by plucking or striking or blowing. This is the stuff or everyday life and

what transforms them into 'heritage' is a series of discursive moves by which the objects or sounds or performances become inseparable from their representation as something special, something not just ordinary, something deemed vital not only to the past/present but to the past/future, something deemed significant, drenched in values worthy of protection by individuals, families, communities or the state (cf. Smith 2006; Harrison 2013). In the heritage business we make transformations akin to those in the three stories: we alter what in many contexts is ordinary, into something that is extraordinary. This 'marking out' is about mimesis, giving the physical form another nature. However, and crucially, this is more than a process of semiosis, or a (re-)coding of things, because it produces effects/affects beyond itself (and yet somehow, seemingly, integral to the materiality of the 'thing' in question). The three scenarios I sketched illustrate this very point.

These transformations relate to something that is greater than knowledge production. As so many writers have recently and powerfully observed, heritage transfigurations – the endeavour of doing heritage – involve memories and memorializing, identities (kin, clan, nation, class, gender, sexuality and so forth), ideologies, aesthetics, nation building, commerce and conservation interventions of various kinds (see, for example, Winter 2007; Logan and Reeves 2008; Labadi and Long 2010; Anheier and Isar 2011). But none of these adequately explains all of the dimensions of the dialogic relationship between heritage places and its visitors. It goes most of the way, but not quite all of the way. The magic is missing. What we observe in the photo of the girl and the skeleton of the *Tyrannosaurus rex* is often absent or subdued in discussions about heritage and identity or heritage and ideology or heritage and conservation.

The 'enchantment'/'wonder'/'rapture' word cluster is an attempt to do a certain type of analytical work. Enchantment, or to enchant, is about filling someone with great delight, with charm, to figuratively put them under a spell, to bewitch them, to induce sensations of bliss, ecstasy, rapture, joy and wonder. What is life without these things? What is heritage visitation without these things? Heritage places are not just encyclopaedias in stone or archives in bricks and mortar or a music performance or a cuisine, all to be decoded or 'read' as 'history' or 'culture' or 'archaeology' or 'ecology'. Barrie Kosky, the theatre director, in his book *On Ecstasy* and writing about particular types of musical performance, says, 'in the end, this music can only be experienced. Interpretation fails. Words are useless' (Kosky 2008: 86). That's not quite true, interpretation is always possible; but he points to the ineffable dimensions of experience, the powerful effects/ affects not easily described and yet so life affirming. And this is not to decry heritage places as sites of knowledge-production and communication (the idea of a heritage site as an encyclopaedia in stone is an enticing one and some sites, like the Acropolis of Athens, can and do perform in this way with great flair). Nor is it an attempt to expel joy, wonder, delight and ecstasy from intellectual pursuits. I'm especially reminded of the Epicureans of ancient Rome and the Renaissance humanists, thanks to the expose of these sorts of pleasures of the intellect by Stephen Greenblatt in his controversial Pulitzer Prize-winning book *The Swerve:*

How the World Became Modern (2011). It is the reductive functionalism of contemporary heritage interpretation, locked in charters and definitions that insist that the dialogic relationship between heritage places and visitors must do this or that (increase awareness, deepen understanding, forge connections, achieve management objectives). This moral crusade, this evangelical bent, is what induces my chiding and my intense desire to fly somewhere else. I have a strong distaste for proselytizing, for zealotry. As many artists, writers, film-makers, performers and cultural critics of many hues will attest, didactic art is bad art, and, for me, the experience of heritage places, whether cultural or natural, is akin to the experience of art whatever its form. But I also have a concern about what could be called the information imperative.

It just so happened that when I was composing this chapter I was back in Bali. At the hotel where I was staying, they programmed what they called a 'Bali Cultural Night'. Setting aside the conspicuous packaging of certain aspects of Balinese culture for tourist consumption, and the vexatious issues this commodification raises (see Picard 1996; Bruner 2005; Vickers 2012), one element of the evening was a performance of parts of the Barong. Unlike the experience I described in Chapter 7, this performance was broken up into discrete episodes, each episode narrated in English with an explanation of the story before and sometimes during the performance. The decoding not only gave priority to information it made the performance an illustration of the narration and by so doing the performance was made subservient to the explanation. The power of the Barong as a highly spiritual dance-drama, enveloped by the rising and falling cadences of the gamelan orchestra, was partly, perhaps entirely, lost. On so many levels the interpretation provided by the narrator altered the Barong into something much less than itself; it became an entity akin to a live cartoon with thought bubbles. And, even though I understand and appreciate the difficulties of cross-cultural translation (see Chapter 7), the information imperative, seemingly in ascendance here, made for an intensely disappointing experience.

'Heritage interpretation is the communication of information about, or the explanation of, the nature, origin, and purpose of historical, natural, or cultural resources, objects, sites and phenomena using personal or non-personal methods.' Thus begins the entry for heritage interpretation on Wikipedia, as accessed at the end of 2012 (en.wikipedia.org). I shudder at the reductive thinking this description entails.

Materiality and mimesis

In the heritage sphere, objects and their representation, mimesis, are inseparable, co-joined because our mimetic faculty (as Taussig calls it) enables us to, wondrously, create a copy that makes objects, places, ecosystems a type of 'other', a representation that can be a power in itself, to exhibit 'sympathetic magic' (Taussig 1993). But the materiality of that which is copied is, therefore, both itself

and its representation, the one imprinting on the other but neither contained or restricted by the other. Semioticians often describe the relationship between object and copy/representation as arbitrary, or the copy as a floating signifier, because they are aware of the complexity of mimetic processes and the not so straightforward relationship between objects and their representations (Gottdiener 1995). As we discovered in Chapter 2, representations can have a 'life of their own' separate from that which they represent. But ,while heritage interpretation is the stuff of mimesis, we must not fall into the Enlightenment error of separating things from people. We now understand the whole planet and everything on it, including its human inhabitants, are all the same substance, the 'and' in the 'world and us' is a fiction despite our mimetic capacity for creating and 'othering' the world through our copying, our reproductions, our imaginings. That first extraordinary NASA photograph of the planet Earth suspended as a blue, glowing sphere in black space was, simultaneously, an expression of the separation (the 'othering' of things) we are capable of, and of the fiction of the world/us separation. There is no opposition between mind and body, between self and the world, between reason and emotion, between matter and spirit, between inside and outside et cetera. If postmodern thinking has taught us anything, it is this.

In recent years the museum literature, after a long spell of fruitfully investigating the representation side of the mimesis ledger, has (re)turned to its historical roots, materiality. Sandra Dudley, in her introduction to *Museum Materialities: Objects, Engagements, Interpretations* (2010), looks at the way information has been fetishized in museum and heritage places over, and sometimes at the expense of, their materiality/material culture. From the nineteenth century onwards, there has been a strong urge for heritage places and museums to emphasize information and scholarly insights as though the material was an excuse to extemporize, to inform, to persuade, to learn, to illustrate, to teach.

This is not hard to understand. Heritage places have been traditionally understood as physical things that are valued enough to warrant inter-generational transfer because of the cultural meanings invested in them or attached to them. Objects stripped of their heritage value are 'merely objects'. A magnificent eucalyptus tree in a private garden in Greece, where it is an exotic plant, is not quite the same as one in the Blue Mountains World Heritage site in New South Wales, Australia, a place sometimes regarded as a sanctuary of eucalyptus species and a 'natural laboratory' for the evolution of eucalypts. It is the 'meaning stuff' that is given such prominence in heritage discourse and heritage practices. The object/site stripped of its meaning, or the information attached to it, or the knowledge associated with it is oddly inert and 'reduced' to a seemingly less noble form of materiality. The conservation legislation of the Australian Government and the Burra Charter of ICOMOS Australia make it very clear that what is protected is values and not things per se. Indeed, many of the meaning-making activities initiated by heritage places, and often under the rubric of 'research' or 'scholarship', has been about data generation, documentation and knowledge-production, all of which have given the place/object a certain authoritative weight.

So we have a history of object-hood in the heritage enterprise that is information-laden. But in heritage places across many cultures, it was never, nor is it, the entire story. Places and objects are deemed special because they are beautiful, they are magical, they are spiritual, they are mystical, they are fonts of mythmaking and storytelling, they are sites of creation, ancestor worship, ritual, remembrance, communal celebration and so forth. Yes, this can be a type of knowledge production too, and aesthetics and spirituality are also qualities associated with materiality and the mimetic production of the 'other', but they are also prominently linked to the affective domain, to the senses, to emotions, to feelings and so on, all of which have a complicated historical relationship to rationality and normative Western epistemological practices.

Andrea Witcomb puts it very succinctly when she refers to 'the irrational power of museums – their ability to make contact with audiences in ways that are beyond the rational and didactic forms of narrative' (Witcomb 2010a: 39). The same could be said of heritage places. I share this interest in the 'irrational power' of heritage places – and here I use the word 'heritage' very loosely to include all places that individuals or groups feel strong connections with and/or places believed to exert a power whether aesthetic, spiritual, familial, communal, or historic; those special places that are delineated, for whatever reason, from the quotidian and draw visitors like moths to a light. Ang Lee also explores this 'beyond didacticism' quality in his film *Life of Pi* (2012). And in mentioning this, I quite consciously bring together museums, heritage sites, special places and a film because these different experiences are linked: the rendering of a physical place as 'special', creativity in all its guises, the imagination, spirituality, aesthetic seduction, history-making, travel, knowledge formation (and so forth) are all endeavours to do with our various human quests to reach beyond ourselves. The motivation barely matters: existential angst, religious belief, enlightenment, understanding, modernist alienation, our demons, our innate sociability, our desire to celebrate, the pursuit of transformative experiences, the credence placed in journeying/wandering/exploring, the craving for ritual and our irrational and yet 'oh so human' attachments of sundry kinds. All these motivations are linked to hope and in this sense they are all orientated to the present/future. One cannot, without considerable difficulty, perceive of heritage outside of such quests, such motivations, and to do so seriously limits, not only the work heritage increasingly does (wherever it is practised) but also reduces the infinite and myriad connections at the heart of the heritage experience. This complex and multifarious connectivity, I suggest, cannot easily be held within functionalist thinking about heritage interpretation as a type of learning.

In the movie *The Life of Pi*, the narrator, Pi, tells two stories of his miraculous survival on a lifeboat after the sinking of the ship on which he and his family were making a journey from India to Canada. Pi is the sole survivor. He floats from somewhere east of the Philippines to Mexico. The first story he narrates is a fantastical tale about himself and the only other survivor on the lifeboat, a Bengal tiger. It is a magical, enchanting, bewitching story with the extremely scary and

threatening situation continuously opening out to some of the most enthralling images of the sea and the sky ever to reach film thanks to digital technology and 3D projection. While the incredible story has its own inner logic, it is more often than not the logic of magic realism and the logic of cinematic narrative rather than the rationality of common-sense realism. We are forced, and happily so, to surrender any sense of disbelief. In the second story, told to the insurance agents representing the ship's Japanese owners who refuse to accept the first story, the fantastical and the mysterious are expelled entirely and the equally scary story of four survivors on the lifeboat, including Pi's mother, who eventually kill each other leaving only Pi, rests on the logic of a news story. It is still a powerful story of survival, human frailty and the capacity for evil but, unlike the first story with the conjuring of surprising and aesthetically mesmerizing images accompanied by lush sounds, the second story is told by Pi from his hospital bed, the film often focussing just on his face as he creates his word-picture of terrible events. There are no hypnotic images or a seductive soundtrack used in the telling of the second story.

Pi asks the writer who has come to hear his story and to whom he entrusts his tale, which is the better story, which one is true? The writer elects the story of the miraculous survival at sea for 227 days on a lifeboat with a tiger. He chooses the story that has so enchanted the audience for most of the film's length. The question we are left with is an important one: what would the world be without enchantment, imagination, magic, without the poetic, the domain of beliefs, without the creativity to invent the fantastical, without the inspirational, without those things that are beyond the rational (narrowly conceived)?

Obviously, no one is going to say we need a world without these human qualities and capacities so this leaves us with a further important question: is this heritage business? Is this heritage interpretation business? I would like to think so. For the Laotians who are the custodians of Luang Prabang, the World Heritage site in northern Laos on the Mekong River, protecting the Naga spirit, the guardian water-serpent spirit, is crucial to their heritage business. The scientific rationality of material conservation is perplexed by such ideas and lived realities (Staiff and Bushell 2013). To enter the interior of Hagia Sophia in Istanbul, or to snorkel on the Great Barrier Reef along Eastern Australia, are, perhaps first and foremost, enchanting, awe-inspiring, rapturous, magical, poetic encounters, and such responses are powerful in and of themselves. Is this heritage interpretation or a prelude to interpretation? I think it's a type of interpretation and can stand alone. For me it is not a prelude to something else (information, storytelling, imaginings, 'mashups'). Of course it *can* be a prelude because there is a dynamic inter-connectivity between the senses, knowledge and our emotions and all three are invariably simultaneously embodied in the visitor, but it doesn't have to be considered thus.

The implications are clear. The 'what', 'how' and 'why' of heritage places constitute just one dimension of the way visitors have and do enter into a dialogic relationship with heritage places (Staiff, Bushell and Watson 2013).

Imagining heritage interpretation

Emerging at heritage sites and museums around the world is an environment characterized by visitor choice. Whether it is the democratization of heritage places; whether it is the recognition of local custodianship at heritage sites; whether it is the veritable array of different visitors marked by place of origin, age, cultural affiliations, gender, socio-economic background, educational level, degrees and types of interest and so forth; whether it is the effect of the digital connectivity of sites and visitors or whether it is the evolving nature of heritage as a concept, the provision of a limited number of highly managed and officially sanctioned interpretations at heritage sites is now impossible and, probably, undesirable. For me this is a very exciting space to be within. For the first time in the history of contemporary heritage visitation, a reconfigured interpretation environment is possible. In general terms this 'space' will allow visitors to design their own experiences; it will allow them to co-author meanings; they will be able to access on site both authorized and unauthorized sources of information and other allied materials (on site and off site); interactions will range from those that are entirely sensate to ones highly mediated by information; to varying degrees, and probably increasingly so, the digital will be a means of on-site interactivity offering a vast range of possibilities from the visual, the aural, the written, from movie clips to oral accounts to games to documents primary and secondary, written and recorded. In this 'space', visitors can play, create, absorb produced materials, negotiate meanings, avoid all designed representations, socialize, flirt, escape, learn, subvert, celebrate, remember, wander, feel, reflect, marvel, be in repose, make associations and so forth. They will be the masters of their own heritage 'world making'.

We may not all be in agreement about what is produced under these circumstances and we may wonder about the veracity of visitor-generated experiences (see Chapter 6). Indeed, when I read a blog about the meaning of the film *Life of Pi*, I was quite astounded by the debates initiated by the bloggers. I thought a lot of the interpretations went way beyond the symbolism carried by the movie, but I was heartened by the debate itself and the very personal ways the film connected to the viewers who were blogging. After all, reaching a consensus about the meaning of the film is hardly the point. And the same can be said of heritage places. For me, the 'conversation' is more important than reaching agreement or being subject to (or subjugated by) something someone else has already agreed upon.

David Crouch, in his book *Flirting with Space* (2010), begins with a prologue that considers the meaning of flirtation:

> Such pregnancy of possibility, and possibility of becoming; the implicit if possibly agonizing playfulness; the very combination of contingent enjoyment, uncertainty, frustration, anxiety and hope would seem to thread across living. Along with these, living holds a felt possibility of connection, meaning, change. To fix may be assurance, certainty or entrapment, closure or a mix of these. (Crouch 2010: 1)

He goes on to consider encounters that by their nature open out, that challenge the ordinary and the repetitive. Most travel has this potential. Visiting heritage places certainly has this potential. To flirt is a creative way of encountering but significantly, like enchantment, it avoids what Crouch calls frames and contexts, determinants that produce a particular legibility, a particular way of understanding and representing and a desired sensibility that is always attempting to solidify, to congeal meaning, to ground the heritage experience. Crouch's book is a type of ode to subjectivity and its importance; to the importance of the poetics of experience; to that which is indeterminate and has the qualities of being alive to the new, the unexpected, the tactile; to that mimetic 'other' that invades and pervades the sensory; that is a potentiality for something that will be uniquely individual and personal. And in visiting heritage places we can be reasonably confident about this because they are, by definition, not of the mundane and the ordinary, but places consciously marked out (by whatever process, physical or metaphysical) as being extraordinary.

Flirting can generally be regarded as an enjoyable interaction but is not always seen in a positive light. Sometimes the attention the flirter seeks to bestow is unwelcome to the recipient. Similarly, with heritage site interactions, there are no guarantees. I vividly recall a story told by a curator at a museum conference I attended. The museum where she worked had a considerable palaeontology collection with soaring skeletons of dinosaurs. She was fascinated by a group of visitors who were with a guide she did not recognize and so she went closer to hear what the guide was saying to his obviously captivated audience. It turned out the assembled party were Creationists, a religious movement who believe in a literal understanding of the Book of Genesis and, therefore, that the age of the Earth is only 4,000-6,000 years and not the 4.5 billion years estimated by cosmologists and geologists. Their leader was telling them how Satan had deliberately planted the dinosaur skeletons into the rocks of the planet in order to seduce humans away from the truth of the Bible.

Evolving conversations

In recent years I have attempted to increase the range of the conversation about heritage interpretation. Why do we do it? When I look at the websites of the various national interpretation associations that have developed in recent decades I am always impressed by the seriousness and the devotion of those involved when they express the public good they deem in their activities. I wonder, therefore, whether heritage interpretation should be regarded within a wider framework of multi-cultural democracies, emergent democracies and non-democratic societies? Is it to do with 'responsible citizenship' and about learning to be a responsible citizen? In other words, is the heritage/visitor dialogue not just about the particular site being visited but also about a much wider and deeper agenda to do with the political health of democracies however conceived? Is it to do with national identities and

engendering patriotism across many political systems democratic and not? Does this explain the increasing emphasis on visitor research and 'knowing the visitor'? Is this why there is a great deal of discussion about attitudes and beliefs, not just as a way of ensuring more 'effective' communication at heritage places, or targeting the particular interests of particular visitors, but because of the ideological function heritage interpretation performs, that is, regimes of discourse and power within the nation state? Or is heritage interpretation a type of nationalist discursive formation about the past, the present and the future, part of the system of representations to do with what Benedict Anderson (1991) has memorably called, and described, as an 'imagined community'? I do not have ready answers to these questions but they do arise from an important and ongoing wider discussion and analysis that has taken place over several years in both museum and heritage studies (see, for example, Karp and Lavine 1991; Karp Kreamer and Lavine 1992; Boswell and Evans 1999; Karp et al. 2006; Langfield, Logan and Craith 2009; Harrison 2010; Labadi and Long 2010).

The Australian historian and essayist Inga Clendinnen, in her collection of lectures *True Stories* (1999), mentions the qualities of responsible citizenship in a complex world. In relation to heritage interpretation, three of these qualities stood out for me: an ability to critically examine oneself and one's traditions; an ability to see beyond immediate group loyalties and to extend to 'strangers' what we already extend to family and kin; and an ability to see unobvious connections between sequences of actions and be able to imagine the consequences intended or unintended. These are noble aims and I recognize in a great deal of heritage interpretation, as currently practised, a profound desire to intervene in a number of national and global 'conversations' because of the perceived urgency of the situation our world faces: resource depletion, the loss of biodiversity, food and water security, climate change, energy production and consumption, and the powerful ascendency of modernity across the planet. I'm not immune to this urgency.

For me, the issues are these. To what degree in heritage interpretation do we acknowledge and articulate these wider perspectives about what we do and why? To what degree can heritage places hope, in their dialogic function, to contribute to either an understanding or an intervention regarding global threats? Is learning at heritage sites the critical portal, or can Clendinnen's qualities of citizenship be achieved in a multitude of ways and where learning is but one? And shouldn't visitor choice be paramount in heritage engagement (and now possible in the digital environment) precisely because we cannot hope to control the multifarious ways people respond to the heritage experience and nor should we. This is not an abdication on my part from the role of heritage interpretation but a call to re-think it as a *platform* for negotiated meaning-making; for non-linear and non-determined experiences; for facilitating choice and for being able to deal with the unauthorized, the non-conforming, the unpredicted, the subversive, the playful; for imagination, creativity and newly performed responses; for experiences where the power of the somatic, the emotional and the serendipitous are acknowledged

as possible ends in themselves; for co-authored experiences and meaning-making; for experiences that are not necessarily born of the information imperative. To achieve such a re-thinking requires a different theoretical architecture: learning theory will not suffice because it is outcome-driven. Representation theory and post-representation theory – and cultural theory more generally – offer greater scope for dealing with the complexity I have been describing throughout this book and offer a way of imagining that incorporates knowing, emotions, visual cultures, the experiential, digital environments and cross-cultural dialogues.

In January 2011, a very controversial private museum opened on the banks of the Derwent River in Hobart, the capital city of the island state of Tasmania in Australia. Called MONA: the Museum of Old and New Art, it has become something of a cause célèbre in museum and heritage circles because of its refusal to abide by any of the 'rules' that have governed museums in recent times. The owner of the museum, David Walsh, is a professional gambler who became a collector. The museum is devoted to sex and death. It is the manifestation of a very personal vision by its owner. It is designed so that visitors get lost within its walls. It completely eschews the traditional educational function of museums. Some exhibits are designed to shock, even disgust. It has no labels or information panels. It consciously refuses didacticism. The owner has expressed a suspicion about scholarship. Its use of digital handheld devices offers the visitor a number of choices with regards to the way they want to interact with the museum and its collections. There are no expectations by the owner of the museum other than, perhaps, 'wonderment'. On-site learning and the communication of information is a secondary concern. A bar that is set at a major intersection of the various paths through the layered world, and cafes throughout the complex, invite visitors to drink exotic cocktails and 'get inebriated'. Most of the museum is underground (and in fact partly below water level), there are no white walls like those of a high modernist museum and the exposed sandstone rock-face walls are made a feature. Other walls are wallpapered. One room is flooded with ink-black water and the visitor has to cross via stepping-stones. Arrivals are usually by boat along the river to a part of Hobart that is not considered 'glamorous' but 'suburban'. The visitor climbs up to the roof level of the museum (to find themselves in an area that has a tennis court and what appears to be a crashed car) only to then have to descend into the bowels of the museum's interior, via a spiral staircase, after entering through a steel and mirrored entrance that reflects, in distortion, the suburb Walsh grew up in. Visitors are often surprised to know the owner has an apartment on site. And it has a glass floor that enables him to look down into the gallery of the museum with its curved walls designed to carry the *Snake*. This vast artwork was painted by Sidney Nolan and comprises 1,620 individually drawn pictures which, when put together, produce an image of a rainbow serpent, an acknowledgement of the deep-seated spirituality of Indigenous Australia, and sometimes profoundly felt by non-Aboriginal Australians. Famously, one of the toilets allows the occupant to watch their own defecation and at 2.00pm each day, a machine that replicates the human digestive system, evacuates excrement. Live music is a feature of the

museum experience, mostly very contemporary idioms. The lighting gives an aura of perpetual twilight. Objects are displayed according to what appears to be whim (and shock value) and aesthetic juxtapositions (although with great scepticism, as aesthetics and notions of beauty are questioned) rather than the curatorial practices many museum-goers are familiar with: chronology, region/place, taxonomies or a combination of these. Objects that become too popular are removed. The art of antiquity is displayed with contemporary art. The novelist, Richard Flanagan, writes:

> MONA is a museum not of conviction and progress, but of doubt and questioning, of despair and wonder … neither celebrating nation nor seeking to preach orthodoxy, freed from the desire to educate. (Flanagan 2013: 27)

The critical reception of the museum has been far from rapturous. Many consider it a place more akin to a theme park (an adult Disneyland); some see it as a strange retrograde step back to the days when museums were 'cabinets of curiosities'; other regard it as faddish and without the depth to sustain it as a museum. Many feel the experience is disorienting. But for every detractor there are a bevy of advocates and, since opening, the museum has hosted about 800 visitors a day. Indeed, Hobart was ranked by Lonely Planet as one of the top ten city destinations for 2013 largely because of MONA.

What these descriptions cannot capture (and even YouTube videos struggle to represent the sensation of the museum's internal spaces) is the sense of discovery, the fun and humour, the surprise, shock and delight, the wonder, the unexpected and open-endedness of the encounter. The multiple possibilities of MONA are its greatest strength. One could go to the museum just to eat, drink and listen to music; or to get lost; or to have a laugh and 'good times' with friends; to be entertained; to enjoy an unusual, memorable and most probably unique experience; to breathe the ether of subversion and transgression; to ponder on what our relationship is to museums, material culture, collections, heritage objects and what such sites could be; and, if one wanted to, delve deeply into the artworks on display and society's responses to sex and death (past and present). The O-system handheld digital device enables the visitor to create their own itineraries, to learn (if they so desire), to listen to music selected for particular artworks, to listen to interviews with artists or to the museum owner's musings. Or visitors can choose not to use 'O' at all. It is the multiplicity of what is available that appeals, along with the visitor's freedom to create their own experience, their own meanings.

What MONA represents to me, in microcosm, is a material and embodied expression of how I imagine heritage interpretation. And philosophically, MONA represents a vision of interpretation that does not begin with an idea of information and informal learning but conceptualizes the visitor experience as something that has to do with wonder and enchantment.

Arriving where we began

The poet T.S. Eliot famously wrote in 'Little Gidding', the final poem in the *Four Quartets*, 'We shall not cease from exploration / And the end of all our exploring / Will be to arrive where we started / And know the place for the first time' (Eliot 1967: 197). One of the things that animated Eliot's concern about the fate of humankind was the need to fuse the past, present and future. With Eliot's idea in mind it is interesting to revisit the Prologue that began this book; and so, as a type of conclusion, I return to the beginning. Here are some extracts:

> Those who do not expect the unexpected will not find it, for it is trackless and unexplored.

These words appear in a surviving fragment of the writings of the philosopher Heraclitus who lived in the ancient Greek city of Ephesus between c.535 and 475 BCE (Kahn 1979: 105). If any aphorism were to somehow capture my expectations of visiting a heritage site, it would perhaps be this one: to expect the unexpected. But Heraclitus suggests something more than this: that the unexpected is not a mapped entity; it is not found along a pre-determined path; it resides in that which has yet to be known.

The dualism between what I expect (a place of discovery, of imaginative engagement, of speculation, of confrontation, of being confounded, of exploring the unknown, of emotional entanglement, of a place where I may tussle with the self, where I might dare to court with danger or bliss or controversy or sensuality, of *being there* – with all its embodied implications) and the often much more prosaic encounter with something that feels as though it has preceded me, something that is already over-determined by the discourses that circulate through a heritage site (and beyond) is, admittedly, a personal conundrum. However, I have never been able to fully ignore this intensity, as I wildly oscillate between entering a heritage place that is already in some way known to me (for whatever reason) and the *desire* to explore afresh (even when I'm aware of how this desire has been constructed and/or manipulated).

And what do visitors do in heritage places? The list is long and cannot easily be exhausted: we look, we hear, we smell, we touch (if we are allowed), we walk, we ramble, we climb, we rest, we interact with our companions, we imagine, we feel, we recall memories, we may laugh, we may cry, we may feel anger, anxiety, maybe disorientation, we may feel loss, we may feel pain, we may feel numb. We photograph (a lot), we read signs, we listen to audio-tours, we trail after a guide, we consult guidebooks, we may attend a lecture or multi-media presentation, we pore over maps, we closely observe models and diagrams, we watch a performance, we refer to Google

on our iPhones, we download an e-tour, we chat with our companions or on our phones, we think about something quite removed from where we are, we reflect, we may argue, we may feel confronted, we may feel small, we may feel proud, we may feel like a cosmopolitan or we may feel patriotic. We may feel nothing. We may feel overwhelmed. Whatever we do, it is a keen mixture: actions often mediated by representations plus somatic and cognitive participation. And what is the common denominator in this less than complete list? All of these interactions focus on the visitor, and all of them, therefore, are infused with social and cultural characteristics. In its broadest sense, visitors at heritage places can be regarded as being in dialogue with places, objects and landscapes; as having a dialogic relationship with parts of our planet marked out as being special (for whatever reason) and with something from the past/present that needs to be kept (for whatever reason, official or unofficial) for the future.

References

Abbot, H. Porter 2002. *The Cambridge Introduction to Narrative*. Cambridge: Cambridge University Press.

Ablett, P. and Dyer, P. 2010. Heritage and hermeneutics: towards a broader interpretation of interpretation. *Current Issues in Tourism*, 12(3), 209-233.

Adair, B., Filene, B. and Koloski, L. (eds) 2011. *Letting Go? Sharing Historical Authority in a User-Generate World*. Philadelphia: Pew Centre for Arts and Heritage.

Aldrich, R. 1993. *The Seduction of the Mediterranean: Writing, Art and Homosexual Fantasy*. London and New York: Routledge.

Allen, G. 2000. *Intertextuality*. London and New York: Routledge.

Alpers, S. 1984. *The Art of Describing*. Chicago: University of Chicago Press.

Anderson, B. 1991. *Imagined Communities: Reflections on the Origin and Spread of Nationalism*. Revised and extended edition. London: Verso.

Andrews, M. 1999. *Landscape and Western Art*. Oxford: Oxford University Press.

Anheier, H. and Isar, Y.R. (eds) 2011. *Heritage, Memory and Identity*, London: Sage Publications.

Appiah, K.A. 2006. *Cosmopolitanism: Ethics in a World of Strangers*. New York: W.W. Norton & Company.

Arthur, P. 2008. Exhibiting history: the digital future. *Recollections Journal of the National Museum of Australia*, 3(1), 33-50.

Ashworth, G. 2008. In search of the place-identity dividend: using heritage landscapes to create place identity, in *Sense of Place, Health and Quality of Life* edited by J. Eyles and A. Williams. Aldershot and Burlington: Ashgate, 185-195.

Atkinson, B. 2009. *Sri Lanka*. 11th edition. Footscray: Lonely Planet.

Baerenholdt, J., Haldrup, M., Larsen, J. and Urry, J. 2004. *Performing Tourist Places*. Aldershot and Burlington: Ashgate.

Barrell, J. 1983. *The Dark Side of the Landscape: The Rural Poor in English Painting 1730-1840*. Cambridge: Cambridge University Press.

Barthes, R. 1984. *Image Music Text*. Translated by S. Heath. London: Fontana/ Flamingo.

Bauman, Z. 2000. *Liquid Modernity*. Cambridge: Polity Press.

Bauman, Z. 2007. *Liquid Times: Living in an Age of Uncertainty*. Cambridge: Polity Press.

Baxandall, M. 1988. *Painting and Experience in Fifteenth Century Italy: A Primer on the Social History of Pictorial Style*. 2nd edition. Oxford: Oxford University Press.

Beck, L. and Cable, T. 1998. *Interpretation for the 21st Century: Fifteen Guiding Principles for Interpreting Nature and Culture*. Champaign: Sagamore Publishing.

Bell, C. and Lyall, J. 2001. *The Accelerated Sublime: Landscape, Tourism and Identity*. Westport: Praeger.

Bellos, D. 2011. *Is That a Fish in Your Ear? Translation and the Meaning of Everything*. London: Particular Books.

Bennett, J. 2001. Stigmata and sense memory: St Francis and the affective image. *Art History*, 24(1), 1-16.

Bennett, T. 1995. *The Birth of the Museum: History, Theory, Politics*. London and New York: Routledge.

Berger, J. 1972. *Ways of Seeing*. London: BBC Books.

Berlitz, 1977. *Pocket Guide to London*. London: Apa Publications.

Black, G. 2005. *The Engaging Museum: Developing Museums for Visitor Involvement*. London and New York: Routledge.

Boo, K. 2012. *Behind the Beautiful Forevers: Life. Death and Hope in Mumbai Undercity*. New York: Random House.

Boswell, D. and Evans, J. (eds) 1999. *Representing the Nation: A Reader: Histories, Heritage, Museums*. London and New York: Routledge.

Brennan, T. and Jay, M. (eds) 1996. *Vision in Context: Historical and Contemporary Perspectives on Sight*. London and New York: Routledge.

Brooks, G. 2008. *People of the Book*. Sydney and Auckland: HarperCollins Publishers.

Brooks, G. 2011. *Caleb's Crossing*. London, New York and Sydney: Fourth Estate.

Brown, D. 2004. *The Da Vinci Code: The Illustrated Edition*. New York: Random House.

Bruner, E. 2005. *Culture on Tour: Ethnographies of Travel*. Chicago and London: Chicago University Press.

Bryson, N. 1983. *Vision and Painting: The Logic of the Gaze*. London: MacMillan.

Burgess, J. and Green, J. 2009. *YouTube: Online Video and Participatory Culture*. Cambridge: Polity Press.

Burnett, R. 2005. *How Images Think*. Cambridge MA and London: MIT Press.

Byrne, D. 2007. *Surface Collection: Archaeological Travels in Southeast Asia*. Lanham and Plymouth: AltaMira Press.

Byrne, D. 2008. Heritage as social action, in *The Heritage Reader* edited by G. Fairclough, R. Harrison, J.H. Jameson and J. Schofield. Abingdon and New York: Routledge, 149-173.

Byrne, D., Brayshaw, H. and Ireland, T. 2003. *Social Significance: A Discussion Paper*. 2nd edition. Hurstville: NSW National Parks and Wildlife Service.

Cameron, F. 2008. The politics of heritage authorship: The case of digital heritage collections, in *New Heritage: New Media and Cultural Heritage* edited by Y. Kalay, T. Kvan and J. Affleck. London and New York: Routledge, 170-184.

Cameron, F. and Kenderdine, S. (eds) 2007. *Theorizing Digital Cultural Heritage: A Critical Discourse*. Cambridge MA and London: MIT Press.

Carbonell, B. (ed.) 2004. *Museum Studies: An Anthology of Contexts*. Oxford: Blackwell Publishing.

Carter, J. (ed.) 2001. *A Sense of Place: An Interpretive Planning Handbook*. 2nd edition. Inverness: Scottish Interpretation Network.

Chakrabarty, D. 2002. Museums in late democracies. *Humanities Research*, 9(1), 5-12.

Clark, K. 1960. *Looking at Pictures*. London: John Murray.

Clark, K. 1969. *Civilization*. London: John Murray.

Clendinnen, I. 1999. *True Stories*. Sydney: ABC Books.

Clendinnen, I. 2003. *Dancing with Strangers*. Melbourne: Text Publishing.

Clendinnen, I. 2006. The history question: who owns the past? *Quarterly Essay*, 23, 1-72.

Coleman, S. and Crang, M. (eds) 2002. *Tourism: Between Place and Performance*. New York and Oxford: Berghahn Books.

Crary, J. 1990. *Techniques of the Observer: On Vision and Modernity in the Nineteenth Century*. Cambridge MA: MIT Press.

Crawshaw, C. and Urry, J. 1997. Tourism and the photographic eye, in *Touring Cultures: Transformations of Travel and Theory*, edited by C. Rojek and J. Urry. London and New York: Routledge, 176-195.

Crouch, D. 2002. Surrounded by place: embodied encounters, in *Tourism: Between Place and Performance*, edited by S. Coleman and M. Crang. New York and Oxford: Berghahn Books, 207-218.

Crouch, D. 2010. *Flirting with Space*. Farnham and Burlington VT: Ashgate.

Crouch, D. and Lubbren, N. (eds) 2003. *Visual Culture and Tourism*. Oxford and New York: Berg.

Curthoys, A. and Docker, J. 2006. *Is History Fiction?* Sydney: University of NSW Press.

Dalrymple, W. 2006. *The Last Mughal: The Fall of Delhi, 1857*. London: Bloomsbury.

Daly, P. and Winter, T. (eds) 2012. *Routledge Handbook of Heritage in Asia*. London and New York: Routledge.

De Botton, A. 2002. *The Art of Travel*. London: Hamish Hamilton/Penguin.

Dessaix, R. 2004. *Twilight of Love: Travels with Turgenev*. Sydney: Picador.

Dessaix, R. 2008. *Arabesques: A Tale of Double Lives*. Sydney: Picador.

Dicks, B. 2003. *Culture on Display: The Production of Contemporary Visitability*. Maidenhead: Open University Press.

Dudley, S. (ed.) 2010. *Museum Materialities: Objects, Engagements, Interpretations*. London and New York: Routledge.

Dutton, D. 2010. *The Art Instinct: Beauty, Pleasure and Human Evolution*. New York and London: Bloomsbury Press.

Eco, U. 1987. *Travels in Hyper-reality*. Translated by W. Weaver. London: Picador.

Eco, U. (ed.) 2004. *On Beauty*. London: Secker and Warburg.

Edensor, T. 1998. *Tourists at the Taj: Performance and Meaning at a Symbolic Site*. London and New York: Routledge.

Eggert, P. 2009. *Securing the Past: Conservation in Art, Architecture and Literature*. Cambridge: Cambridge University Press.

Eliot, T.S. 1969. *The Complete Poems and Plays of T.S. Eliot*. London: Book Club Associates/Faber and Faber.

Evans, J. and Hall, S. (eds) 1999. *Visual Culture: The Reader*. London: Sage Publications.

Fairclough, G. 2012. Others: a prologue, in *Heritage and Social Media: Understanding Heritage in a Participatory Culture*, edited by E. Giaccardi. Abingdon and New York: Routledge, xiv-xviii.

Falk, J. and Dierking, L. 2000. *Learning from Museums: Visitor Experiences and the Making of Meaning*. Lanham and Plymouth: AltaMira Press.

Flanagan, M. 2013. The gambler: David Walsh and MONA. *The Monthly: Australian Politics, Society and Culture*, 86, 16-25.

Fletcher, J. 2004. *The Search for Nefertiti*. New York: HarperCollins Publishers.

Foster, H. (ed.) 1988. *Vision and Visuality*. Seattle: Bay Press.

Foucault, M. 1973. *The Order of Things: An Archaeology of the Human Sciences*. New York: Vintage Books.

Gere, C. 2006. *The Tomb of Agamemnon: Mycenae and the Search for a Hero*. London: Profile Books.

Giaccardi, E. (ed.) 2012. *Heritage and Social Media: Understanding Heritage in a Participatory Culture*. Abingdon and New York: Routledge.

Gibson, J. 1979. *The Ecological Approach to Visual Perception*. Boston: Houghton Mifflin.

Gibson, R. 2006. Spirit house, in *South Pacific Museums: Experiments in Culture* edited by C. Healy and A. Witcomb. Clayton: Monash University ePress, 23.1-23.6.

Gibson, W. 1993. *Neuromancer*. London: Harper Collins Publishers.

Gottdiener, M. 1995. *Postmodern Semiotics: Material Culture and the Forms of Postmodern Life*. Oxford: Blackwell.

Graham-Dixon, A. 2010. *Caravaggio: A Life Sacred and Profane*. London: Allen Lane.

Greenblatt, S. 2011. *The Swerve: How the World Became Modern*. New York: W.W. Norton & Company.

Gregory, K. and Witcomb, A. 2007. Beyond nostalgia: the role of affect in generating historical understanding at heritage sites, in *Museum Revolutions: How Museums Change and Are Changed*, edited by S. Watson, S. MacLeod and S. Knell. London and New York: Routledge, 263-275.

Grosz, E. 2001. *Architecture from the Outside: Essays in Virtual and Real Space*. Cambridge MA: MIT Press.

Gurian, E. 2006. *Civilizing the Museum*. London and New York: Routledge.

Hall, S. (ed.) 1997. *Representation: Cultural Representations and Signifying Practices*. London: Sage Publications.

Hallam, E. and Street, B. (eds) 2000. *Cultural Encounters: Representing 'Otherness'*. London and New York: Routledge.

Hancock, M. 2008. *The Politics of Heritage from Madras to Chennai*. Bloomington: Indiana University Press.

Haraway, D. 1991. *Simians, Cyborgs and Women: the Reinvention of Nature*. London and New York: Routledge.

Harris, A. 2010. Everyone has a story to tell. Unpublished PhD thesis: University of Western Sydney.

Harrison, J. 2001. Thinking about tourists. *International Sociology*, 16(2), 159-172.

Harrison, R. (ed.) 2010. *Understanding the Politics of Heritage*, Manchester: Manchester University Press.

Harrison, R. 2013. *Heritage: Critical Approaches*. Abingdon and New York: Routledge.

Haynes, R. 1998. *Seeking the Centre: The Australian Desert in Literature, Art and Film*. Cambridge: Cambridge University Press.

Hein, G. 1998. *Learning in the Museum*. Abingdon and New York: Routledge.

Hibbard, H. 1983. *Caravaggio*. London: Thames and Hudson.

Hillis, K. 1999. *Digital Sensations: Space, Identity and Embodiment in Virtual Reality*. Minneapolis and London: University of Minnesota Press.

Hillis, K. 2009. *Online a Lot of the Time: Ritual, Fetish, Sign*. Durham and London: Duke University Press.

Hollinshead, K. 2009. The 'worldmaking' prodigy of tourism: the reach and power of tourism in the dynamics of change and transformation. *Tourism Analysis*, 14, 139-152.

Hollinshead, K., Ateljevic, I. and Ali, N. 2009. Worldmaking agency – worldmaking authority: the sovereign constitutive role of tourism. *Tourism Geographies*, 11(4), 427-443.

Holt, J. 2009. *Spirits of the Place: Buddhism and Lao Religious Culture*. Honolulu: University of Hawai'i Press.

Hooper-Greenhill, E. 1992. *Museums and the Shaping of Knowledge*. London and New York: Routledge.

Hooper-Greenhill, E. 2000. *Museums and Interpretation of Visual Culture*. London and New York: Routledge.

Hooper-Greenhill, E. 2007. *Museums and Education: Purpose, Pedagogy, Performance*. London and New York: Routledge.

Horne, D. 1992. *The Intelligent Tourist*. McMahons Point: Margaret Gee Publishing.

ICOMOS 2008. *Charter on the Interpretation and Presentation of Cultural Heritage Sites*. 16th General Assembly Quebec. International Council on Monuments and Sites: Paris.

Jenkins, H. 2008. *Convergence Culture: Where Old and New Media Collide*. New York and London: New York University Press.

Kahn, C. (ed.) 1979. *The Art and Thought of Heraclitus*. Cambridge: Cambridge University Press.

Kalay, Y., Kvan, T. and Affleck, J. (eds) 2008. *New Heritage: New Media and Cultural Heritage*. London and New York: Routledge.

Karp, I. and Lavine, S. (eds) 1991. *Exhibiting Cultures: The Poetics and Politics of Museum Display*. Washington and London: Smithsonian Institution Press.

Karp, I., Kreamer, C. and Lavine, S. (eds) 1992. *Museums and Communities: The Politics of Public Culture*. Washington and London: Smithsonian Institution Press.

Karp, I., Kratz, C., Szwaji, L. and Ybarra-Frausto (eds) 2006. *Museum Frictions: Public Cultures/Global Transformations*. Durham and London: Duke University Press.

Kavanagh, G. 2000. *Dream Spaces: Memory and the Museum*. London and New York: Leicester University Press.

King, R. 2005. *Brunelleschi's Dome: The Story of the Great Cathedral of Florence*. London: Pimlico.

Kos, J. 2008. Experiencing the city through a historical digital system, in *New Heritage: New Media and Cultural Heritage* edited by Y. Kalay, T. Kvan and J. Affleck. London and New York: Routledge, 132-152.

Kosky, B. 2008. *On Ecstasy*. Carlton: Melbourne University Press.

Labadi, S. and Long, C. (eds) 2010. *Heritage and Globalisation*. London and New York: Routledge.

Lancaster and York Heritage, 2007. *Telling Our Stories: An Interpretation Manual for Heritage Partners*. Lancaster and York PA: County Planning Commissions.

Langfield M., Logan, W. and Craith, M. (eds) 2009. *Cultural Diversity, Heritage and Human Rights*. London and New York: Routledge.

Lee, H. [1960] 2006. *To Kill A Mockingbird*. London: Arrow Books.

Leed, E. 1991. *The Mind of the Traveler*. New York: Basic Books.

Lister, M., Dovey, J., Giddings, S., Grant, I. and Kelly, K. 2009. *New Media: A Critical Introduction*. 2nd edition. London and New York: Routledge.

Logan, W. and Reeves, K. (eds) 2008. *Places of Pain and Shame: Dealing with 'Difficult Heritage'*. London and New York: Routledge.

Lormahaomongkol, P. 2005. A critical analysis of heritage interpretation for visitors at Sukhothai World Heritage Site, Thailand. Incomplete doctoral thesis. Bangkok: Silpakorn University.

Lowenthall, D. 1998. *The Heritage Crusade and the Spoils of History*. Cambridge: Cambridge University Press.

MacCannell, D. 1999. *The Tourist: A New Theory of the Leisure Class*. 3rd edition. Berkeley and Los Angeles: University of California Press.

MacCannell, D. 2011. *The Ethics of Sightseeing*. Berkeley and Los Angeles: University of California Press.

McGinn, C. 2004. *Mindsight: Image, Dream, Meaning*. Cambridge MA and London: Harvard University Press.

MacLachlan, G. and Reid, I. 1994. *Framing and Interpretation*. Melbourne: Melbourne University Press.

Mandela, N. 1965. *No Easy Walk to Freedom*. London: Heinemann.

Mann, T. 1998. *Death in Venice and Other Stories*. First published in German in 1898. Translated by T. Luke. London: Vintage.

Marin, L. 1993. Frontiers of Utopia: past and present. *Critical Inquiry*, 19(3), 397-420.

Massumi, B. 2002. *Parables for the Virtual: Movement, Affect, Sensation*. Durham and London: Duke University Press.

Maushart, S. 2010. *The Winter of Our Disconnect*. London: Penguin.

Merleau-Ponty, M. 2002. *Phenomenology of Perception*. Abingdon and New York: Routledge.

Messineo, G. and Borgia, E. 2005. *Ancient Sicily: Monuments Past and Present*. Rome: Vision Publications.

Minca, C. and Oakes, T. (eds) 2006. *Travels in Paradox: Remapping Tourism*. Lanham: Rowman and Littlefield Publishing.

Mirzoeff, N. 2002. *The Visual Culture Reader*. 2nd edition. London and New York: Routledge.

Mitchell, T. 1989. The world as exhibition. *Comparative Studies in Society and Literature*, 31, 217-236.

Mitchell, W. (ed.) 1994. *Landscape and Power*. Chicago and London: University of Chicago Press.

Moran, D. and Mooney, T. (eds) 2002. *The Phenomenology Reader*. London and New York: Routledge.

Morkham, B. and Staiff, R. 2002. The cinematic tourist: perception and subjectivity, in *The Tourist as a Metaphor of the Social World* edited by G. Dann. Wallingford and New York: CABI Publishing, 297-316.

Munos Vinas, S. 2005. *Contemporary Theory of Conservation*. Oxford and Burlington: Elsevier Butterworth-Heinemann.

Ndalianis, A. 2004. *Neo-baroque Aesthetics and Contemporary Entertainment*. Cambridge MA and London: MIT Press.

Nelson, R. and Shiff, R. (eds) 1996. *Critical Terms for Art History*. Chicago and London: Chicago University Press.

Ngaosrivathana, M. and Ngaosrivathana, P. 2009. *The Enduring Sacred Landscape of the Naga*. Chiang Mai: Mekong Press.

Nochlin, L. 1994. *The Body in Pieces: The Fragment as a Metaphor of Modernity*, London: Thames and Hudson.

Pallasmaa, J. 2005. *The Eyes of the Skin: Architecture and the Senses*. Chichester: John Wiley and Sons.

Parks Australia, 1996. *Uluṟu-Kata Tjuṯa National Park Media Information Folio*. Canberra: Australian Government.

Parks Australia, 2012. *Uluṟu-Kata Tjuṯa Vistors' Guide*. Canberra: Australian Government.

Parry, R. 2008. Afterword: The future in our hands? Putting potential into practice, in *Digital Technologies and the Museum Experience*, edited by L. Tallon and K. Walker. Lanham and Plymouth: AltaMira Press, 179-193.

Pastorelli, J. 2003. *Enriching the Experience: An Interpretive Approach to Tour Guiding*. French's Forest: Pearson Education Australia.

Paton, A. 1987. *Cry the Beloved Country*. Harmondsworth: Penguin.

Peleggi, M. 2002. *The Politics of Ruin and the Business of Nostalgia*. Bangkok: White Lotus.

Peleggi, M. 2007. *Thailand: The Worldly Kingdom*. London and Singapore: Talisman and Reaktion Books.

Perrottet, T. 2004. *The Naked Olympics: The True Story of the Ancient Games*. New York: Random House.

Picard, M. 1996. *Bali: Cultural Tourism and Touristic Culture*. Singapore Books: Archipelago Press.

Pier 21, 2007. *Our Canadian Stories: Educators' Manual*. Halifax: National Museum of Immigration.

Plato, 1952. *The Republic*. Translated by B. Jowett. Chicago: University of Chicago Press and Encyclopaedia Britannica.

Roberts, G. (ed.) 2001. *The History and Narrative Reader*. London and New York: Routledge.

Rojek, C. 1997. Indexing, dragging and the social construction of tourist sights, in *Touring Cultures: Transformations of Travel and Theory*, edited by C. Rojek and J. Urry. London and New York: Routledge, 52-74.

Rooney, D. 2008. *Ancient Sukhothai: Thailand's Cultural Heritage*. Bangkok: River Books.

Rosenstone, R. 2001. The historical film: looking at the past in a post-literate age, in *The Historical Film: History and Memory in Media*, edited by M. Landy. London: Athlone Press, 50-66.

Rosenstone, R. 2006. *History on Film/Film on History*. Harlowe: Pearson Education.

Rountree 2006. Performing the divine: neo-pagan pilgrimages and embodiment at sacred sites. *Body and Society*, 12(4), 95-115.

Said, E. 1985. *Orientalism*. London: Peregrine Books.

Saipradist, A. and Staiff, R. 2007. Crossing the cultural divide: Western visitors and interpretation at Ayutthaya World Heritage site, Thailand. *Journal of Heritage Tourism*, 2(3), 211-224.

Saslow, J. 1999. *Pictures and Passions: A History of Homosexuality in the Visual Arts*. New York and London: Viking/Penguin.

Schubert, K. 2009. *The Curator's Egg: The Evolution of the Museum Concept from the French Revolution to the Present Day*. London: Ridinghouse.

Silverman, H. 2011. Border wars: the ongoing temple dispute between Thailand and Cambodia and UNESCO's World Heritage List. *International Journal of Heritage Studies,* 17(1), 1-21.

Smith, B. [1960] 1989. *European Vision and the South Pacific*. 3rd edition. Melbourne: Oxford University Press.

Smith, L. 2006. *Uses of Heritage*, Abingdon and New York: Routledge.

Smith, L and Akagawa, N. (eds) 2009. *Intangible Heritage*. London and New York: Routledge.

Spivey, N. 2005. *How Art Made the World*. London: BBC Books.

Staiff, R. 2008. Cultural inscriptions of Nature: some implications for sustainability, nature-based tourism and national parks, in *Tourism, Recreation and Sustainability: Linking Culture and Environment*, edited by S. McCool and R. Moisey. 2nd edition. New York: CABI Publishing, 220-235.

Staiff, R. 2010. History and tourism: intertextual representations of Florence. *Tourism Analysis*, 15(5), 601-611.

Staiff, R. 2013. Swords, sandals and togas: the cinematic imaginary and the tourist experience of Roman heritage sites, in *Heritage and Tourism: Place, Encounter, Engagement*, edited by R. Staiff, R. Bushell and S. Watson. London and New York: Routledge, 85-102.

Staiff, R. and Bushell, R. 2003a. Travel knowledgeably: the question of content in heritage interpretation, in *Interpreting the Land Down Under: Australian Heritage Interpretation and Tour Guiding*, edited by R. Black and B. Weiler. Golden Col: Fulcrum Publishing, 92-108.

Staiff, R. and Bushell, R. 2003b. Heritage interpretation and cross-cultural translation in an age of global travel: some issues. *Journal of Park and Recreation Administration*, 21(4), 104-122.

Staiff, R. and Bushell, R. 2013. Mobility and modernity in Luang Prabang, Laos: re-thinking heritage and tourism. *International Journal of Heritage Studies*, 19(1), 98-113.

Staiff, R., Bushell, R. and Kennedy, P. 2002. Interpretation in national parks: some critical questions. *Journal of Sustainable Tourism*. 10(2), 97-113.

Staiff, R., Bushell, R. and Watson, S. (eds) 2013. *Heritage and Tourism: Place, Encounter, Engagement*. London and New York: Routledge.

Starkey, D. 2010. *Crown and Country: A History of England Through the Monarchy*. London: Harper Press.

Steinberg, L. 1996. *The Sexuality of Christ in Renaissance Art and in Modern Oblivion*. 2nd edition. Chicago: Chicago University Press.

Stubbs, J. 2009. *Time Honored: A Global View of Architectural Conservation*. Hoboken: John Wiley & Sons.

Sutton, P. (ed.) 1988. *Dreamings: The Art of Aboriginal Australia*. Ringwood and London: Viking/Penguin.

Taussig, M. 1993. *Mimesis and Alterity: A Particular History of the Senses*. New York and London: Routledge.

Taylor, J. 1994. *A Dream of England: Landscape, Photography and the Tourist's Imagination*. Manchester and New York: Manchester University Press.

Tilden, F. 1977. *Interpreting Our Heritage*. 3rd edition. Chapel Hill: The University of North Carolina Press.

Tilden, F. 2007. *Interpreting Our Heritage*. 4th expanded edition. Chapel Hill: The University of North Carolina Press.

Trinh Minh Ha 1989. *Women, Native, Other: Writing, Postcoloniality and Feminism*. Bloomington and Indianapolis: Indiana University Press.

UNWTO, 2011. *Communicating Heritage: A Handbook for the Tourism Sector*. Madrid: UNWTO in association with ICOMOS ICTC.

Urry, J. 1990. *The Tourist Gaze*. London: Sage Publications.

Urry, J. 1995. *Consuming Places*. London and New York: Routledge.

Urry, J. 2007. *Mobilities*. Cambridge: Polity Press.

Urry, J. and Larsen, J. 2011. *The Tourist Gaze 3.0*. London: Sage Publications.

Uzzell, D. (ed.) 1989. *Heritage Interpretation*. Volumes 1 and 2. London: Belhaven Press.

Venuti, L. 1993. Translation as cultural politics: regimes of domestication in English. *Textual Practice*, 7(2), 208-223.

Venuti, L. (ed.) 2000. *The Translation Studies Reader*. London and New York: Routledge.

Vickers, A. 2012. *Bali: A Paradise Created*. 2nd edition. Tokyo and Rutland: Tuttle Publishing.

Walsh, P. 2010. The Web and the unassailable voice, in *Museums in a Digital Age*, edited by R. Parry. Abingdon and New York: Routledge, 229-236.

Wartofsky, M. 1979. Picturing and representing, in *Perception and Pictorial Representation,* edited by C. Nodine and D. Fisher. New York: Praeger.

Wartofsky, M. 1980. Cameras can't see: representation, photography and human vision. *Afterimage*, 7(9), 8-9.

Wartofsky, M. 1984. The paradox of painting: pictorial representation and the dimensionality of visual space. *Social Research*, 51(4), 863-883.

Waterton, E. and Watson, S. (eds) 2010. *Culture, Heritage and Representation: Perspectives on Visuality and the Past*. Aldershot and Burlington: Ashgate.

White, H. 2010. *The Fiction of Narrative: Essays on History, Literature and Theory, 1957-2007*. Baltimore: John Hopkins University Press.

Williams, R. 1975. *The Country and the City*. Oxford: Oxford University Press.

Williams, T. 1949. *A Street Car Named Desire*. New York: Signet.

Winichakul, T. 1995. *Siam Mapped: A History of the Geo-body of a Nation*. Chiang Mai: Silkworm Books.

Winter, T. 2003. Tomb raiding Angkor: a clash of cultures. *Indonesia and the Malay World*, 31(89), 58-68.

Winter, T. 2004. Landscape memory and heritage: New Year celebrations at Angkor, Cambodia. *Current Issues in Tourism*, 7(4&5), 330-345.

Winter, T. 2007. *Post-Conflict Heritage, Postcolonial Tourism: Conflict, Politics and Development at Angkor*. London and New York: Routledge.

Winterson, J. 2009. *Midsummer Nights*. London: Quercus Publishing.

Witcomb, A. 2003. *Re-imagining the Museum: Beyond the Mausoleum*. London and New York: Routledge.

Witcomb, A. 2010a. Remembering the dead by affecting the living: the case of a miniature model of Treblinka, in *Museum Materialities: Objects, Engagements, Interpretations* edited by S. Dudley. London and New York: Routledge, 39-52.

Witcomb, A. 2010b. The politics and poets of contemporary exhibition making: towards an ethical engagement with the past, in *Hot Topics, Public Culture, Museums*, edited by F. Cameron and L. Kelly. Newcastle: Cambridge Scholars, 245-264.

Wongthes, M. 2003. *Intellectual Might and National Myth: A Forensic Investigation of the Ram Khamhaeng Controversy in Thai Society*. Bangkok: Matichon.

Wright, T. 2008. *Visual Impact: Culture and the Meaning of Images*. Oxford and New York: Berg.

Wyke, M. 1997. *Projecting the Past: Ancient Rome, Cinema and History*. London and New York: Routledge.

Films and television series

Ancient Megastructures (National Geographic, 2007)

Ancient Rome: Rise and Fall of an Empire (BBC, 2006)

Australia (dir Baz Luhrmann, 2008)

Avatar (dir James Cameron, 2009)

Ben Hur (dir William Wyler, 1959)

Civilization (BBC, 1969)

Classical Destinations (Sky Arts, 2006 and 2009)

Cleopatra (dir Joseph L. Mankiewicz, 1963)

Confucius (dir Hu Mei, 2010)

Crouching Tiger, Hidden Dragon (dir Ang Lee, 2000)

Curse of the Golden Flower (dir Zhang Yimou, 2006)

Death on the Nile (dir John Guillermin, 1978)

Evil Angels (and also titled *A Cry in the Dark*) (dir Fred Schepisi, 1987)

Gladiator (dir Ridley Scott, 2000)

Hero (dir Zhang Yimou, 2002)

House of Flying Daggers (dir Zhang Yimou, 2004)

How Art Made the World (BBC, 2005)

I Claudius (BBC, 1976)

Jurassic Park (dir Steven Spielberg, 1993)

Lara Croft: Tomb Raider (dir Simon West, 2001)

Life of Pi (dir Ang Lee, 2012)

Metropolis (dir Fritz Lang 1927)

Molière (dir Laurent Tirard, 2007)

Mulan (dir Jingle Ma, 2009)

Pompeii: The Last Day (BBC, 2003)

Red Cliffs (dir John Woo, 2008 and 2009)

Rome (HBO and BBC, 2005 and 2007)

Rome: Rise and Fall of an Empire (History Channel, 2008)

Romeo and Juliet (dir Franco Zeffirelli, 1968)

Slum Dog Millionaire (dir Danny Boyle, 2008)

Spartacus (dir Stanley Kubrick, 1960)

Stephen Fry in America (BBC, 2008)

The Emperor and the Assassin (dir Chen Kaige, 1998)

The Last Days of Pompeii (ABC, 1984)

The Lord of the Rings (dir Peter Jackson, 2001-2003)
The Matrix (dir Andy and Lana Wachowski 1999)
The Robe (dir Henry Koster, 1953)
The Sheltering Sky (dir Bernado Bertolucci, 1990)
Troy (dir Wolfgang Petersen, 2004)
Walking with Dinosaurs (BBC, 1999)
Warriors (BBC, 2008)

Index